# IRELAND

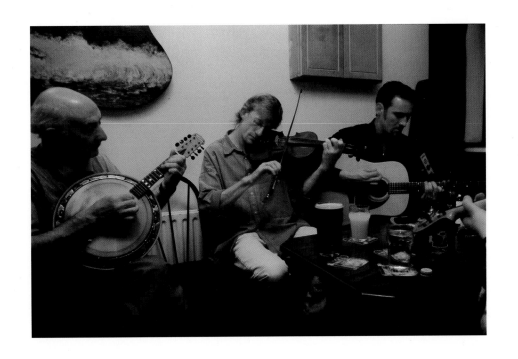

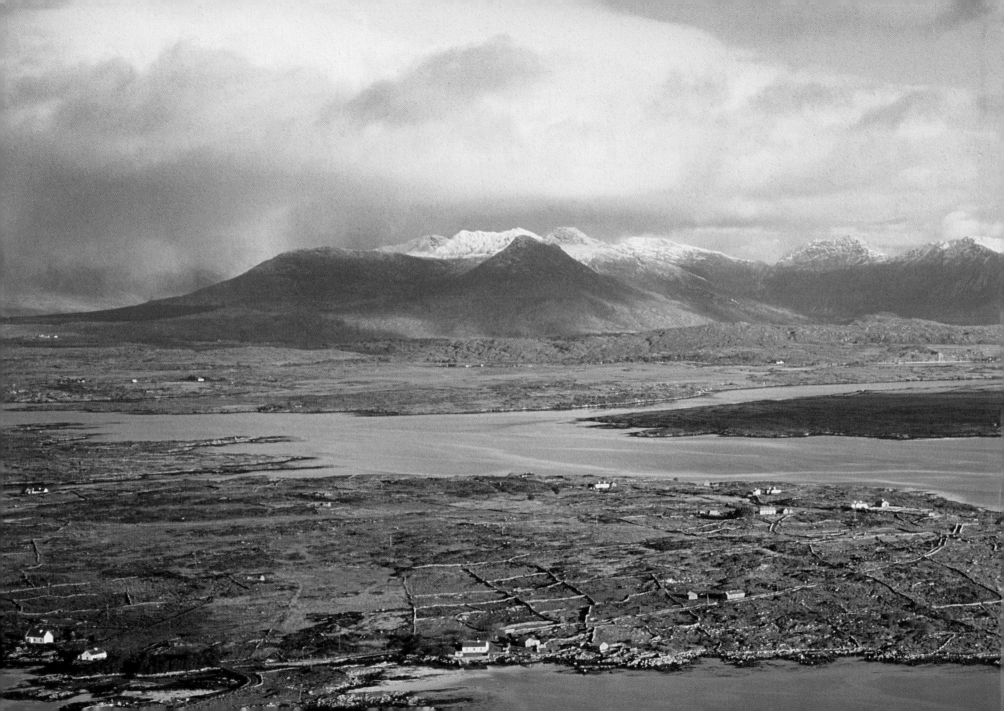

# IRELAND

## DAVID LYONS

CHARTWELL
BOOKS, INC.

CHARTWELL BOOKS, INC.
A Division of
**BOOK SALES, INC.**
276 Fifth Avenue Suite 206
New York, New York 10001

ISBN-13: 978-0-7858-2242-4
ISBN-10: 0-7858-2242-9

© 2004 Compendium Publishing, 43 Frith Street, London, Soho, W1V 4SA,
United Kingdom

Cataloging-in-Publication data is avaialable from the Library of Congress

Printed in China through Printworks Int. Ltd

Design: Tony Stocks and Danny Gillespie

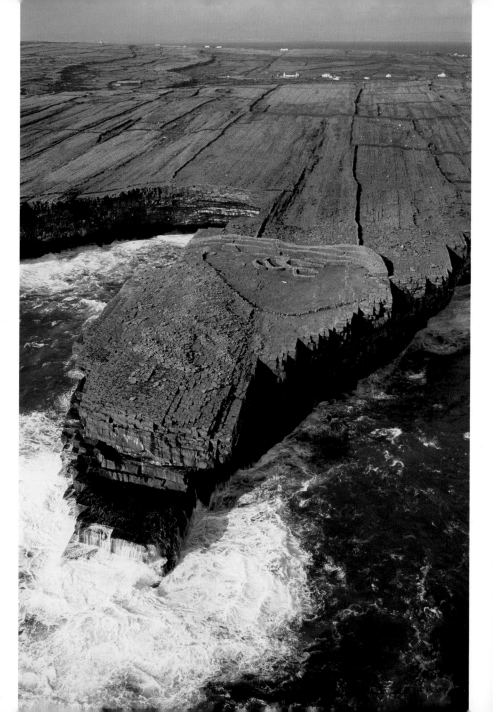

**PAGE ONE:** Musicians at the bar during *Scoil Acla*—the Clew Bay annual music festival on
Achill Island, County Mayo.

**PREVIOUS PAGES:** Connemara, County Galway—the view north over Inishee on
Bertraghboy Bay toward the snow-topped Twelve Pins.

**RIGHT:** Dun Duchathair (the Black Fort)—an ancient promontory fort on the cliffs of
Inishmore, Aran Islands, County Galway.

# Contents

Introduction      6

Ulster      12

Connacht      64

Munster      118

Leinster      192

Central      128

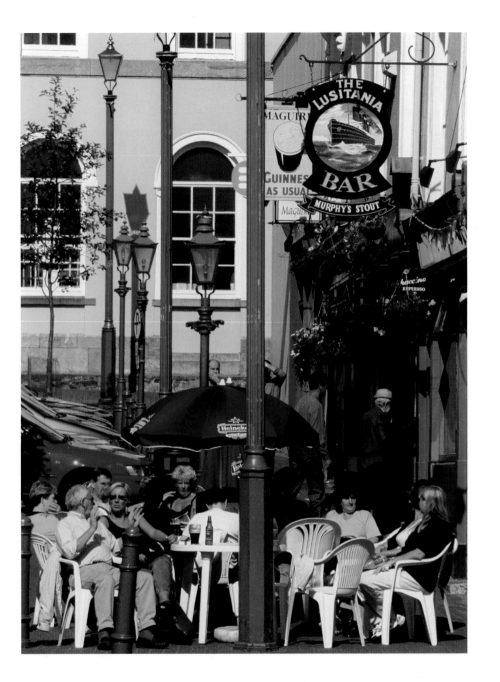

# Introduction

The history of Ireland is as complicated, colorful, and tortured as that of any equivalent area of land anywhere in the world. Yet for all its historical richness it is also one of the most beautiful places on Earth—perhaps it is for this simple reason alone that so many people have fought to possess the land.

Little is known about pre-Christian Ireland other than what can be derived from the mysterious remnants of megalithic structures that are left scattered around the countryside. The first inhabitants were Mesolithic peoples dating from 9000 BC who lived in County Derry at Mount Sandel and in County Offaly at Lough Boora. More itinerant tribespeople moved in as the icecaps and glaciers retreated leaving a more habitable landscape and climate. By 3500 BC the Neolithic tribes had arrived from southern Europe; they created huge stone monuments and astonishingly sophisticated ornaments worked from gold found in the Wicklow Mountains. During the Bronze Age these peoples prospered and increased in numbers; working gold and bronze ornaments, as well as metal weapons.

Around 500 BC the Celts—also known as Gaels—arrived, having spread across western Europe and mainland Britain, finally overwhelming the Iron Age inhabitants of Ireland. The land was soon divided into small kingdoms and was in near constant conflict. Through all the fighting, five kingdoms eventually emerged in the 4th century: these very roughly correspond to the provinces of Connacht, Munster, Ulster, Leinster, and counties Meath and Westmeath. The religious and political centers were at Emain Macha in Armagh, the seat of the kings of Ulster; at Tara, the seat of the kings of Meath; and Rath Cruacha in Connacht. However, despite all the upheavals a rich culture flourished, especially for literature—the most famous of these being the epic poem Táin Bó Cúainge (The Cattle-Raid of Cooley) and the tales of the Fianna.

The clan system was the basis of the Celtic social structure, which was a communal , agricultural society that worked together on an area of communal land. Celts paid taxes and fought together when necessary. Politically, they elected members to local assemblies to administer clan affairs. A number of clans together formed a regional kingdom (a tuatha). Of more importance were the druids, doctors, and brehons (judges), all of whom required years of training for their positions. The rulers were the chiefs, Ri, the highest being the Ard Ri or High King of Ireland. These were elected offices as hereditary power was an unknown concept for the Celts; women could be elected as chiefs in their own right.

PREVIOUS PAGE: Knockahollet Moat is the remnant of a motte and bailey castle on a prehistoric site six miles south of Armoy, County Antrim.

RIGHT: Map of Ireland

FAR RIGHT: Sherkin Island, County Cork— view northeast over Ordree Point toward Baltimore.

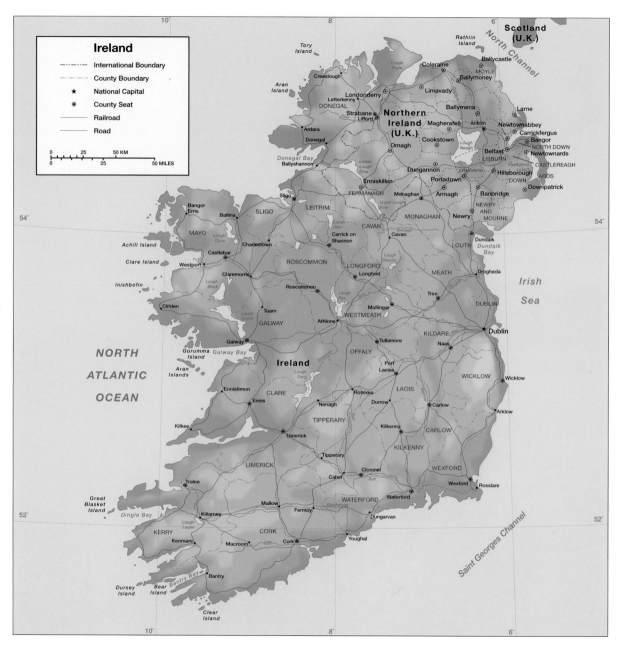

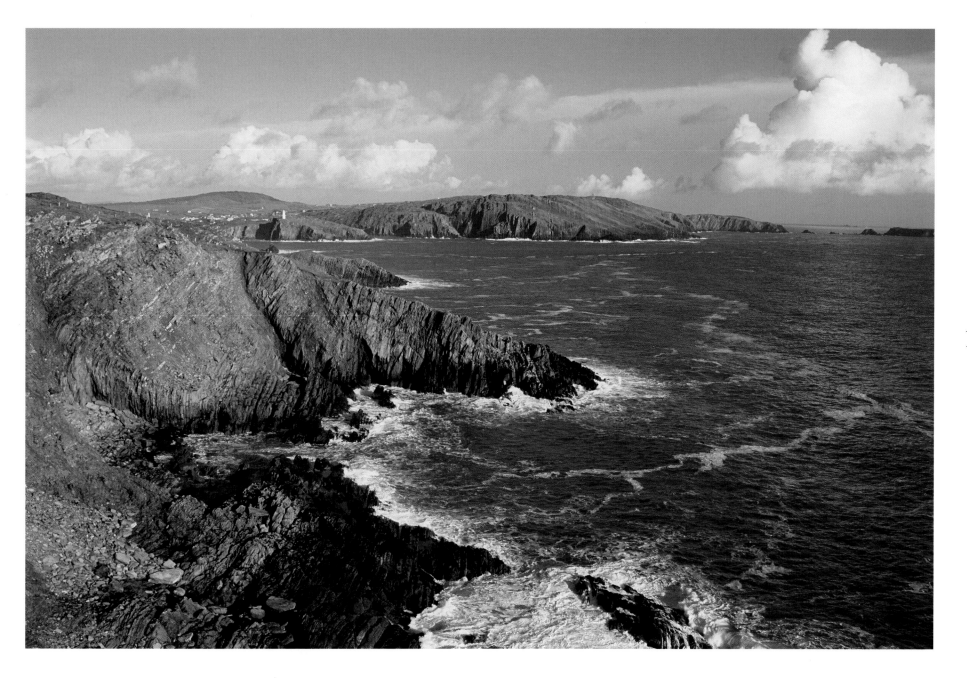

The Romans did not invade Ireland, although recent archaeological excavations show that they did make extended visits. Christianity, however, arrived in the 5th century AD but it was not until St. Patrick appeared, possibly from southwest England, that the country became Christian. St. Patrick introduced the Roman alphabet, codified the existing laws while keeping the Celtic social and tribal patterns intact as far as Christian practice allowed. Soon the pagans and druids were squeezed out and instead wealthy monastic foundations arose to became the centers of worship and learning, attracting literate and cultivated men from the Continent. The arts in general flourished—especially calligraphy and illumination of early Christian literature, notably the Book of Kells. Irish scholars were particularly renowned for their Latin scholarship, while Irish metalwork and sculpture were among the best in Europe: it is from this period that many of the wonderful Celtic crosses date. This was the golden age of Celtic Ireland when it was known abroad as the "Island of Saints and Scholars."

Such cultural richness brought great wealth and inevitably attracted the attention and stirred the greed of Scandinavian raiders: the Vikings. All the coastal settlements around the British Isles were plundered by repeated waves of violent Viking raids for 200 or so years. Ireland was first raided in 795 and fortified Viking settlements were founded at important maritime locations—such as Dublin and Cork. Internecine clan warfare continually sapped Irish efforts to present a unified front against the Vikings until a brief period when the High King Brian Boru managed to more or less unite his people against the invaders. Together with his Celtic allies he beat the Vikings at Clontarf in 1014 ending their reign of terror. But Boru was murdered soon after and Ireland has never been united again as dynastic rivalries split the country, although the Celtic culture remained strong until the 17th century.

The Normans arrived in Ireland in 1069 and so started three centuries of bitter fighting for control of Ireland. The Normans brought trade and law and soon the Norman king of England was also king of Ireland. The Normans left their mark in the shape of huge castles and fortified towns. Under Norman rule three Anglo-Norman houses came to promenance —the Butlers of Ormonde, the FitzGeralds of Desmond, and the FitzGeralds of Kildare, their power and wealth made them in effect rulers of Ireland. In the 12th century Pope Adrian IV gave Ireland to the king of England, exacerbating an already difficult political climate. The Anglo-Normans were never popular, especially when in 1366 the colonial parliament forbade intermarriage and all Irishness—dress, language, customs, and even Irish names—in the Statutes of Kilkenny.

By the 16th century, King Henry VIII had continuous trouble from his Irish subjects. He asserted his power when he dissolved the monasteries in Ireland and—as he had in England and Wales—pocketed much of their wealth and lands or granted them to his faithful subjects. Henry now personally appointed the Irish bishops and in 1541 he was acknowledged as King of Ireland. However, the majority of Irish stuck with the old faith of Catholicism. During Queen Elizabeth I's reign, especially between 1558 and 1603, the crown again fought in Ireland to violently suppress numerous revolts

against English/Protestant influence and control. This became a continuous theme for the next hundred years as first one revolt after another led to bloodshed and tears.

In May 1609 the Plantation Articles granted most of Ulster to English and Scottish Protestant colonists in an attempt to establish a land faithful to the English crown. Since then Ulster has been separate from the rest of Ireland both politically and philosophically. During the English Civil War the Irish used the distraction to try to break away from their overlords, but Oliver Cromwell came in person from 1649 until 1655 and left a bloody trail of death in his wake as he put the land to the torch and thousands to the sword in an orgy of brutal suppression. The Irish garrisons at Drogheda and Wexford were butchered and many surviving Irish were driven away to the poorer lands to the west in Connacht. Even when the English crown was restored to the monarchy King Charles II considered it prudent to ratify Cromwell's harsh confiscations and laws. Charles's successor, James II, was a Catholic deposed in 1688 by the Protestant William of Orange. Much of the fighting between the two camps took place in Ireland after James fled there. The Battle of the Boyne on July 1, 1690, is one of the biggest Irish historical landmarks when King James II's Catholic Jacobite supporters were defeated by the Protestant army of William of Orange, leaving Protestants in the ascendancy.

The following year saw the signing of the Treaty of Limerick and the end of the war. The Catholic losers were effectively outlawed from society as they lost their jobs, churches, education, and political rights and they were forbidden to hold any lands. At this time many Catholic Irishmen fled to either France or Spain where they could fight their English enemies fighting under a foreign flag.

All this time the power and influence of the Protestant landed gentry had grown until they wanted a greater degree of independence and liberty than the English crown and parliament was happy to give them. A group of powerful landed gentry formed the Patriot Party to lobby for greater concessions from the Crown. Their opportunity came when the American colonies revolted and the crown needed an Irish volunteer levy of troops: they were able to bargain in 1780 with the English Parliament and were initially granted free trade, then in 1782 a further major concession—Irish parliamentary independence.

In 1789 the French Revolution woke up Ulster Presbyterians and Catholic middle-class southerners to the possibilities of radical politics and together they formed the Society of United Irishmen in Belfast and Dublin in 1791. The United Irishmen sought help from Catholic France—Wolfe Tone, a Protestant in France, called on Republican France for assistance—and rebellion was planned. But government informers had infiltrated the main organizing body in Dublin and on March 11, 1798, the ringleaders were captured. Martial law was declared and atrocities committed by the soldiers around Dublin. This did nothing to stop the rebellion that started in May—and the scale surprised the British who had few forces on the ground. (Indeed, when hostilities finished over 48,000 muskets, 70,000 pikes, and 22 cannon

were taken, proof of the size, organization, and commitment of the revolutionaries.) Unfortunately for the United Irishmen, the French side of the rebellion did not arrive in Ireland until August. They landed at Killala in County Mayo on August 22 but it was too little, too late.

In 1800 the Act of Union was signed creating the United Kingdom of England, Scotland, Ireland, and Wales, in the course of which the Dublin parliament was dissolved. In 1829 the "Liberator"—Daniel O'Connell—was elected to the UK Parliament and helped force through a law emancipating Catholics. But he went too far when he attempted to repeal the Union and he was stopped. After O'Connell's death in 1847 the Young Ireland movement carried on his work.

The years 1845–49 are notorious for the Irish famine, years when the potato harvest repeatedly failed, leaving thousands of people to starve on their own land. Many courageous souls emigrated to America in the first wave of mass Irish migration. Against this backdrop it was hardly surprising that in 1848—the year of European revolutions—there were reverberations in Ireland. Irish nationalism regained momentum. In 1858 the secret Fenian movement (also known as the IRB—Irish Republican Brotherhood) started: its mission, armed rebellion against the British. A failed rebellion in 1867 was a setback but support and feeling remained strong. In 1874 an openly ambitious independence party led by Charles Stewart Parnell—the Home Rule Movement—was formed. Land reforms started in 1881 and the campaign for Home Rule and self government gained pace.

In 1905 Sinn Féin (Ourselves Alone) was founded as a political movement; Irish trade unionism started in 1913 in Dublin. But, as ever in Ireland, the debate was not one-sided. Home Rule was a political hot potato opposed by the Ulster Unionists. Civil war seemed ever more likely as opinions polarised. After long debates and discussions the Westminster parliament passed the Home Rule Bill in 1912 effectively severing the six northern Protestant counties, collectively known as Ulster, from the remainder of Ireland. They were now in law two separate countries but the outbreak of World War I saw the suspension of the bill for the duration of the war. Outraged at the suspension of home rule, a number of Irish rebels led by Padraic Pearse and James Connolly seized parts of Dublin on Easter Monday 1916—the Easter Rising. There was little public support for a rebellion taking place in the middle of a European conflagration. After a week they were captured , but then the British badly mishandled the situation, executing the 16 leaders—including shooting one in a chair—threatening conscription, and alienating previously uncommitted Irish opinion. As a direct consequence Sinn Féin took two-thirds of the Irish seats in the 1918 election.

The Anglo-Irish War of Independence broke out immediately. Eventually Prime Minister Lloyd George had little option but to give in to Irish resistance. In 1920 the compromise was that the six predominantly Protestant counties were to remain in the United Kingdom but were given home rule; the 26 counties comprising the rest of Ireland became the Irish Free State in 1922. Ireland was officially partitioned.

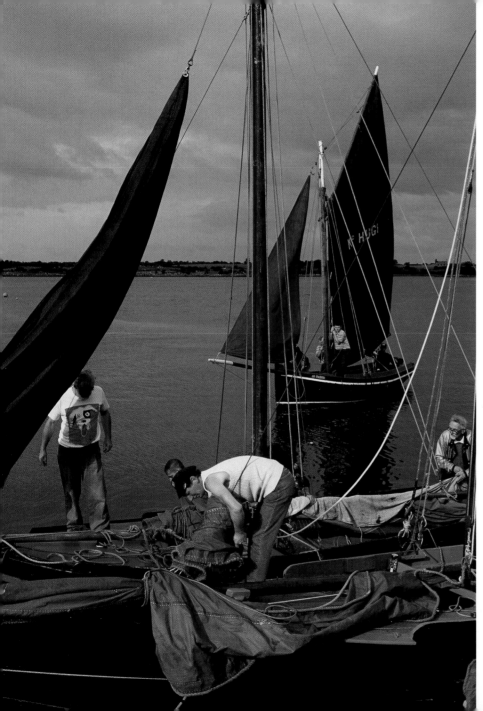

The fighting, however, did not stop. There was civil war in the south between the militant republicans in the Irish Republican Army and the Army of the Free State. Some 700 died, including the architect of the republic, Michael Collins. Fighting raged until May 1923 when the government of William Cosgrave prevailed. Ireland joined the League of Nations and negotiated greater freedom of rule within the British Commonwealth. One of the defeated leaders of the civil war, Eamonn De Valera, founded the opposition Fianna Fáil party. He eventually prevailed and was in power for most of the period from 1932 until he became president of the Republic in 1959.

In 1937 De Valera brought in a Catholic constitution; British military bases were handed back to the Irish and during World War II he proclaimed Southern Ireland's contentious neutrality, although in fact many Irishmen fought on the Allied side in the British Army. While De Valera was briefly out of power, Ireland became the Republic of Ireland.

Throughout this period thousands of poor Irish men and women emigrated to the United States to try to find a better life for themselves and their families. Some succeeded, many did not: the Irish became one of the largest immigrant groups to settle in the New World.

Postwar southern Ireland was slowly industrialized, although the Protestant north had traditionally been more mechanized, industry-based, and prosperous with much of the manufacturing based around Belfast, especially the great shipbuilding yards at Harland and Wolfe.

By 1969 the civil, political, and religious unrest in Northern Ireland came to a head with a nonviolent Catholic campaign for civil rights and equality. This in turn provoked the Protestant response and hideous violence erupted across the Province. The IRA (Irish Republican Army) responded and launched a terrorist offensive against the state and the British. Paramilitary groups formed and the country dissolved into open civil war. British troops were sent into Northern Ireland to keep the two sides apart but were inevitably drawn into what had become a notoriously viscous contest. In 1972 Britain suspended local Ulster institutions and imposed direct rule, only for the mainland to come under direct terrorist attacks with a horrifying bombing campaign.

The Troubles forced the governments in London and Dublin to unite in attempts to quell the war. Eventually in 1993 the Downing Street Declaration, issued jointly by the British and Irish prime ministers, recognized Irish self determination. Since that time various ceasefires and agreements have been declared and broken but the situation has quietened down enough to allow the Northern Irish economy to start to recover.

Meanwhile in the rest of Ireland, membership of the EEC (European Economic Union) which came in 1972 at the same time as Britain, has brought considerable prosperity to the Republic. Ireland has the most rapidly growing economy in Europe earning itself the nickname of the "Celtic Tiger" and the country as a whole has prospered. In 1900 the country was largely rural and agriculture based, now most of the population lives in the towns and cities.

# Ulster

Northern Ireland remains part of the United Kingdom. It comprises the six northeastern counties of Antrim, Armagh, Londonderry, Down, Fermanagh, and Tyrone—all of which were once part of the ancient Irish kingdom of Ulster. Counties Cavan, Monaghan, and Donegal were Ulster counties that stayed with the Republic.

The Protestant majority mostly settled here from Scotland and England in the 17th century plantations. A dozen American presidents have come from the descendants of Northern Ireland, including the famous Civil War commander Ulysses S. Grant, the 18th president. Heavy industry is concentrated around the capital and port of Belfast while much of the spectacular mountainous countryside is dedicated to farming.

Belfast lies at the mouth of the River Lagan where it flows out of Belfast Lough. The city grew most during the Industrial Revolution in the 18th and 19th century with its primary wealth coming from the linen industry and shipbuilding yards. On the River Lagan lie the Harland & Wolff shipbuilding yards where over 70 White Star line ships were built including the ill-fated *Titanic* and her sisters *Britannic* and *Olympic*.

As for natural beauty Northern Ireland contains the Giant's Causeway, one of the most famous landscapes in the world and also a World Heritage Site. The causeway is at the foot of the sea coast of County Antrim and is a remarkable conglomeration of around 40,000 massive polygonal basalt columns which stick out of the sea. There are many legendary explanations for these spectacular black columns: they were, in fact, caused by volcanic activity when rapidly cooling lava during the Tertiary age, some 50–60 million years ago, formed some of the most spectacular rocks in the world.

Other wonderful natural landscapes include the beautiful Mountains of Mourne in County Down. These are granite mountains cooled then formed and from volcanic magma underneath the surface of the earth before being thrust through the crust onto the surface where they have over the aeons been eroded and sculpted into these romantic features.

**RIGHT:** Harry Avery's Castle in County Tyrone is a good example of medieval military architecture. Associated with the O'Neill's, the story goes that Aimhréidh O'Neill had a sister with the head of a pig. The castle was offered as dowry—but all the suitors who refused her after seeing her would be hanged. It is said that 19 men preferred this fate!

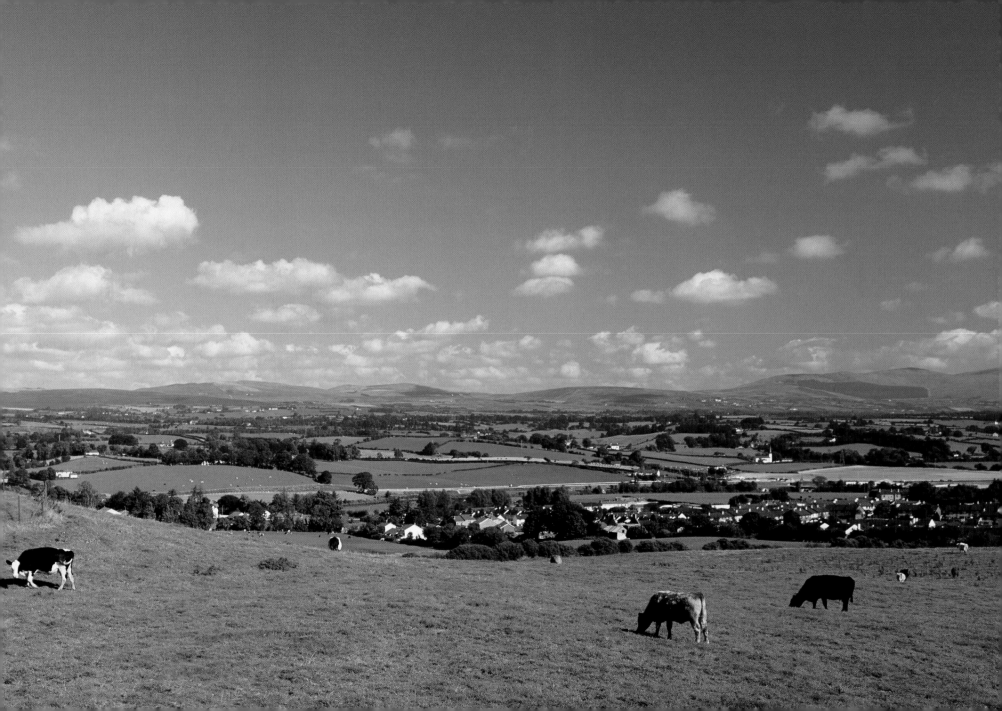

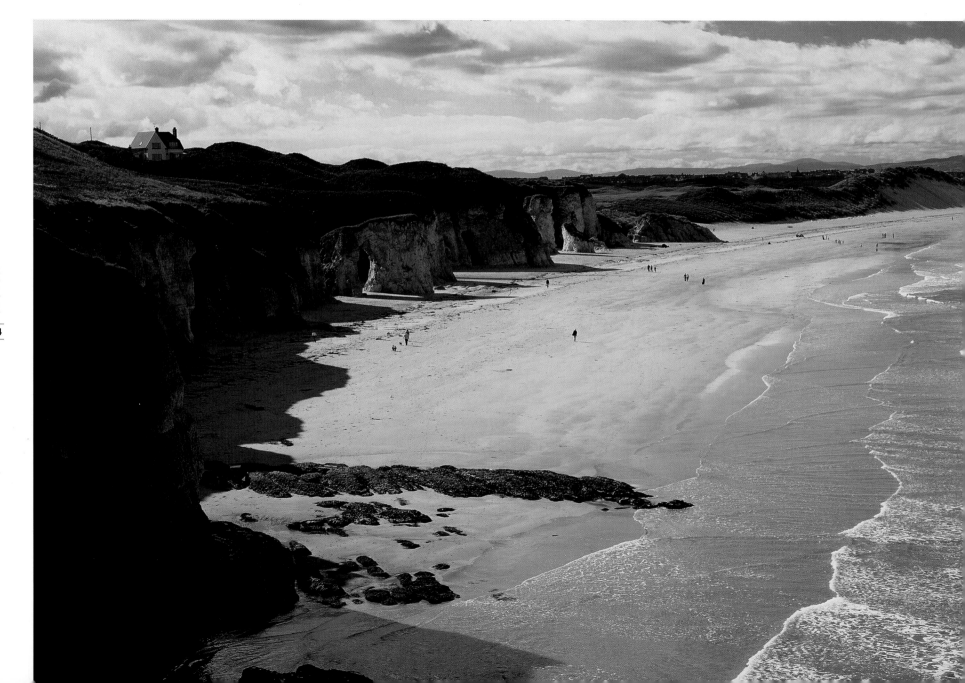

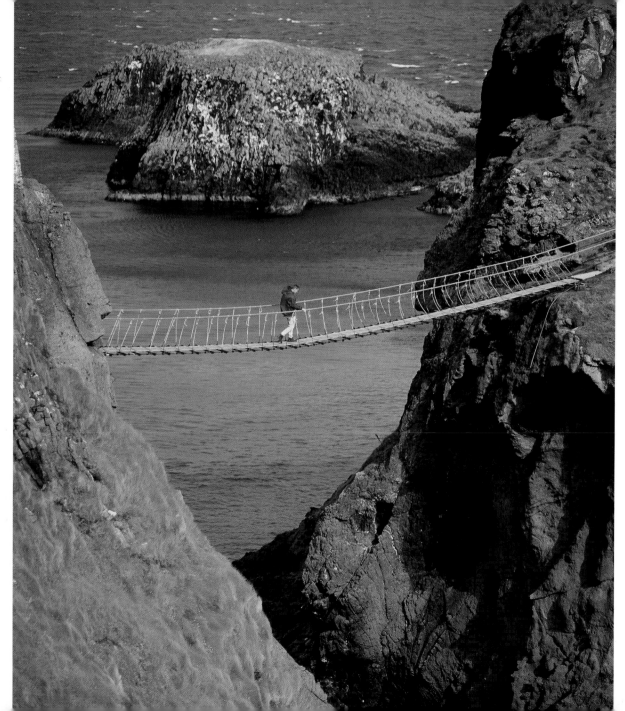

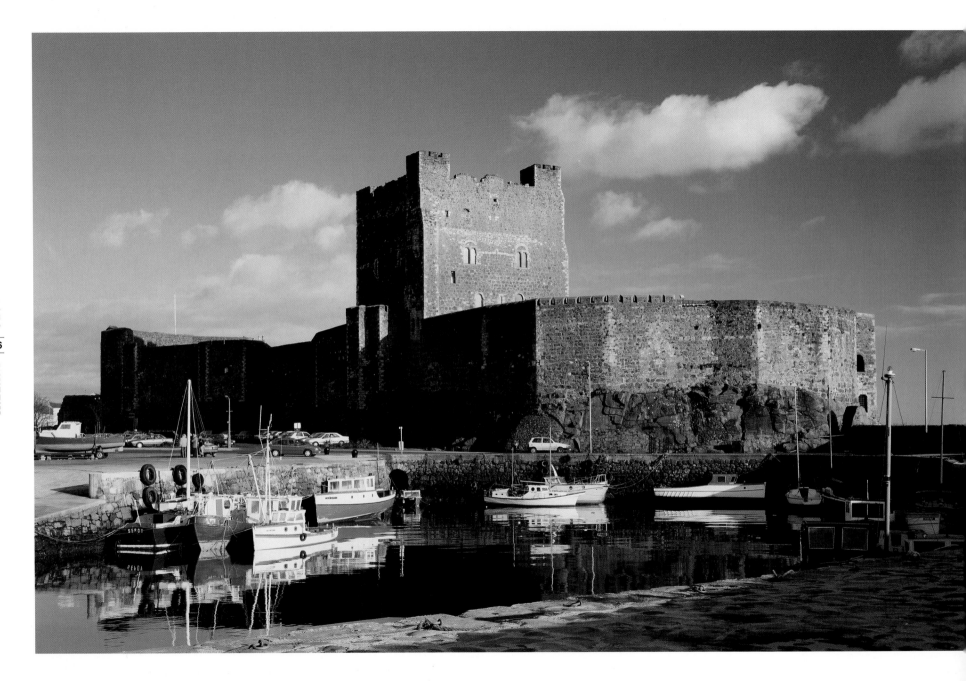

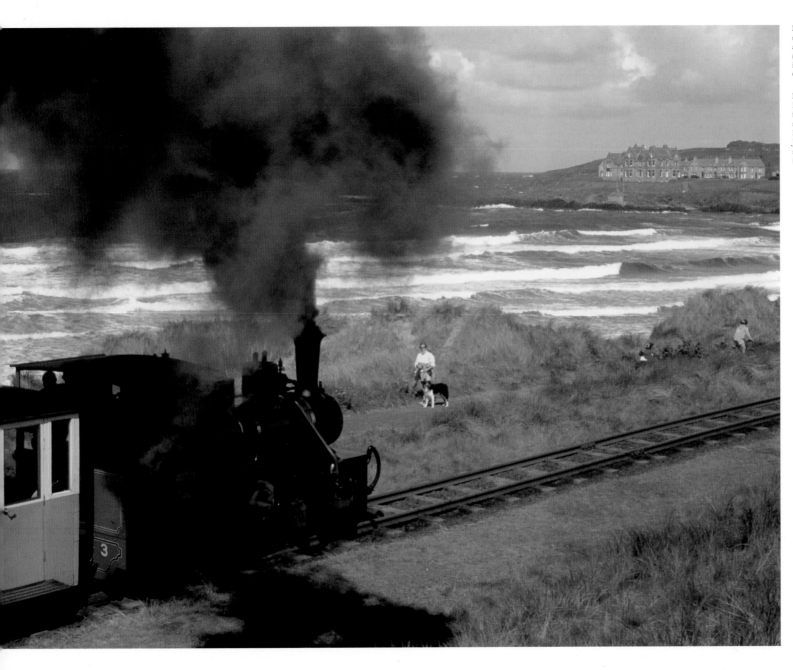

**LEFT:** Bushmills and Giant's Causeway narrow gauge steam railway along the beach at Portballintrae, County Antrim. Bushmills (the author's home town) is best known for its whiskey distillery and proximity to the Giant's Causeway.

**FAR LEFT:** Carrickfergus Castle on Belfast Lough (a lough, as loch in Scottish, stems from the Gaelic word for a lake that is sometimes open to the sea). This key Norman stronghold was begun in 1180 by John de Courcy and was enhanced over several centuries. It was taken for William III in 1690.

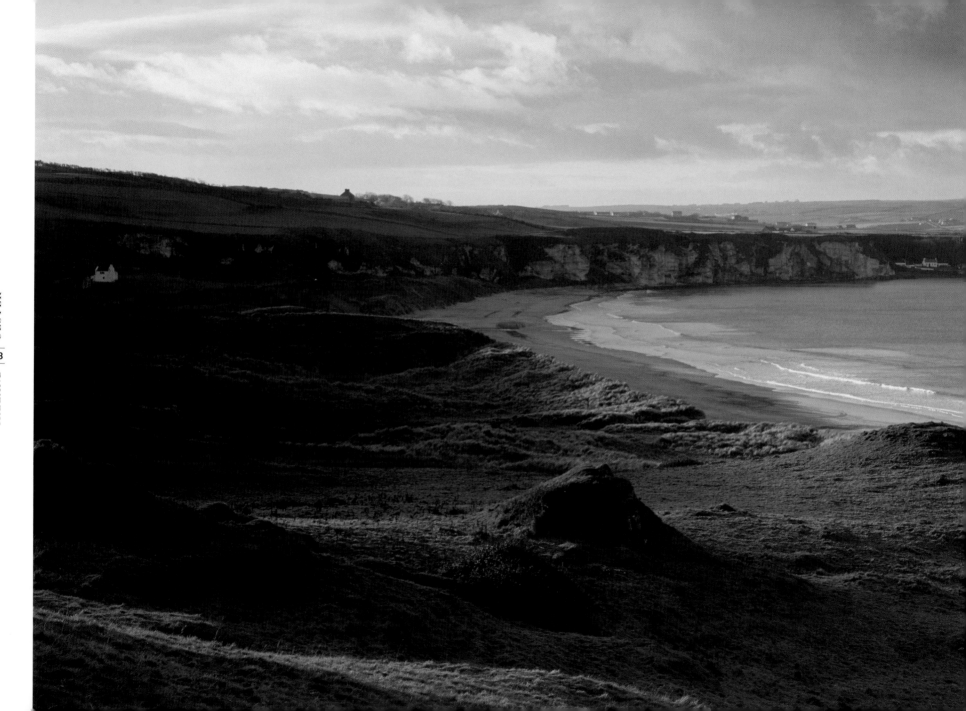

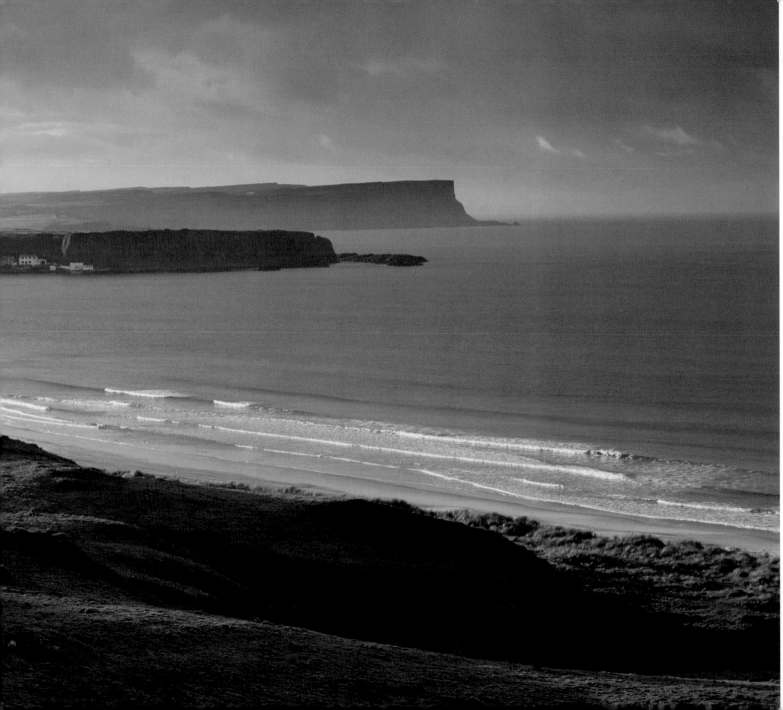

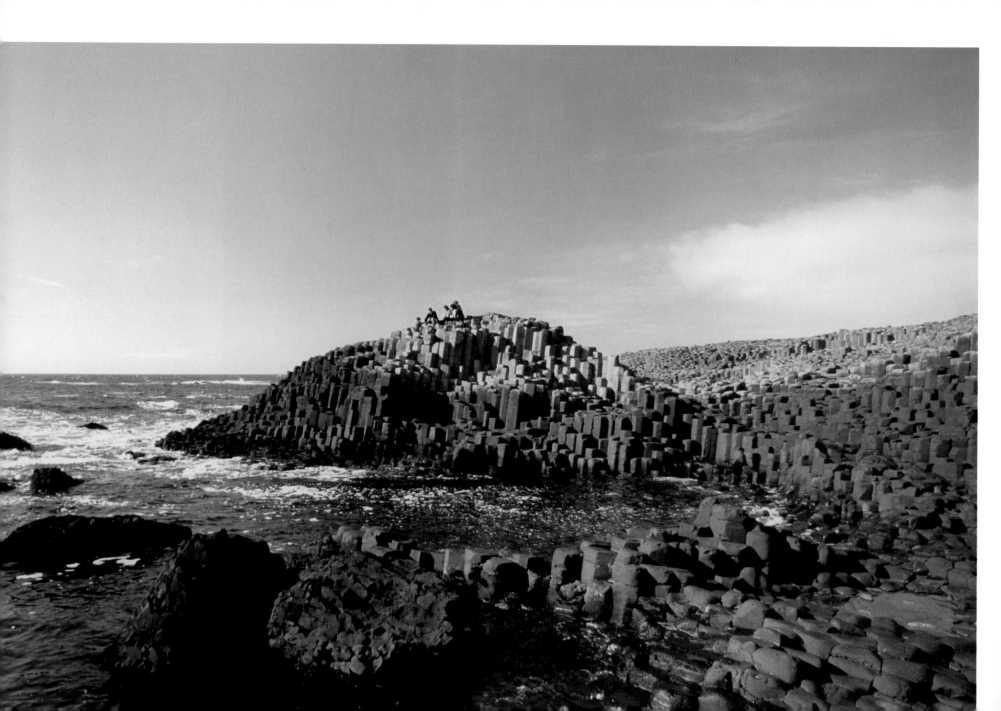

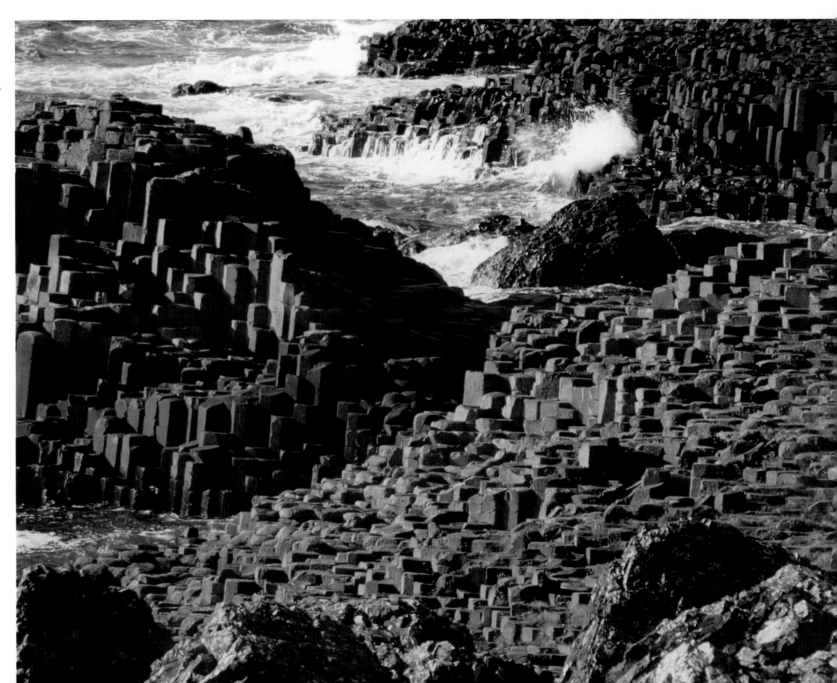

**LEFT AND RIGHT:** Two views of the Giant's Causeway, County Antrim. This remarkable natural phenomenon is explained by geologists as having been caused by volcanic action and the way that basalt cooled after the eruptions. However, a more likely explanation is that the giant Finn MacCool created it so that he could reach his lady love who lived on the island of Staffa off the Scottish coast!

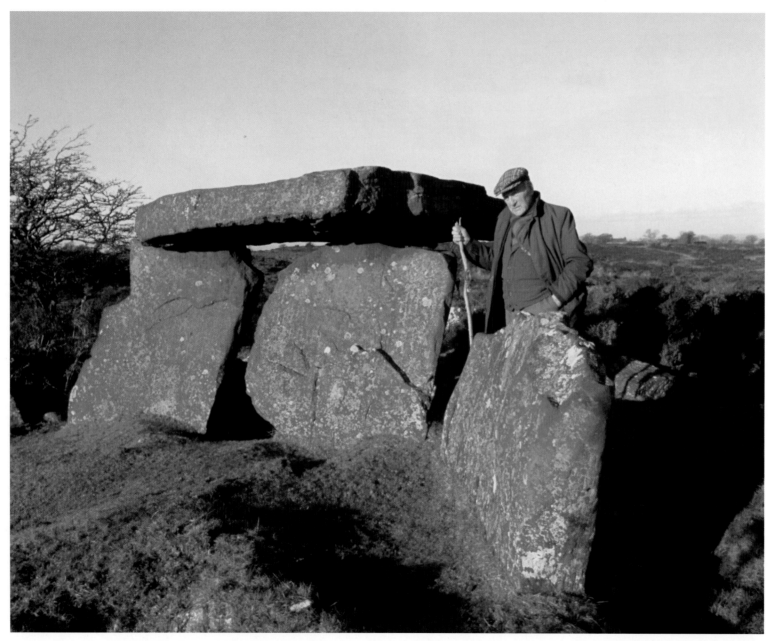

LEFT: Craig's Tomb—a neolithic tomb in County Antrim.

RIGHT: The parish church at Ballintoy Harbour with Rathlin Island beyond, County Antrim. Rathlin was the first place in Ireland to be attacked by the Vikings in 795 AD and was also the hiding place of Robert Bruce, King of Scotland, in 1306 when he was evading the English.

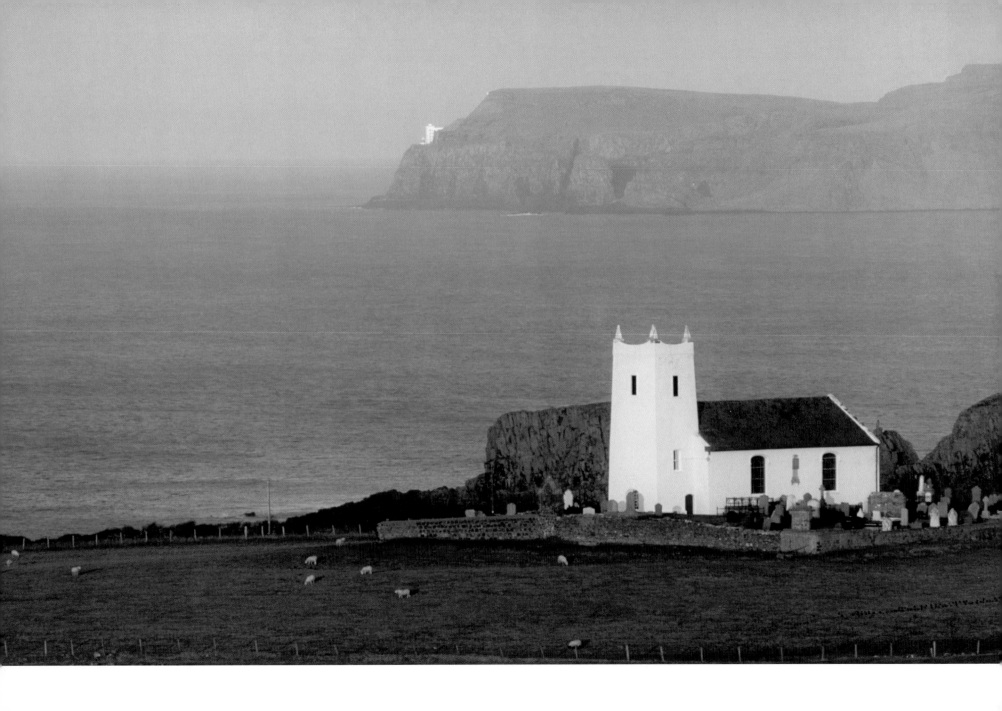

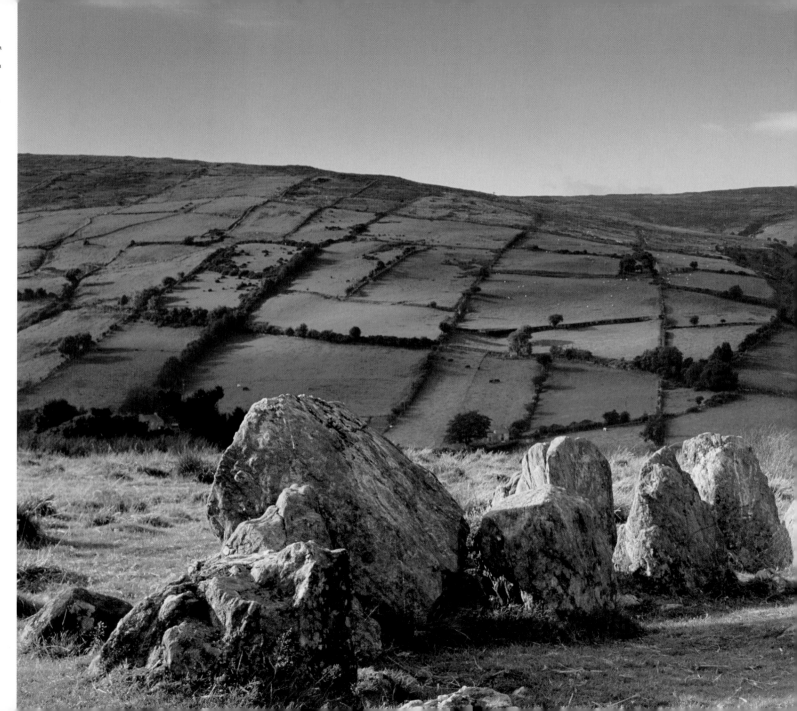

**RIGHT:** Ossian's Grave, County Antrim, is a court grave—the earliest kind of Neolithic tomb. It is named after the warrior poet son of the legendary giant Finn MacCool.

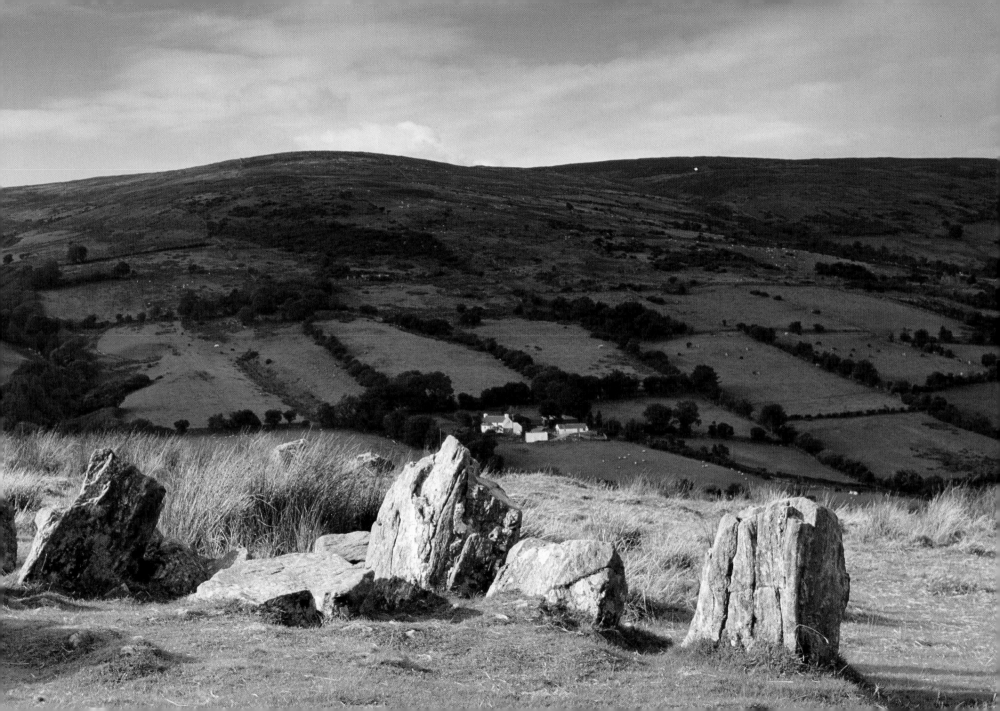

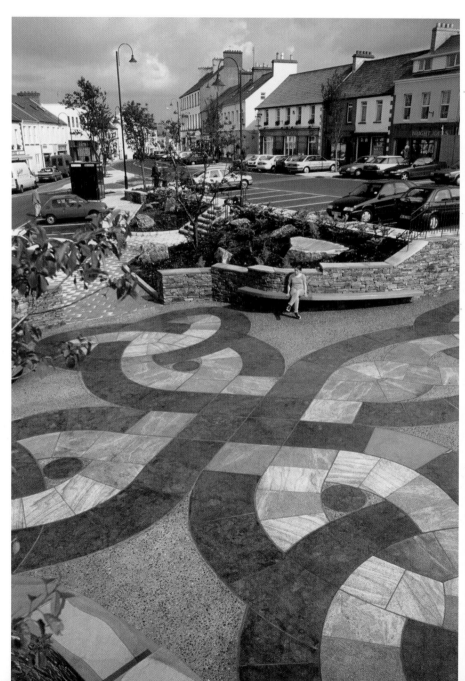

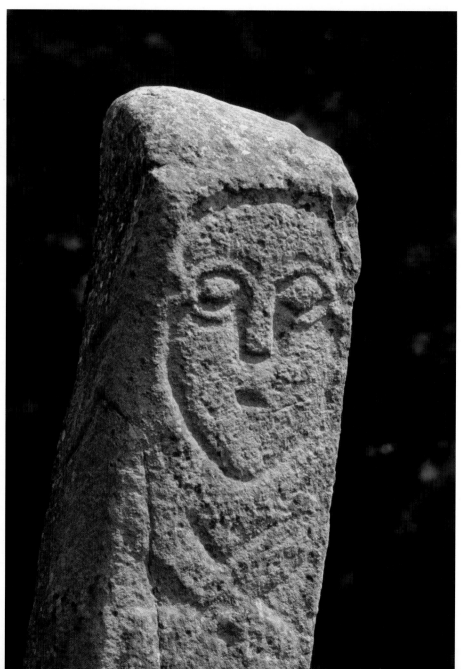

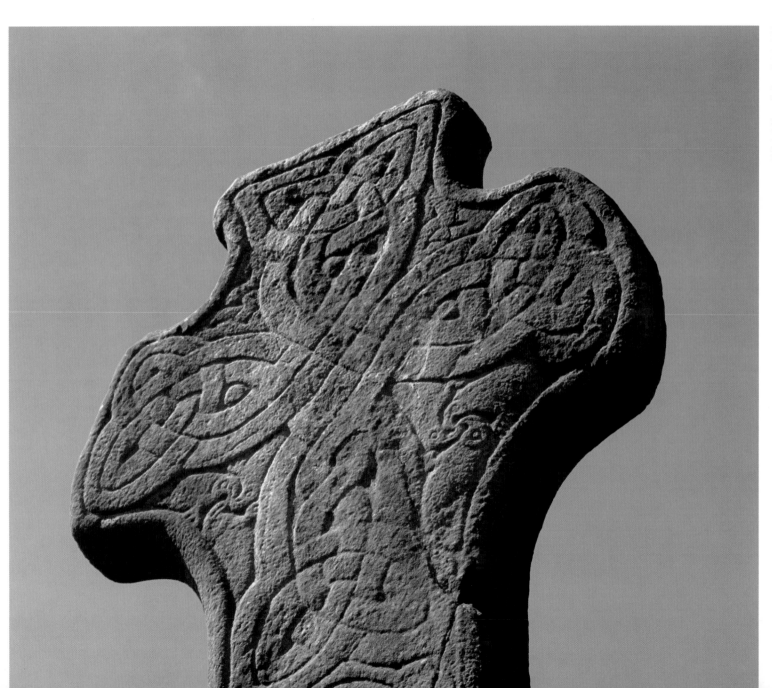

**LEFT:** The Carndonagh Cross in County Donegal is one of the earliest in Ireland— and in Britain. It is also known as St. Patrick's Cross, St. Patrick being the patron saint of the local church.

**CENTER LEFT:** Figure on one of the two stones that flank the Carndonagh Cross.

**FAR LEFT:** The patterning on the floor at the village center of Carndonagh mirrors the patterns on the early Christian Celtic Carndonagh Cross which possibly dates back to the 7th century.

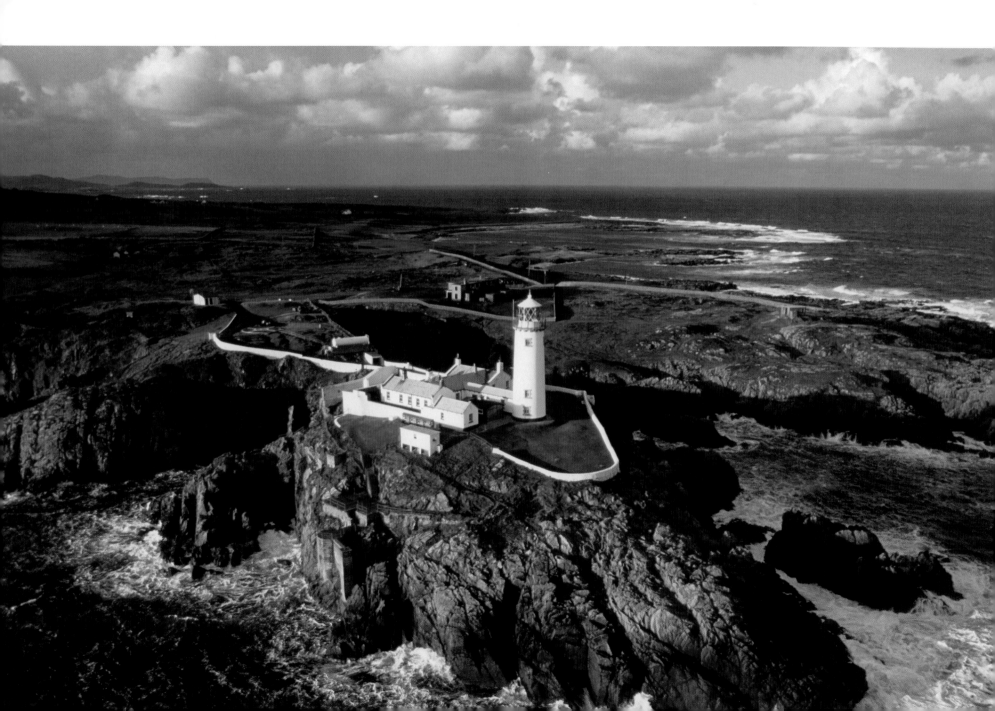

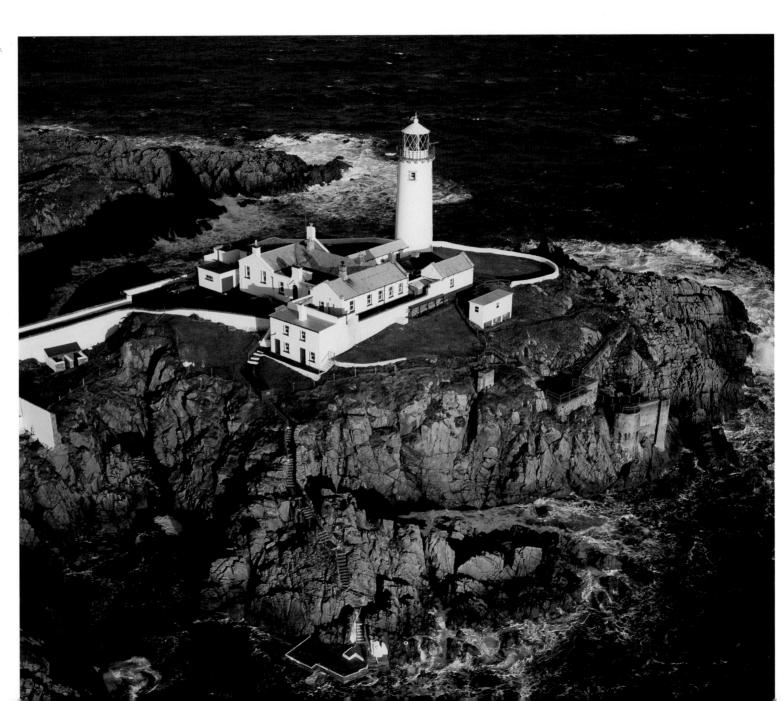

**LEFT AND RIGHT:** The Fanad Peninsula, County Donegal, juts out past Lough Swilly. At its tip is Fanad Head light.

**LEFT AND FAR LEFT:** Two garden statues, Glenveagh Castle, County Donegal. Glenveagh National Park includes Donegal's highest point, Errigal Mountain (2,466ft), the country's largest herd of red deer, and Poisoned Glen. The castle was built in 1875 overlooking Lough Veagh by the notorious John Adair, who evicted many families from the area during the Great Famine.

**OVERLEAF:** View west over the southern end of Lough Swilly to the northeast edge of Letterkenny, County Donegal. Best known for its August folk festival, Letterkenny has one of the longest main streets in Ireland and a cathedral (St. Eunan's) that boasts an enormous 215ft steeple.

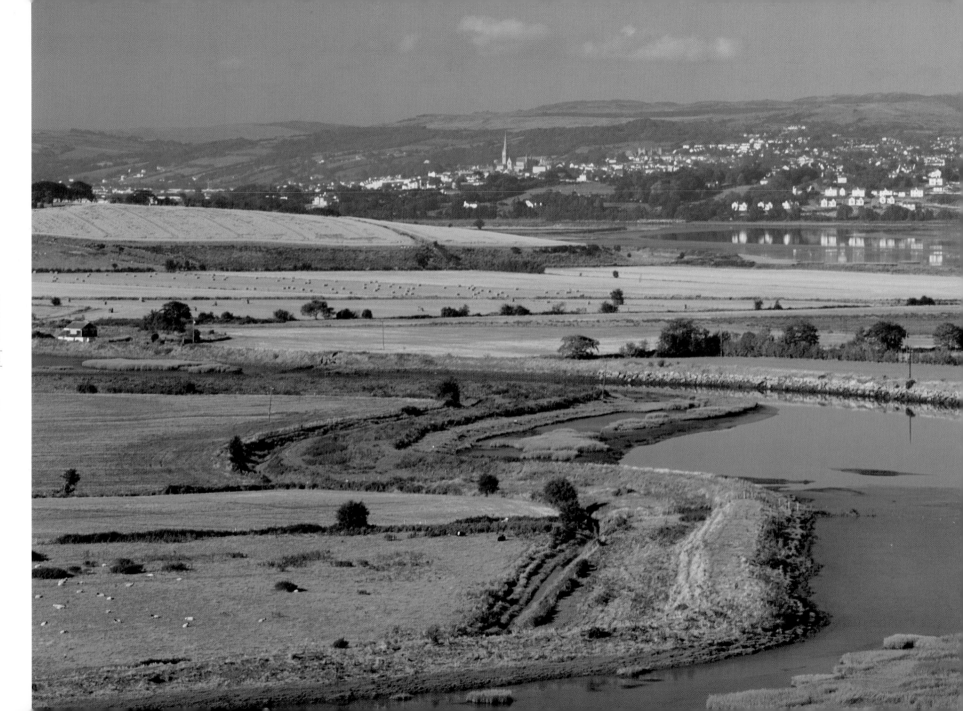

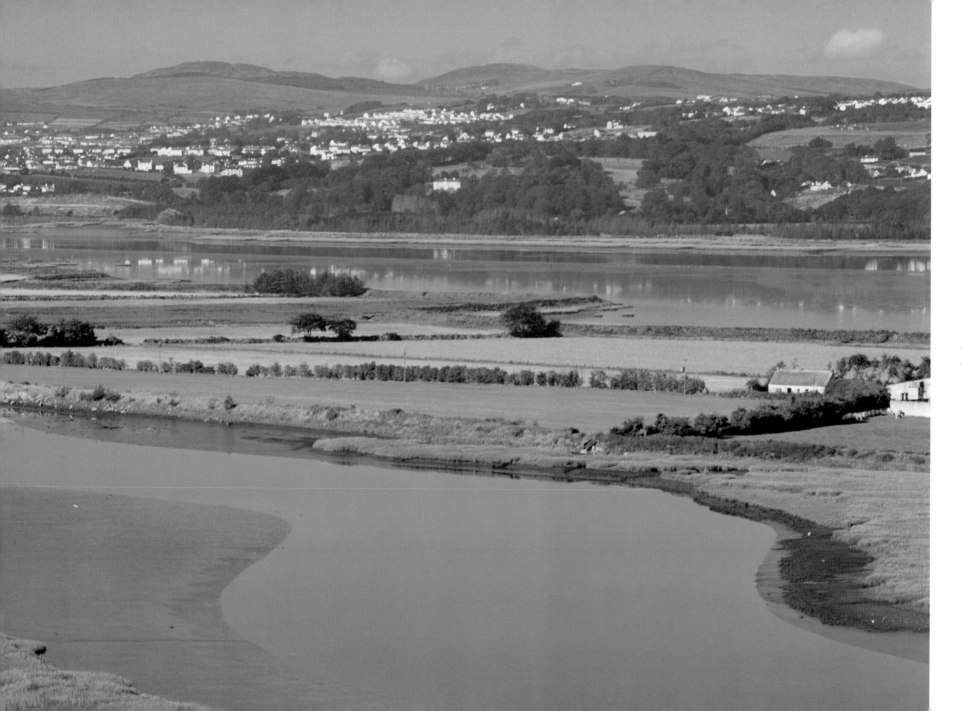

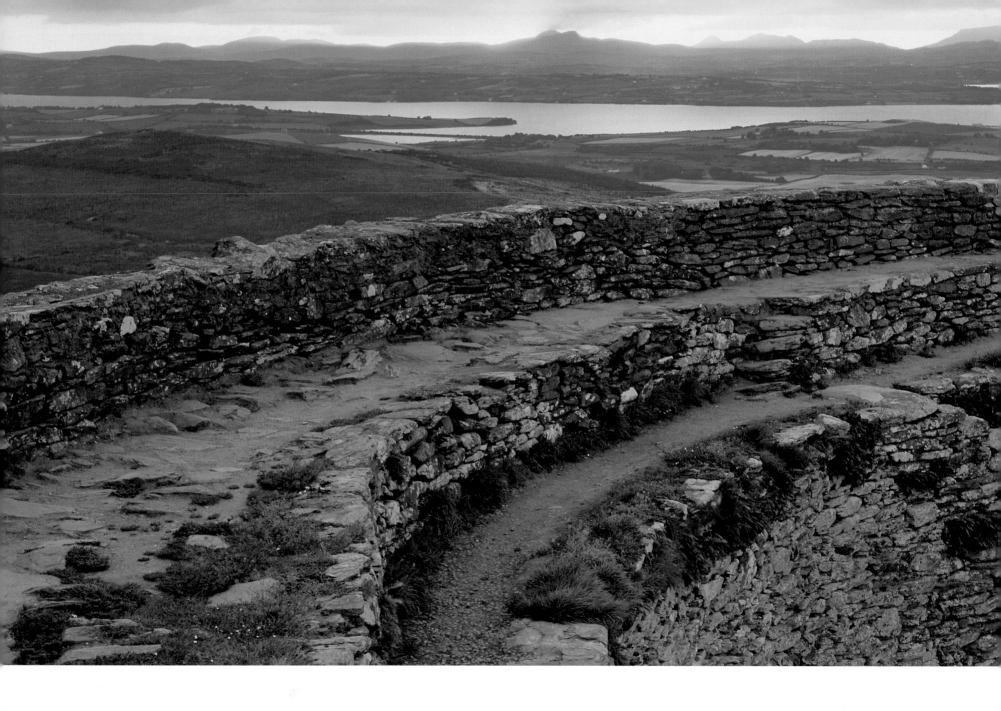

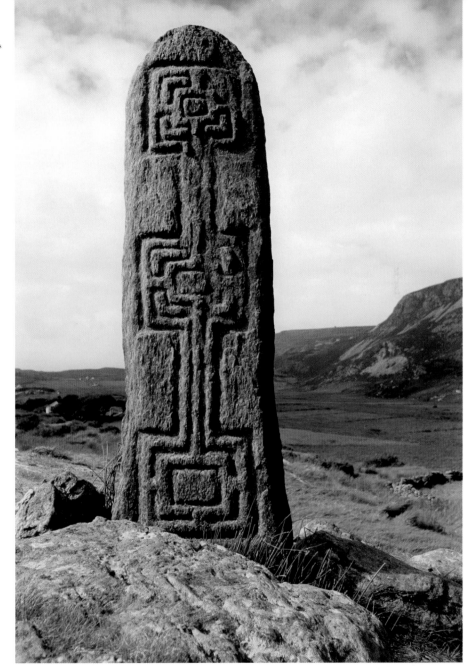

**LEFT:** Looking west over the inside rampants of Grianan of Aileach prehistoric hill fort over Lough Swilly toward the Derryveagh Mountains, County Donegal.

**RIGHT:** One of the carved station pillars in Glencolumbkille—the Glen of St. Colmcille—County Donegal. This quiet valley is home to the village of Cashel, a church visited by St. Colmcille (Columba), and the Folk Village Museum showing the lifestyle of rural Donegal.

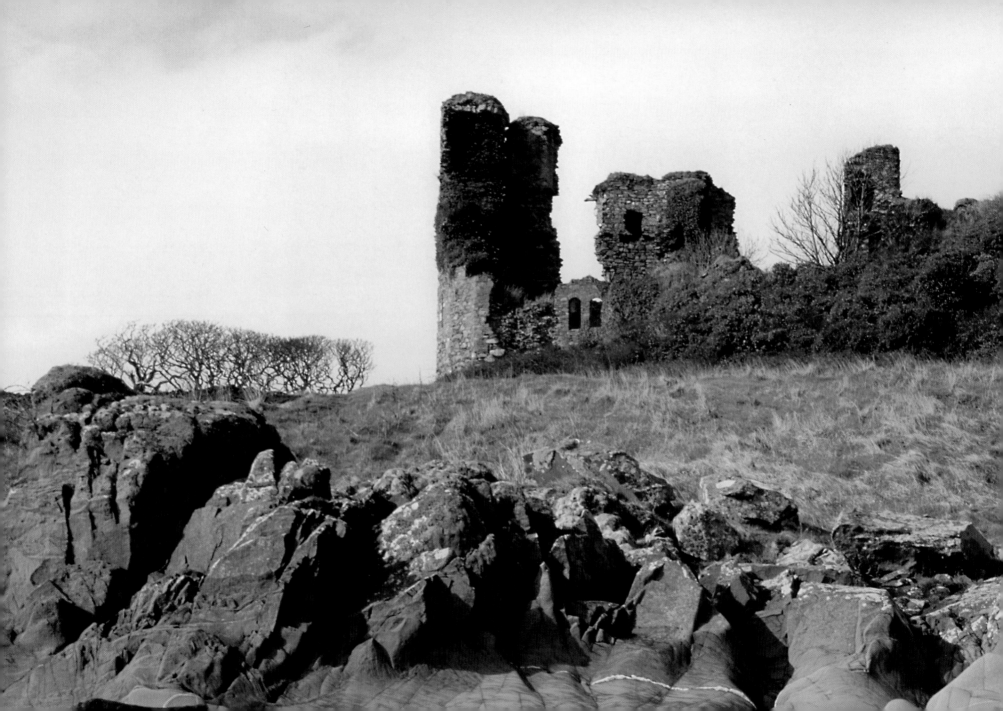

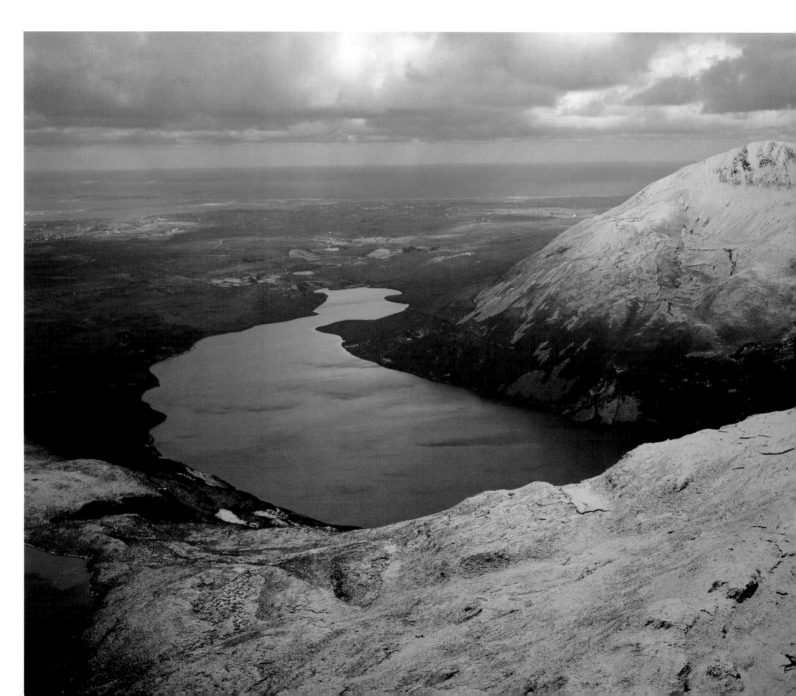

**RIGHT:** Lough Altan in the Derryveagh Mountains near Gweedore, County Donegal. This lonely lough is flanked by Mt. Errigal, whose white quartzite cone stands out for miles around.

**FAR RIGHT:** Another view of Fanad Head lighthouse, County Donegal.

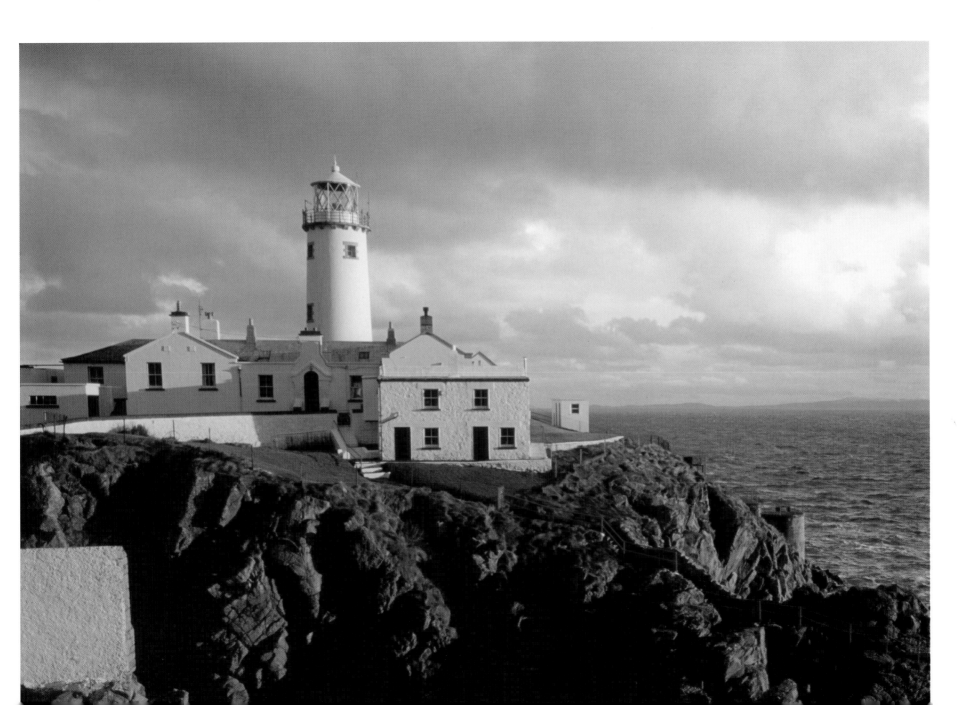

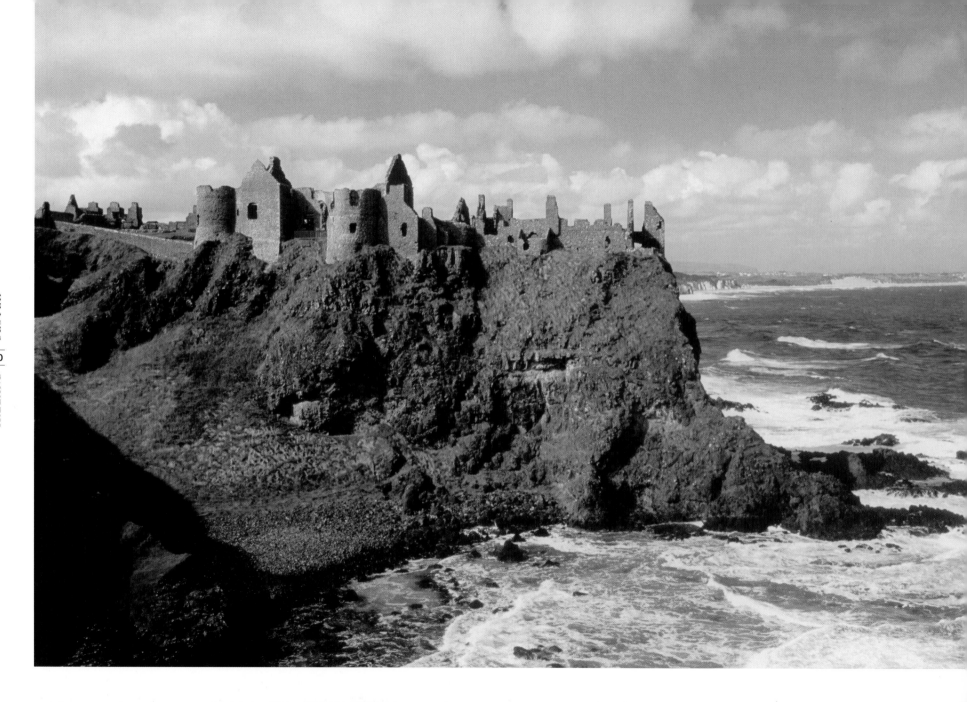

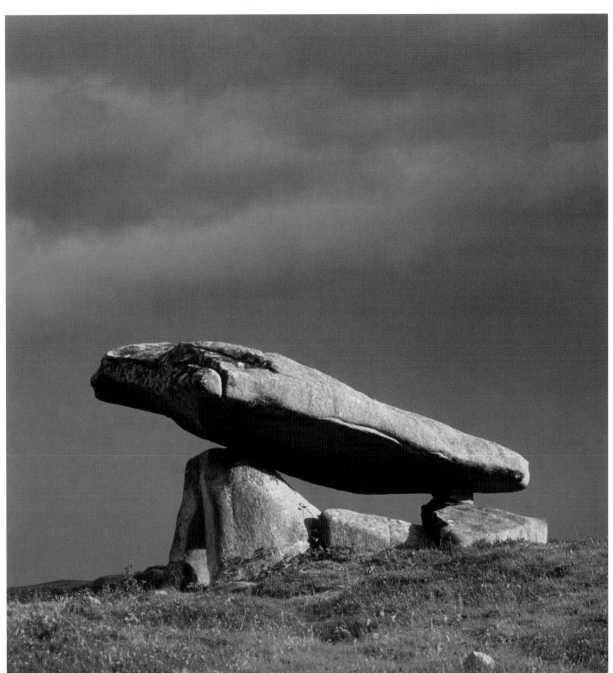

**LEFT:** Dunluce Castle, Country Antrim, is an evocative 13th century ruin perched atop the cliffs of an island off the North Antrim coast. The fortress of the O'Donnells can only be approached by a wooden bridge. The castle is built on a prehistoric site, the Norman castle having been started by Richard de Burgo, Earl of Ulster.

**LEFT:** Kilclooney portal dolmen near Ardara, County Donegal. Dolmens are neolithic tombs, and there are two of them near Ardara. They are known—as are so many dolmens—as the beds of Diarmaid and Grainne. This comes from a story in Irish mythology in which the beautiful Grainne sees Diarmid at her wedding banquet and entices him into elopement. Pursued by her erstwhile bridegroom, the story ends tragically after Diarmaid is killed in a fight with a wild boar.

**OVERLEAF:** Narrow Water Castle is on the northern edge of Carlingford Lough, County Down. Heavily restored, the three-story castle and tower-house was built in the mid-16th century.

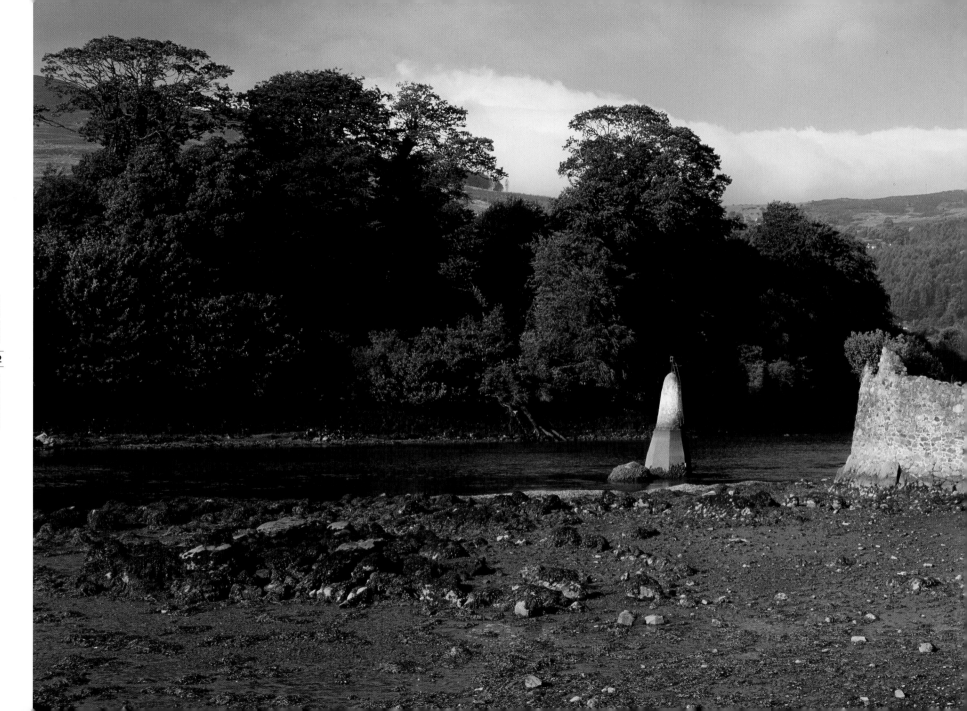

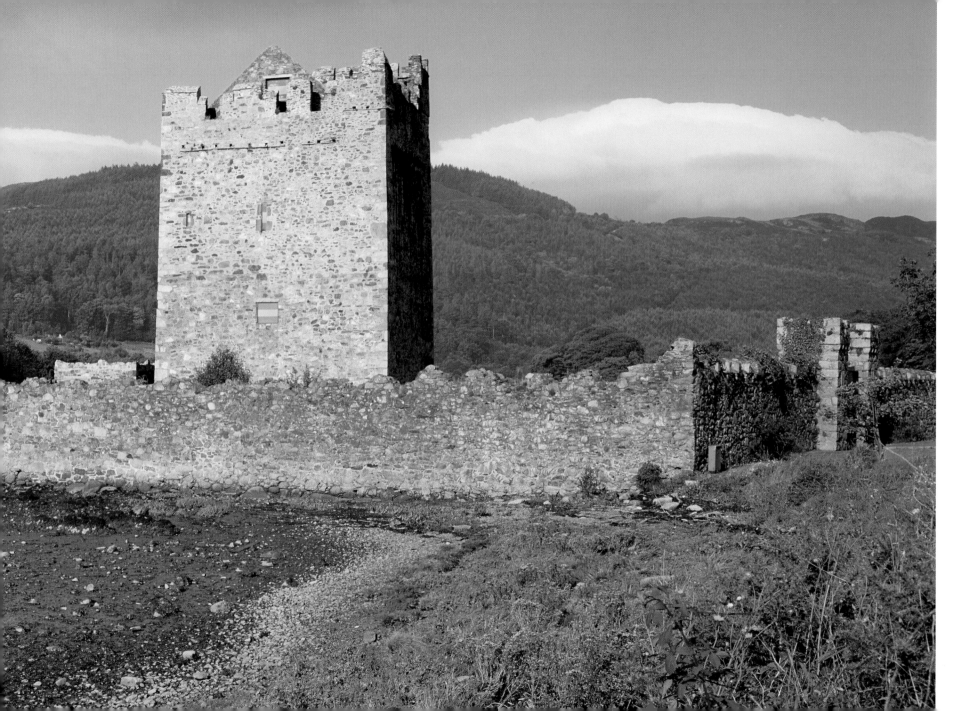

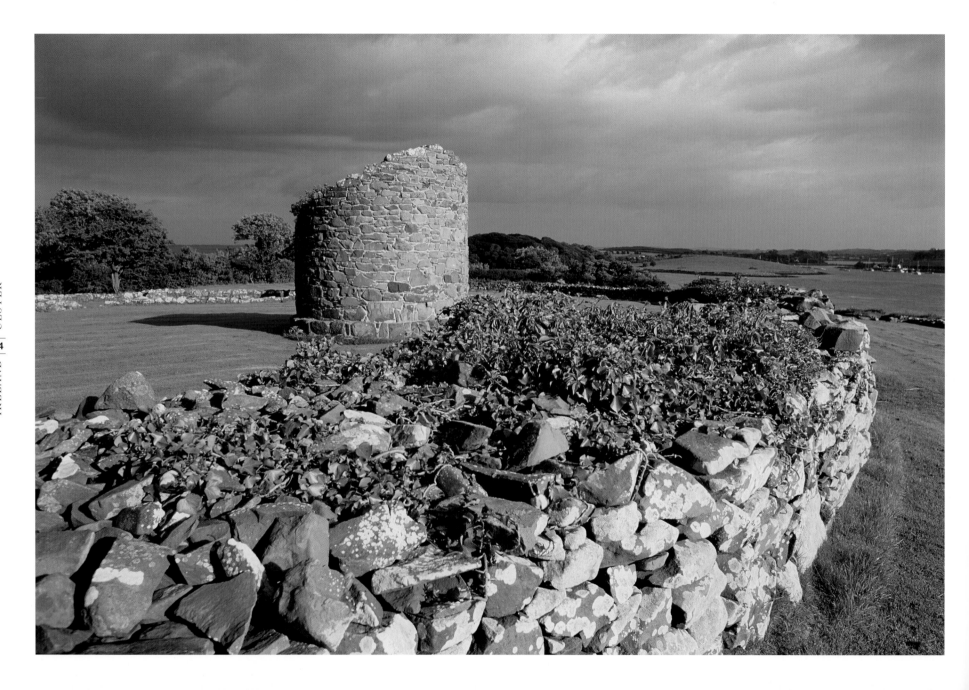

**LEFT:** The substantial early monastic site at Nendrum, County Down, is situated on Mahee Island in the middle of Strangford Lough and is one of the best-preserved pre-Norman sites in Ireland. A 12th century Benedictine cell on the older site was abandoned in the 15th century.

**RIGHT:** Inch Abbey, County Down, is the site of a pre-Norman monastery known by the island's earlier name of Inis Cumhscraigh that was founded before 800 AD. Inch is situated on an islet in the Quoile marshes near Downpatrick; the visible remains are of a Cistercian abbey founded in 1180 by Norman John de Courcey, conqueror of Ulster.

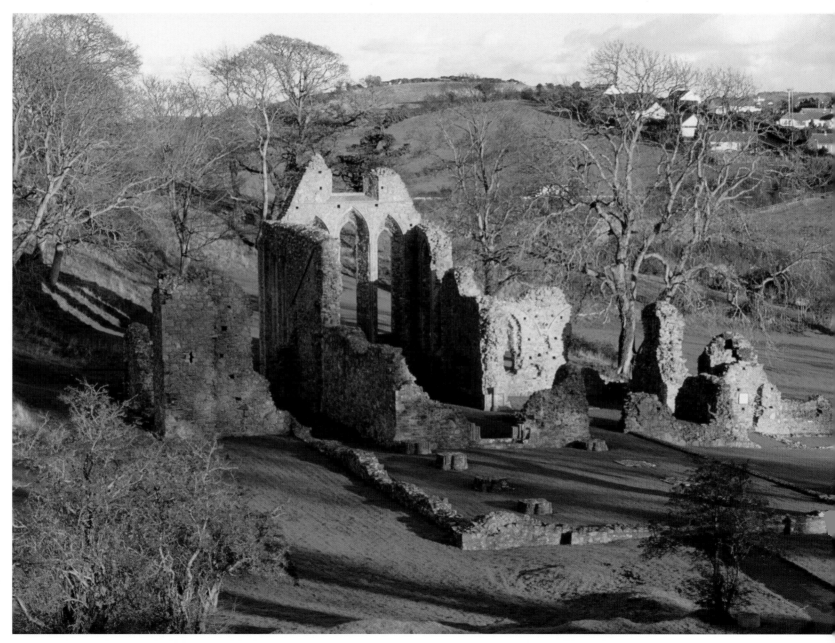

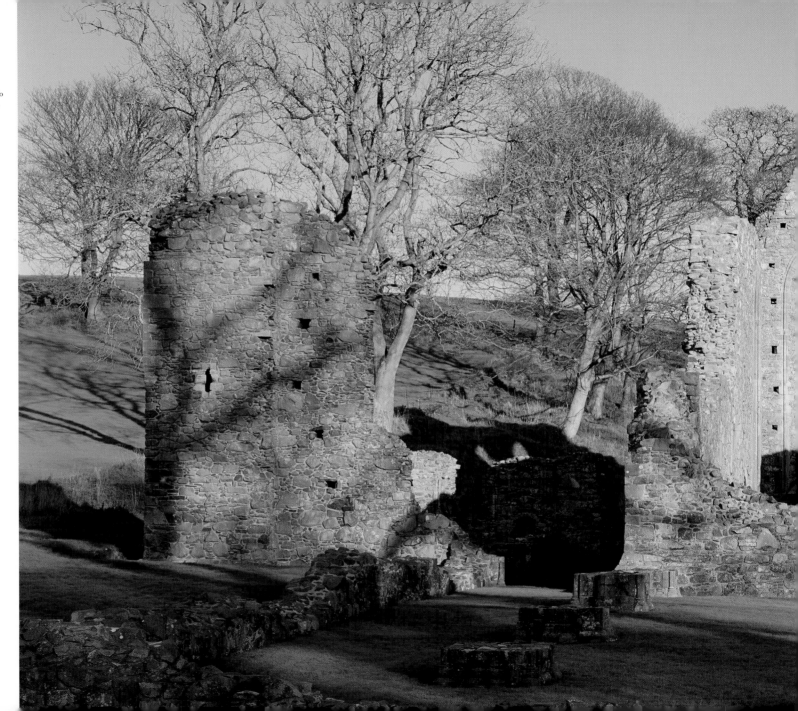

**RIGHT:** Another view of the ruins of Inch Abbey, County Down. After John de Courcey had burned Inis Cumhscraigh, he founded a Cistercian Abbey that was populated by monks from Furness in Lancashire. Irishmen were not accepted into the community and it remained an English stronghold. It was dissolved in 1541 at the Dissolution of the Monasteries, and it and its lands were granted to Gerald, Earl of Kildare.

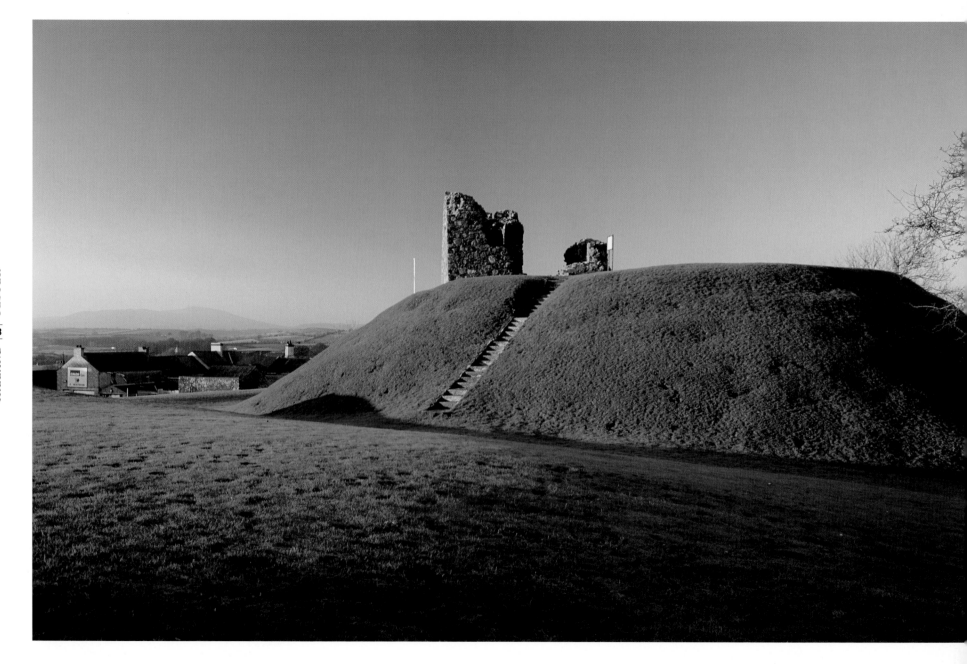

**LEFT:** Clough Castle, County Down, is a fine Norman motte and bailey castle from the reign of King John (1199–1216) with wonderful views over to the Mourne Mountains.

**RIGHT:** This early Christian cashel is at Drumena, County Down. It was excavated—and its walls rebuilt—in 1925. "Cashel" is the name given to a walled enclosure in which there was a settlement or farmstead. When protected only by an earth rampart and ditch it is called a "rath." This cashel also has a *souterrain*—an underground chamber.

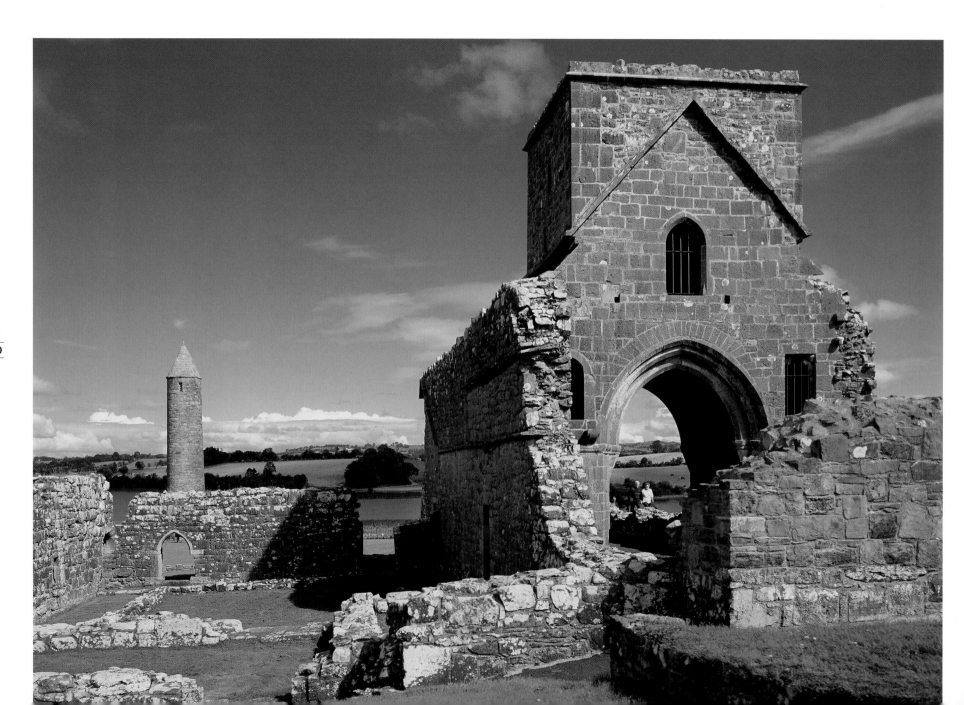

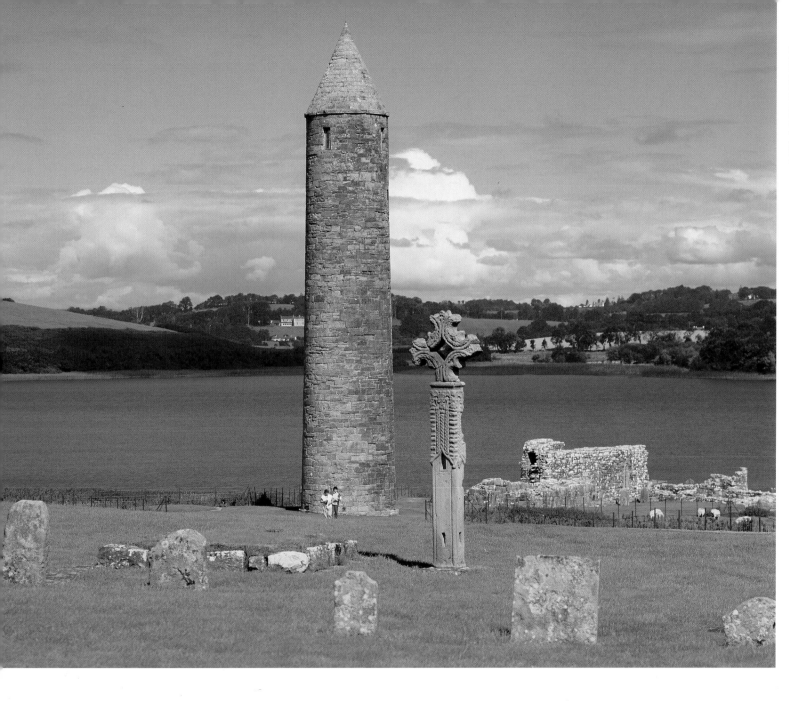

**LEFT AND FAR LEFT:** Two photographs of the monastic site on Lower Lough Erne, Devenish Island, County Fermanagh. Founded in the 6th century, it was attacked by Vikings in the 8th century, burned down in 1157, but continued on until the 17th century. These views show the Augustine St. Mary's Priory (**FAR LEFT**) that was built in the 15th century and a detail of the round tower and late medieval cross (**LEFT**). The perfectly preserved five-story round tower dates back to the 12th century and is 82ft tall.

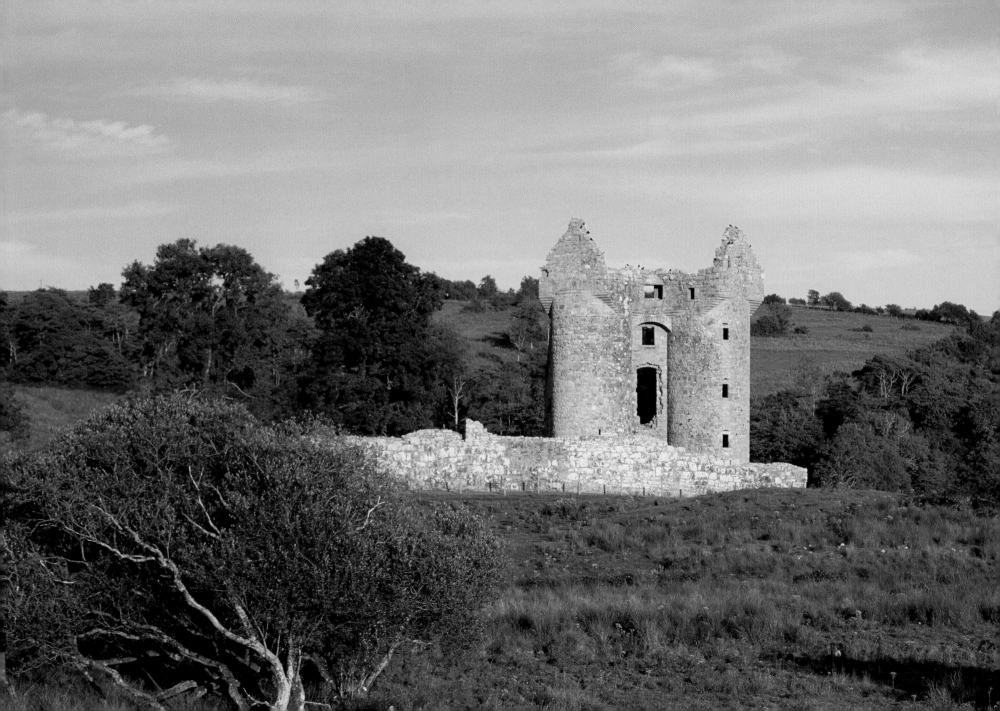

**LEFT:** Monea Castle, County Fermanagh. This substantial ruin dates back to the 17th century and was built as a "plantation" castle. The hateful plantation system was a direct result of Henry VIII's break with Rome. The great Anglo-Norman and Irish Catholic families that lived in Ireland resisted strongly the English Protestant ascendancy. Settlements of Protestants in Ireland, dispossessing the Catholics, could only be achieved by continued military action—and the construction of defensive castles such as this.

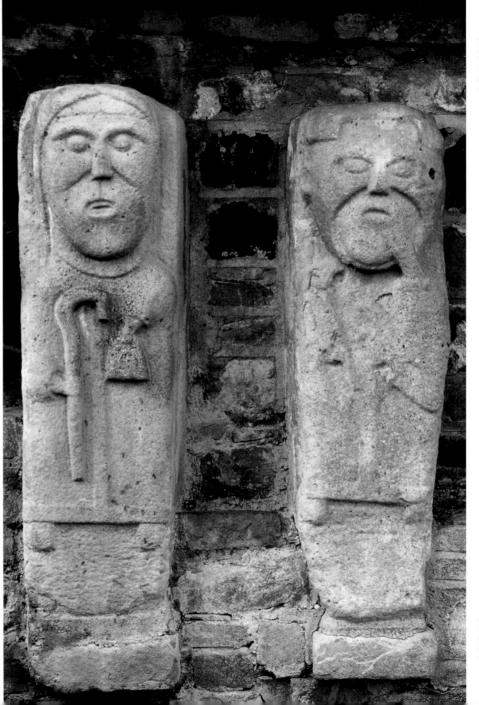

**LEFT AND RIGHT:** Two images of figures found within early monastic remains on White Island in Lower Lough Erne. White Island's Romanesque church is on the site of an earlier monastery—but these figures look ancient and pagan.

**OVERLEAF:** It is easy to understand why Lough Erne in County Fermanagh became such an important monastic site. Tranquil, beautiful, a breeding ground for trout and waterfowl, it is one of Ulster's jewels.

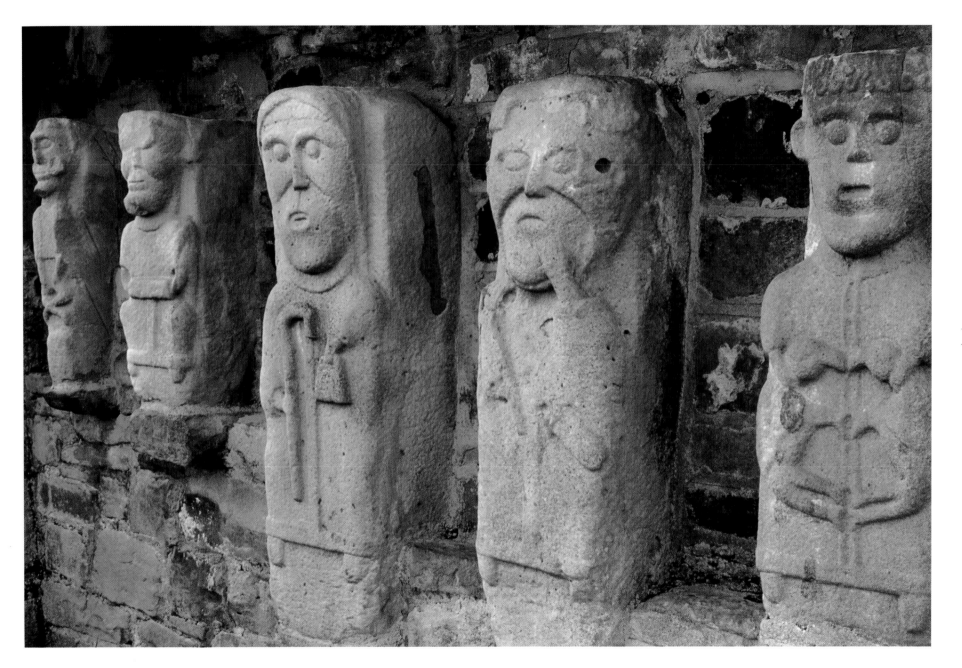

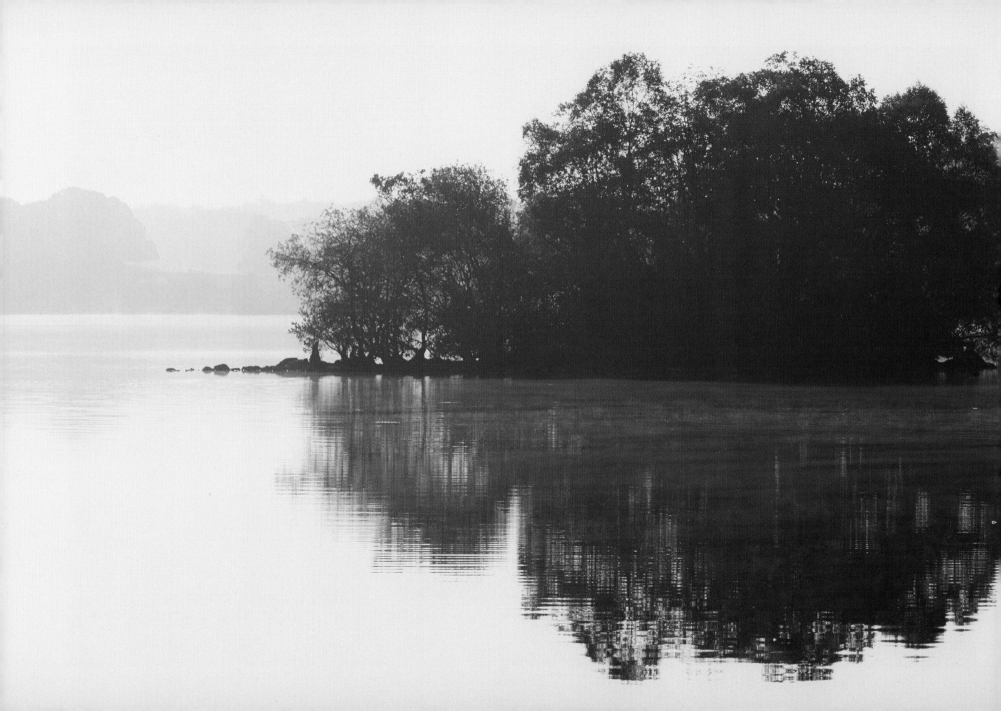

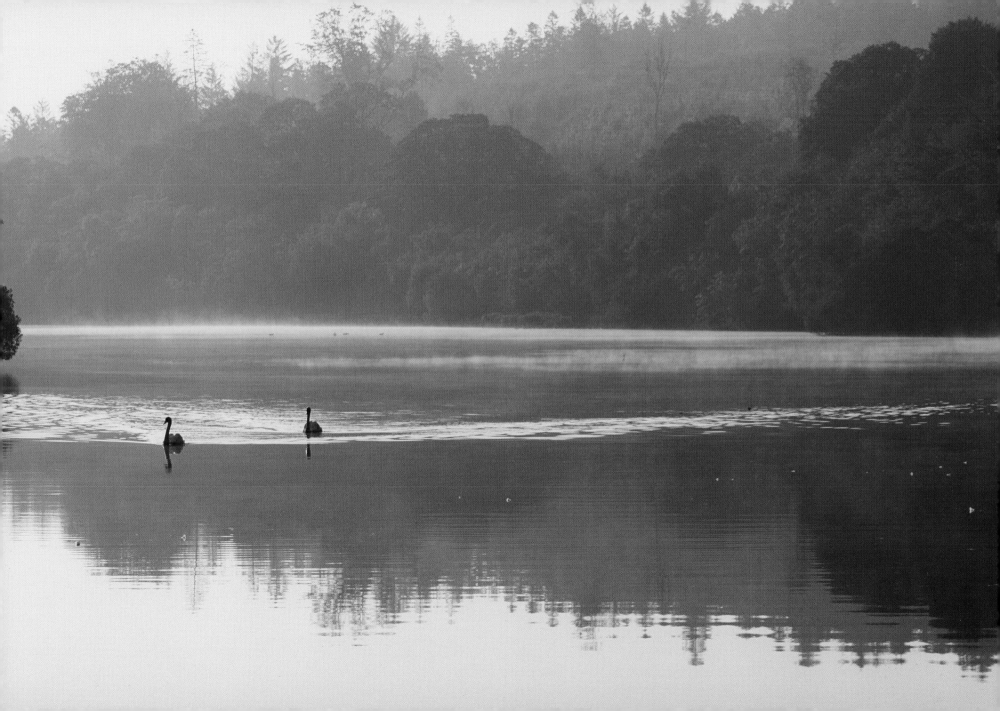

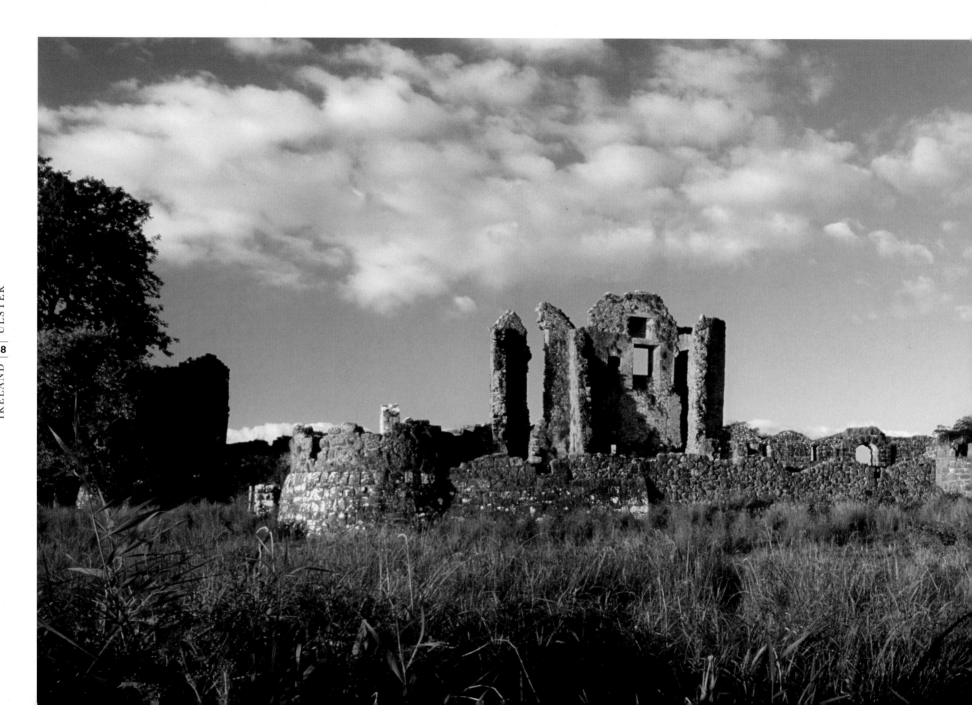

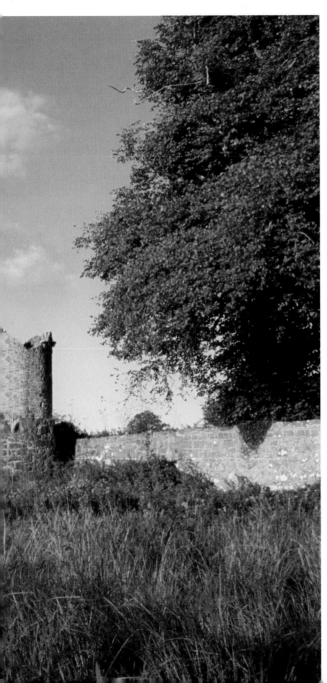

**LEFT:** Old Crom Castle on the shore of Upper Lough Erne, County Fermanagh, is a plantation castle of 1611. It was destroyed by fire in the 18th century and the replacement was built next door.

**RIGHT:** Celtic carved stone head on another of Lower Lough Erne's islands—Boa Island. Caldragh cemetery has two of these double-sided figures.

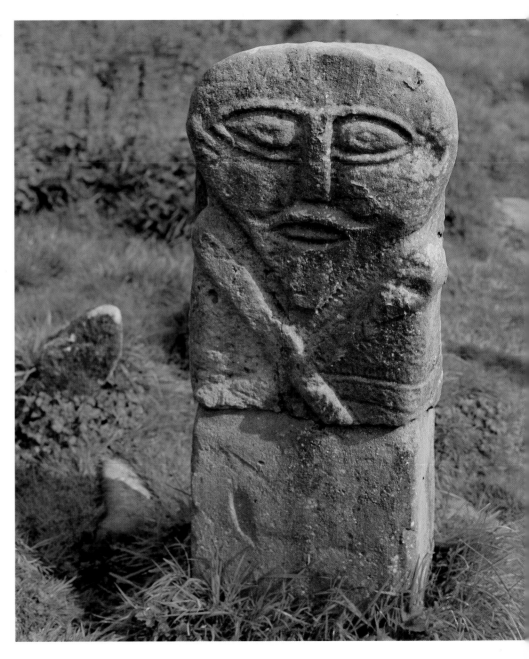

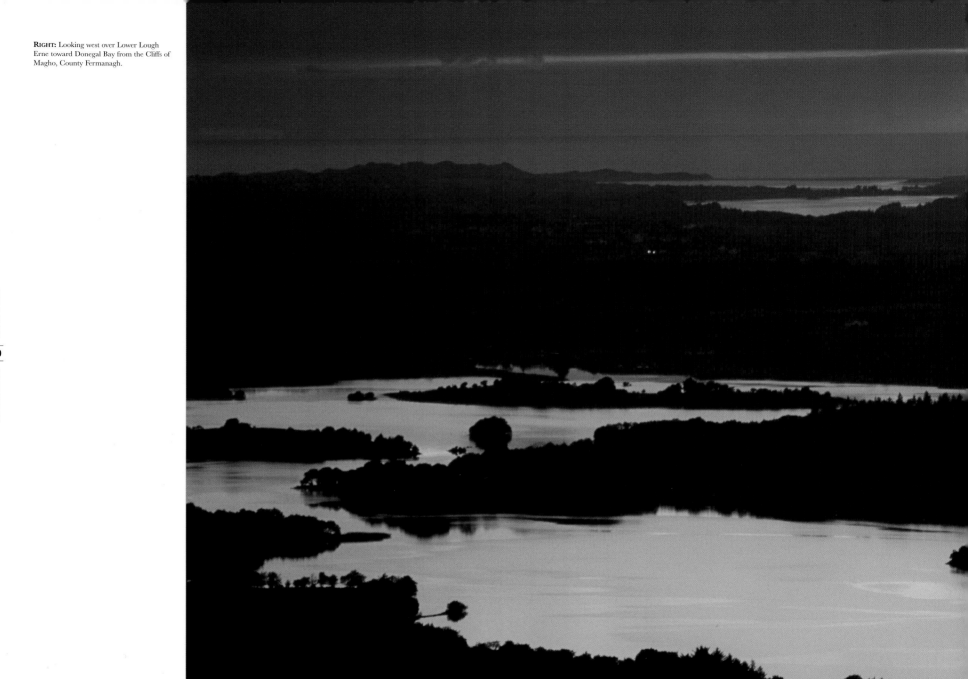

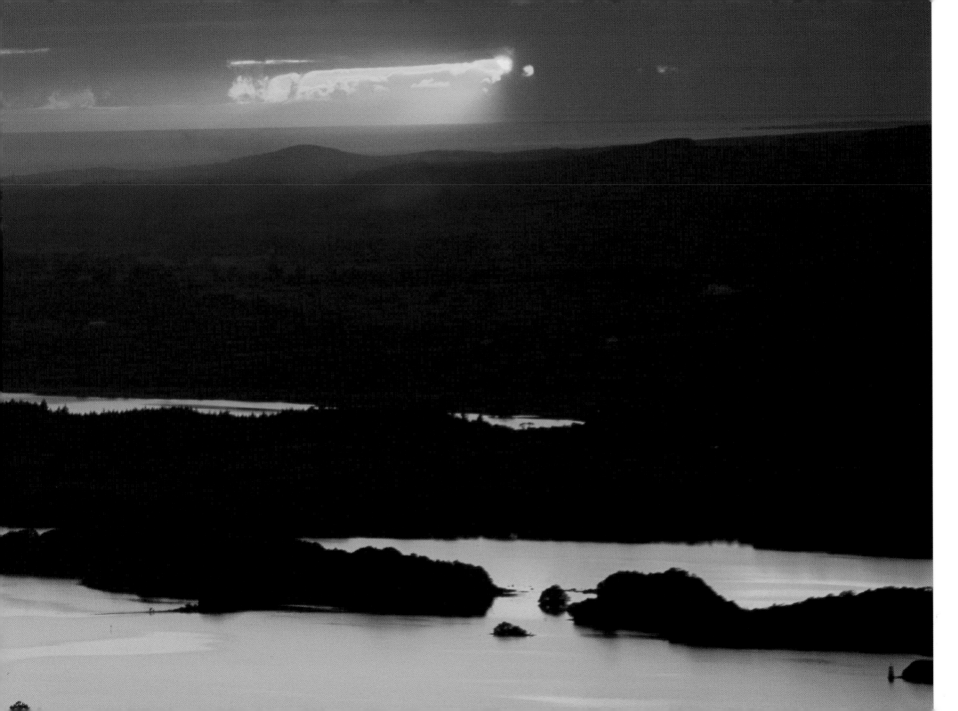

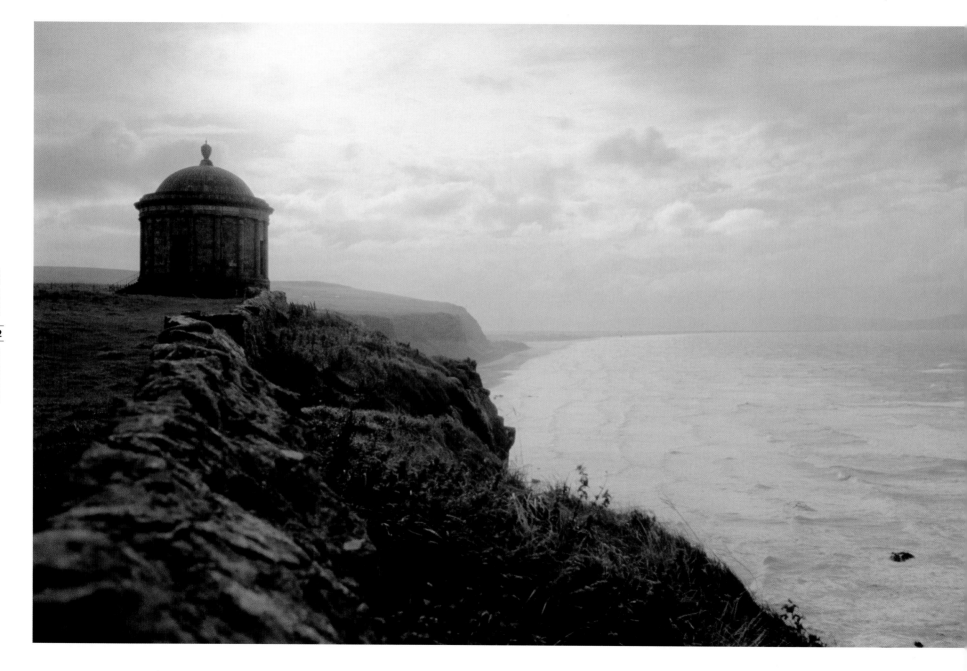

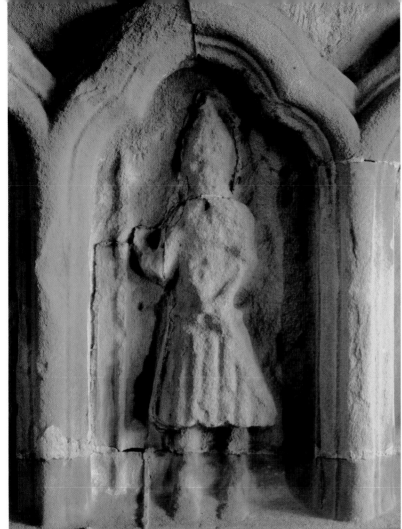

**LEFT:** View of the Mussenden Temple at Downhill Castle along the beach to Magilligan Point, County Londonderry. Built in 1785 by the eccentric Bishop of Derry Frederick Hervey, it is a memorial to his cousin, Mrs. Frideswide Mussenden, and is based on the Temple of Vesta at Tivoli outside Rome.

**ABOVE:** Dungiven Priory, County Londonderry: a gallowglass (an armed retainer of an Irish chieftain) stands guard over a tomb, traditionally that of Cooey-na-Gall O'Cahan who died in 1385. Founded in 1100, the remains at Dungiven include features from the 12th to the 18th century—it was in 1784 that the round tower at the southwest corner collapsed.

**RIGHT:** Benburb Castle above the River Blackwater, County Tyrone, was built in 1611 by Sir Richard Wingfield. Benburb was the seat of the O'Neills, the leaders of the opposition to English rule and in 1646 Benburb was the site of a great victory by the Confederate Army under Owen Roe O'Neill.

# Connacht

Connacht lies on the northwest side of Ireland; much of it has a wild Atlantic coast. Connacht contains the counties of Galway, Leitrim, Mayo, Roscommon, and Sligo. Connacht is the least inhabited province in Ireland with a scattered, mostly rural population. In much of it the pace of life is slower and less touched by the modern world. The Gaelic heritage is still strong here in both custom and language. The areas where Gaelic is spoken are known collectively as the Gaeltacht and this is the largest Gaeltacht in Ireland.

The busiest town in the area is Galway—the fourth largest city in Ireland—despite which it still retains much of its medieval flavor with its ancient university (founded 1345) and the fine Collegiate Church of St. Nicholas among many others. Galway became a thriving port largely thanks to the Spanish who brought ships laden with wine making the city the Irish wine capital. Christopher Columbus visited the city in 1477 as part of a trade mission.

Off the coast in Galway Bay lie the stony, treeless Aran Islands, the remnants of a ridge of carboniferous limestone. The Gaelic-speaking Aran islanders either scrape a difficult living farming, a tough life fishing, or—a more recent occupation—looking after tourists who come to enjoy the unique landscape and atmosphere. Almost all the topsoil was stripped away aeons ago and to preserve what little there was the farmers built tiny stone-walled fields known as gardens. The best-known products of island living are the famous intricately worked Aran sweaters knitted from the wool of the tough island sheep.

Many people cite Connemara as their favorite place in Ireland: it is a quiet, remote, and wild place that encompasses most of Galway. The landscape is one of loughs, mountains, heath, moors, bogs, and variable weather—prepare for at least three seasons a day and you won't be disappointed! Connemara even has the only Irish indigenous breed of pony, a tough, resilient little animal renowned for its remarkable agility.

**RIGHT:** View from Roundstone toward the Twelve Pins, Connemara, County Galway. Connemara is the wild region of bogs, mountains, and Atlantic coastline in the southwest of Connacht.

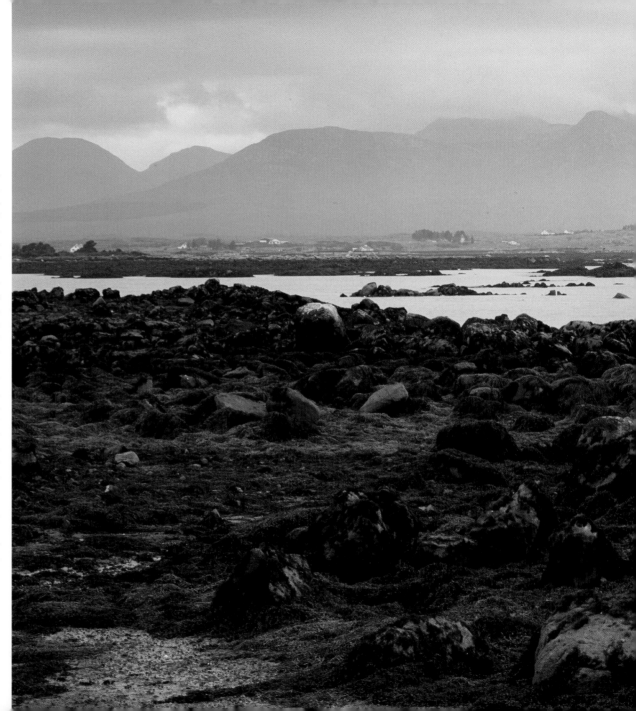

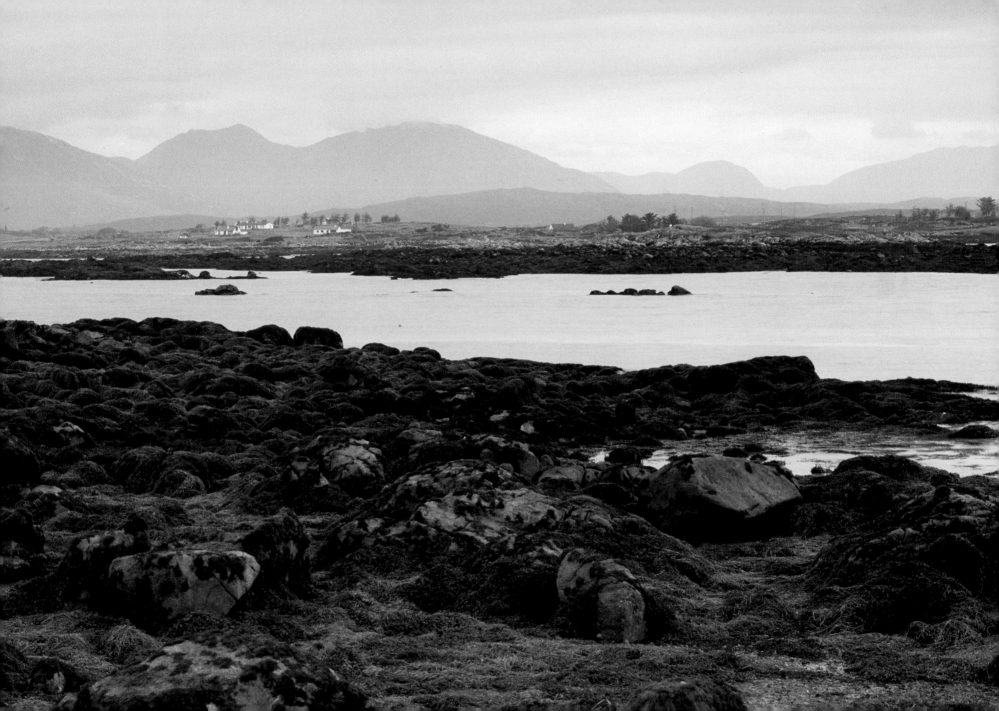

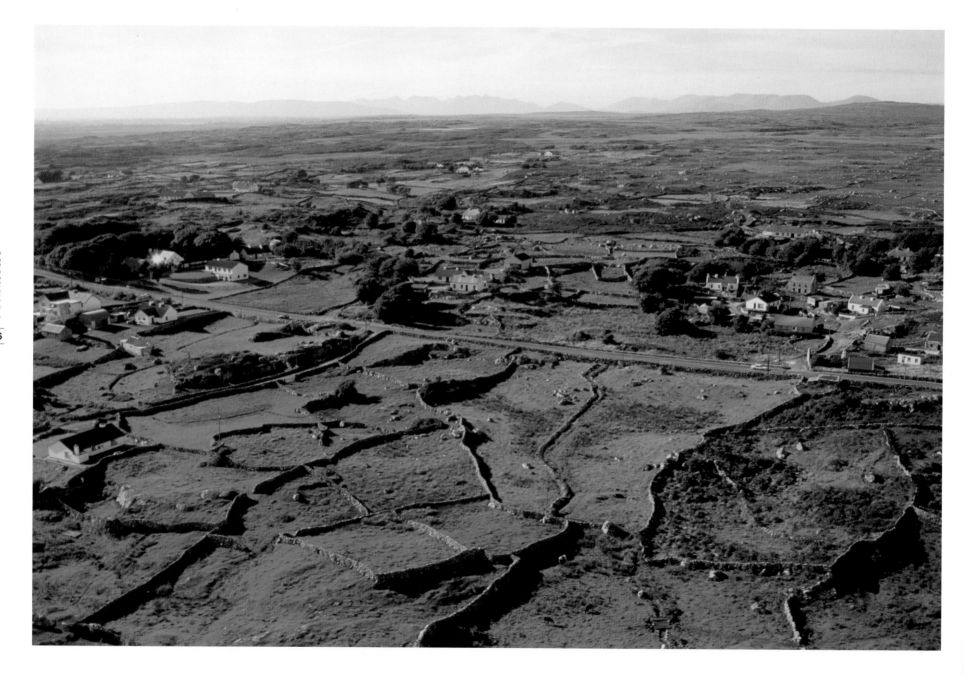

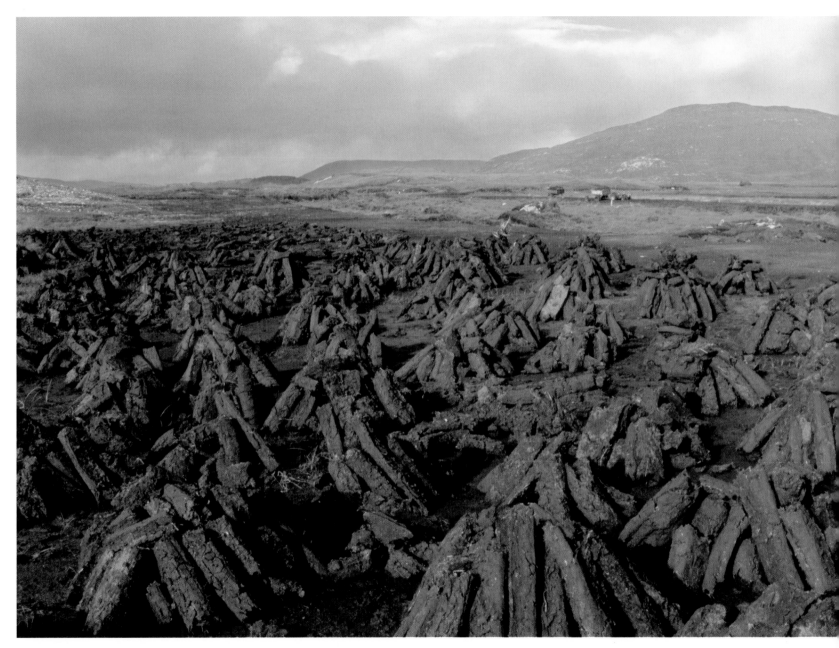

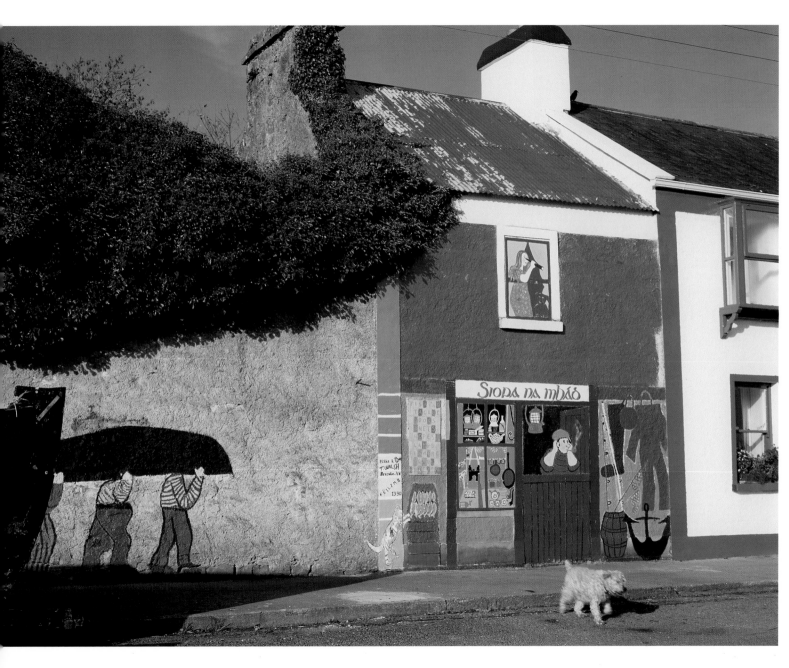

**LEFT AND FAR LEFT:** The murals at Kinvara, County Galway are a tourist attraction in themselves, although most people use this beautiful fishing village as a base for visiting the Burren in neighboring County Clare. Note also the traditional Aran sweater—in the old days each family of knitters could be distinguished by the traditional patterns on these hard-wearing clothes.

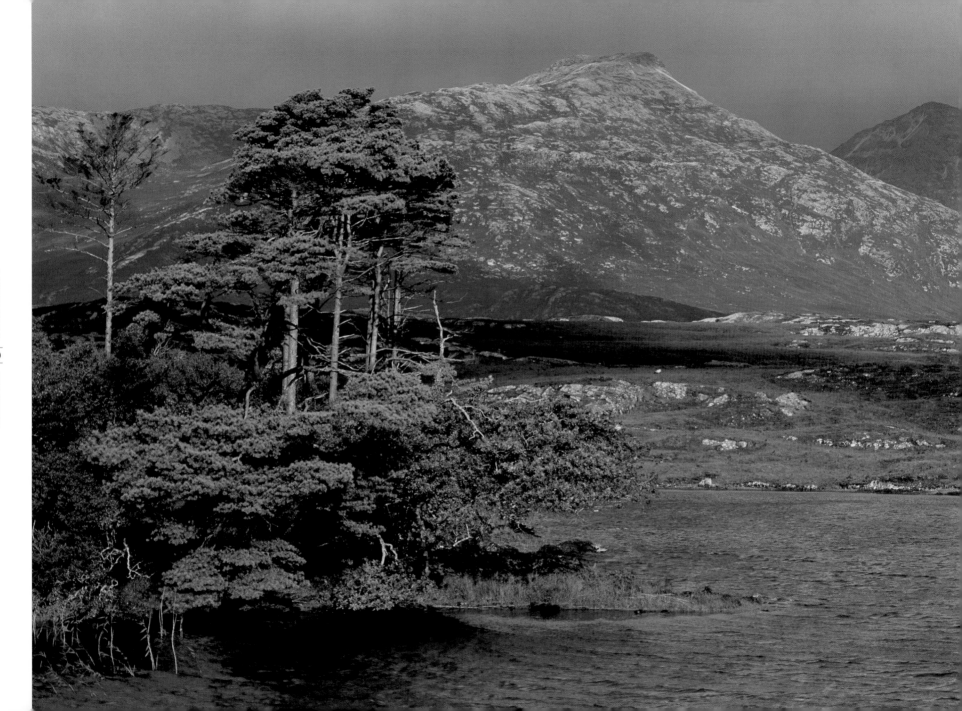

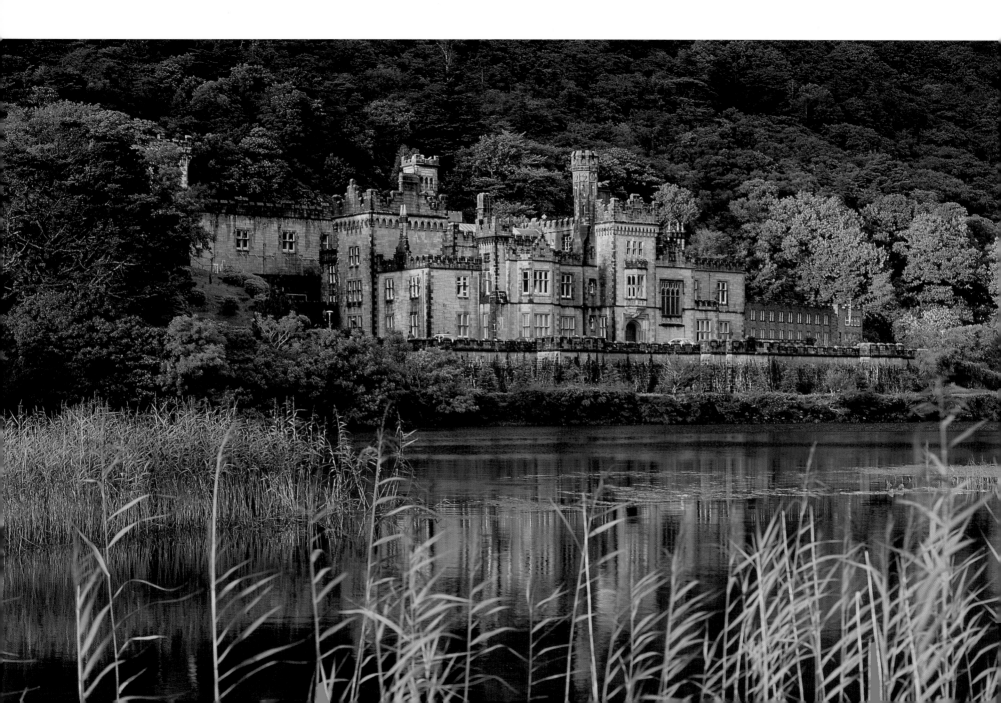

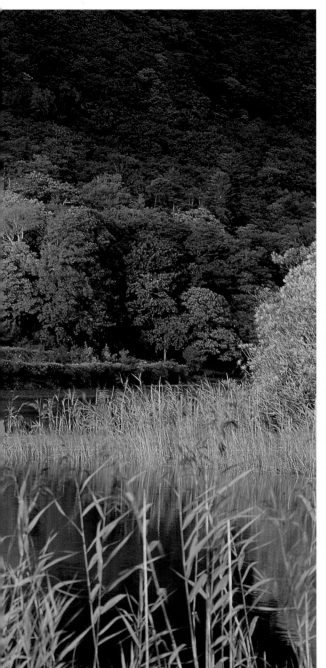

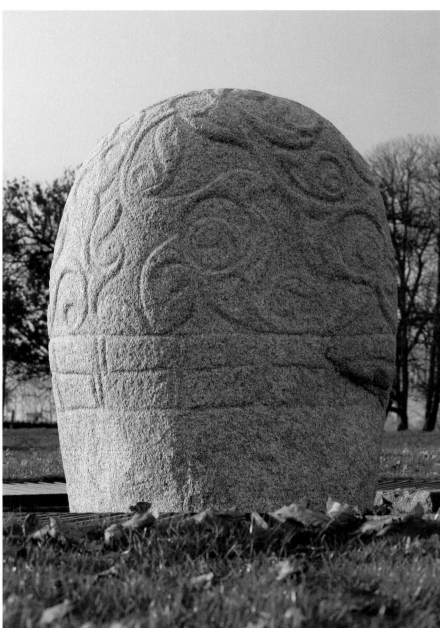

FAR LEFT: Kylemore Abbey, County Galway, is a lakeside fantasy of Gothic Revival architecture. Built by a wealthy Liverpool merchant, Mitchell Henry MP, it became a Benedictine convent after World War I and then a school.

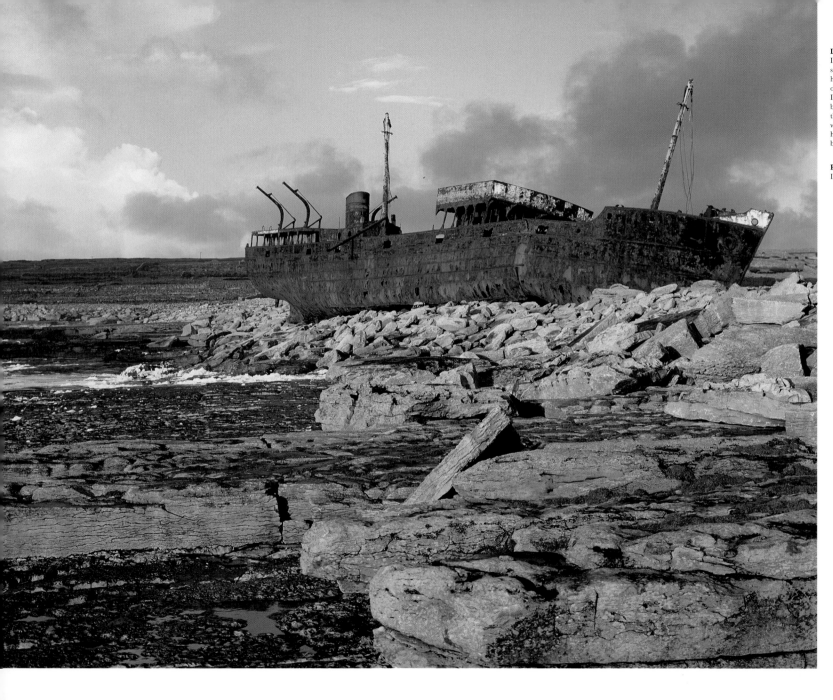

**LEFT:** There are three Aran Islands—Inishmore, Inishmaan, and Inisheer. They stand off Galway and have ever been a hazard to shipping. This is the rusting hulk of the cargo ship *Plassy* on the east coast of Inisheer. It was wrecked on March 8, 1960, but thanks to the quick and heroic work of the islanders, the 11 crewmembers were winched to safety. More recently the *Plassy* has starred in the title sequence of the brilliant "Father Ted" TV comedy series.

**RIGHT:** Jaunting car—pony and trap on Inishmore.

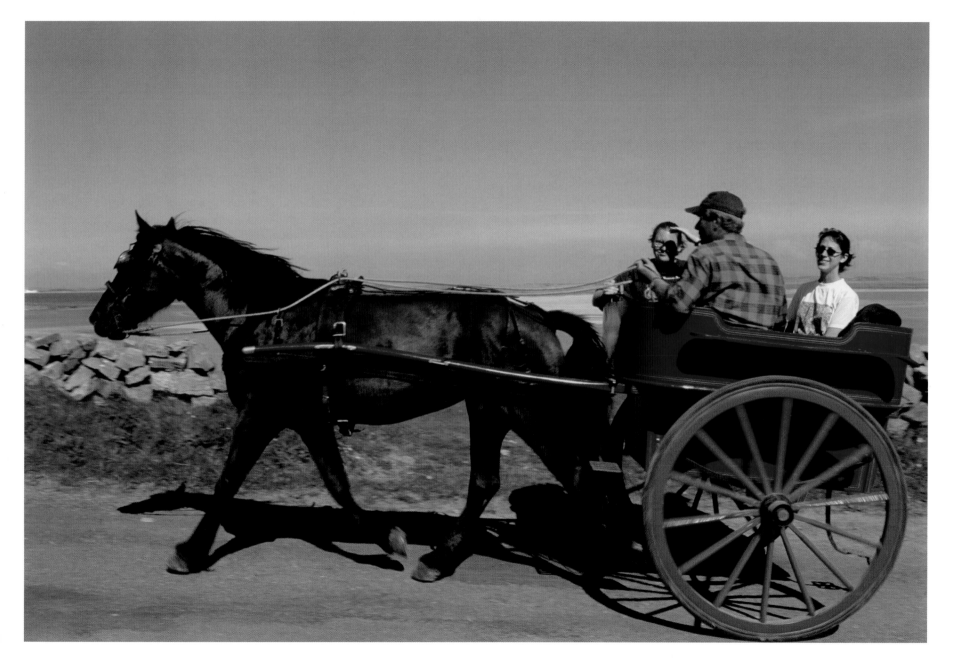

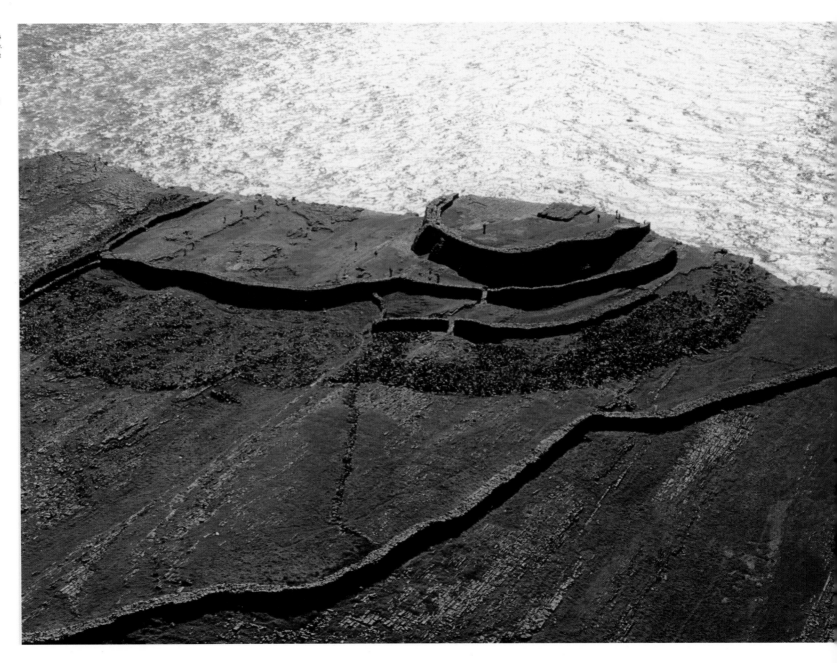

**LEFT AND RIGHT:** Two views of the Dun Aenghus ancient stone fort high on the cliffs of Inishmore, Aran Islands, County Galway. One of the most magnificently sited ancient monuments in Europe, it sits atop 200ft sheer cliffs. On the landward side it has three defensive walls and then, outside, chevaux de frise—thousands of stones set with points upward, to make access difficult for intruders. There's another wall outside these.

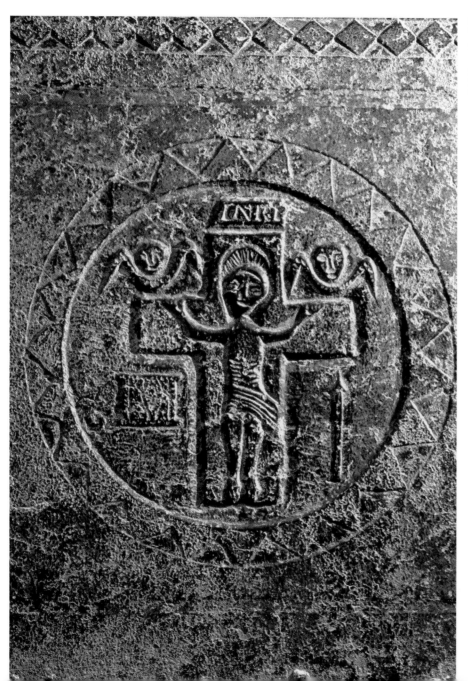

**LEFT:** Altar detail in the church ruins of St. Caomhan on Inisheer. In use between the 10th and 14th centuries, it regularly has to be dug out of shifting sands.

**RIGHT:** Dun Eochla on Inishmore is a Bronze Age fort with remarkably thick walls situated close to the center of the island.

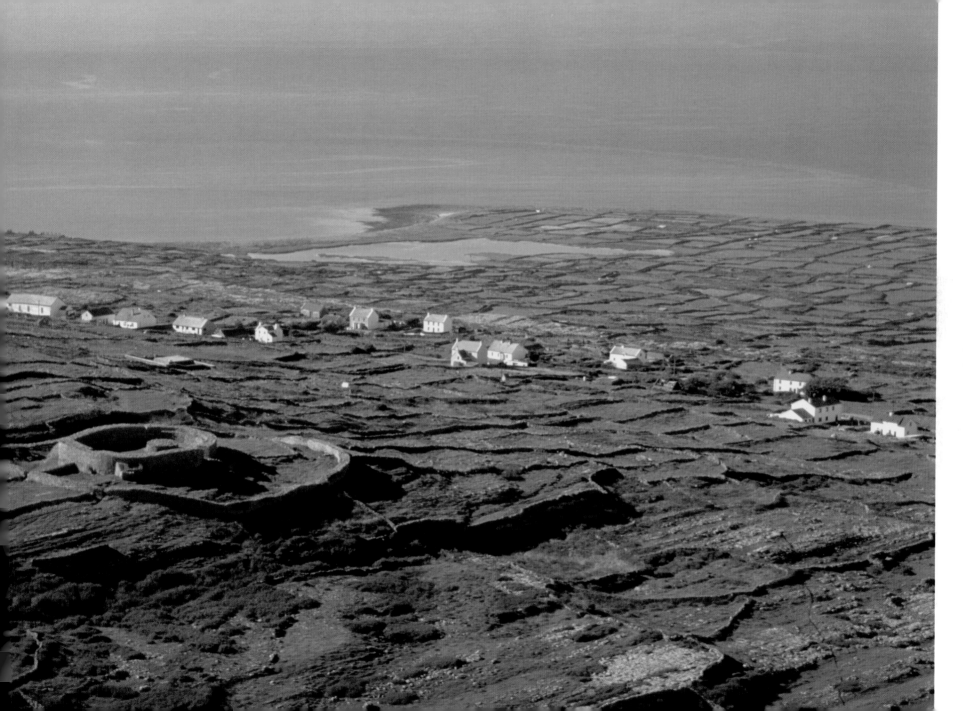

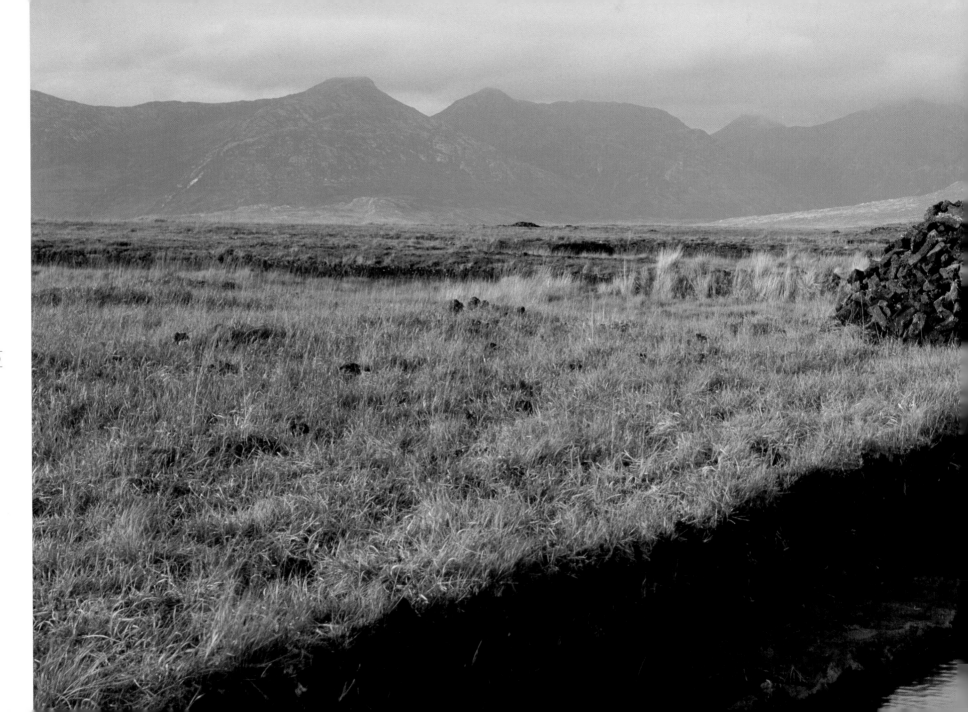

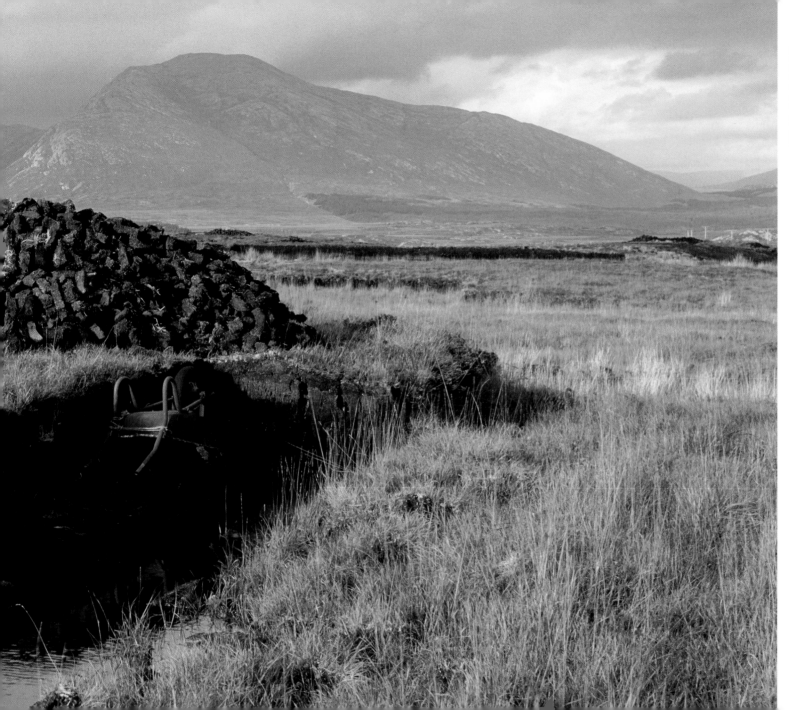

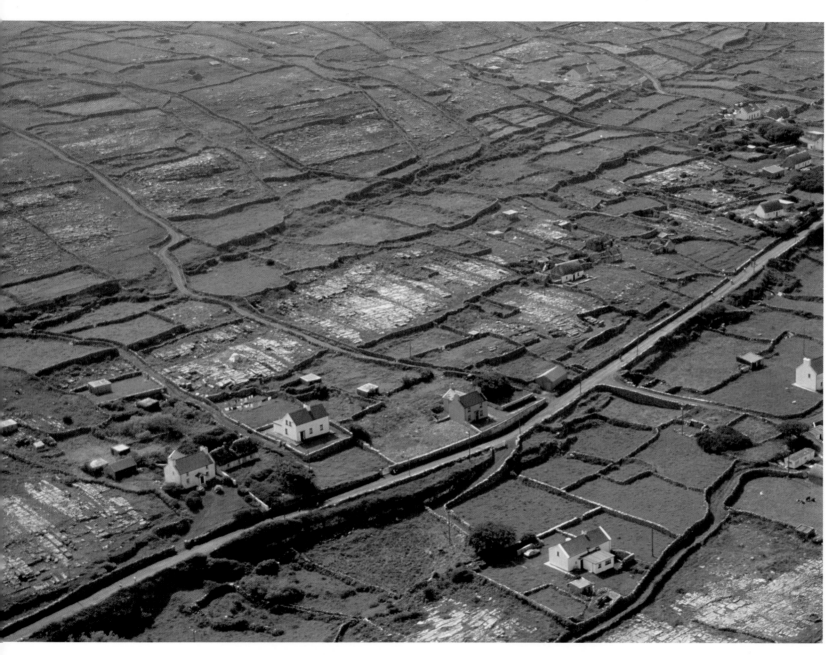

**LEFT:** Homesteads on Inishmore, Aran Islands, County Galway.

**RIGHT:** Donkeys and a traditional Aran currach—a canvas-covered boat.

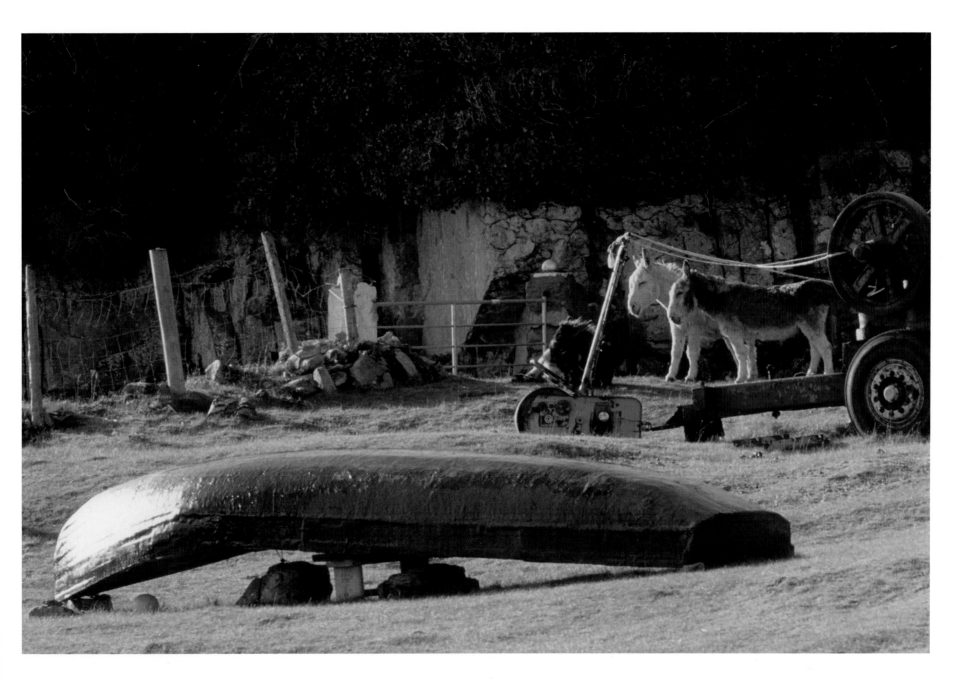

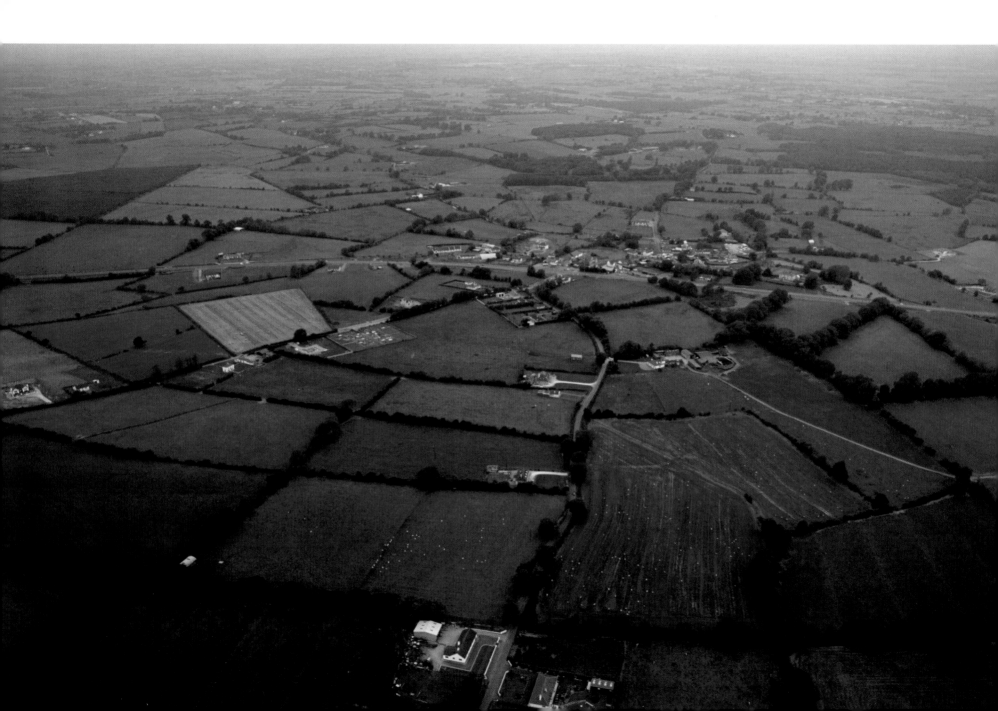

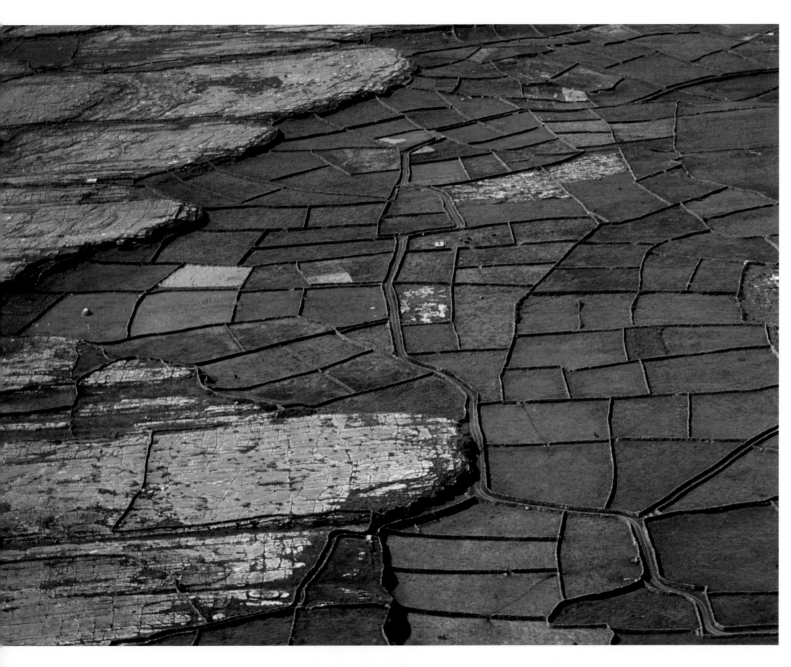

**FAR LEFT:** Aughrim, County Galway, was the site of a famous battle on July 12, 1691, in which the Jacobites were defeated by the Prince of Orange's men. Above the village is a ring fort near which—at a crucial moment in the battle—the Jacobite forces' general, St. Ruth, was killed by cannon fire.

**RIGHT:** The operational lighthouse on Inisheer was built in 1857. It is 112ft high and sits opposite Doolin in County Clare. It replaced the 1818 light on Innishmore that was found to be sited too high so that it was too often shrouded in mist to be useful.

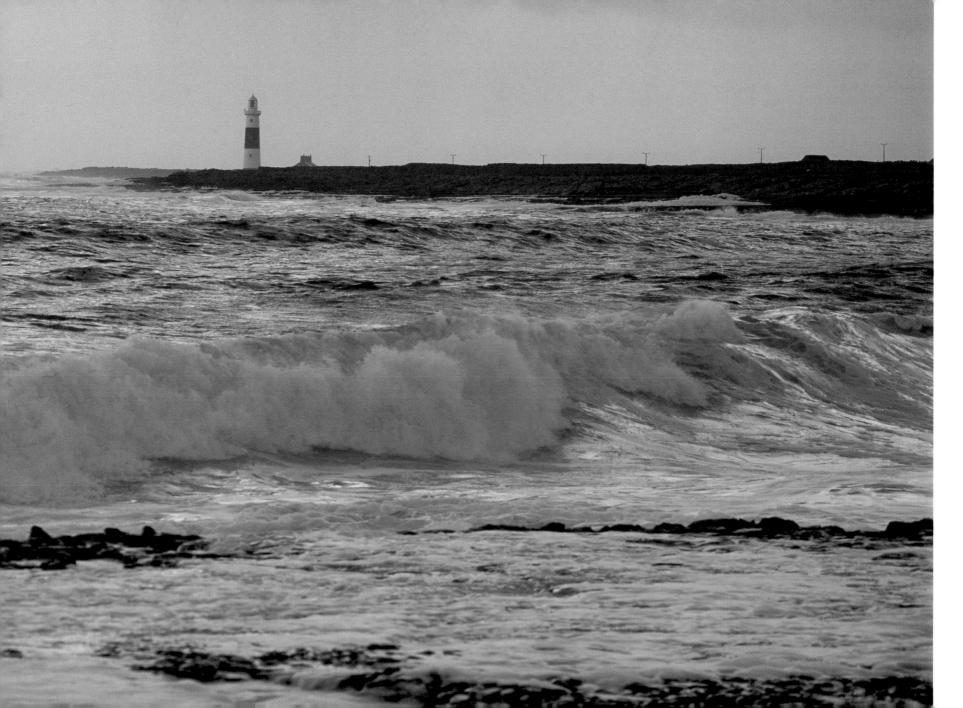

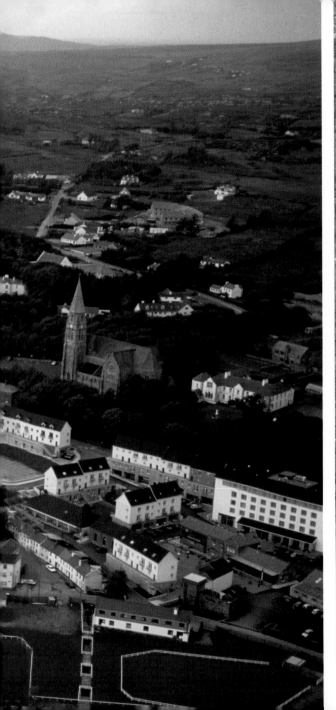

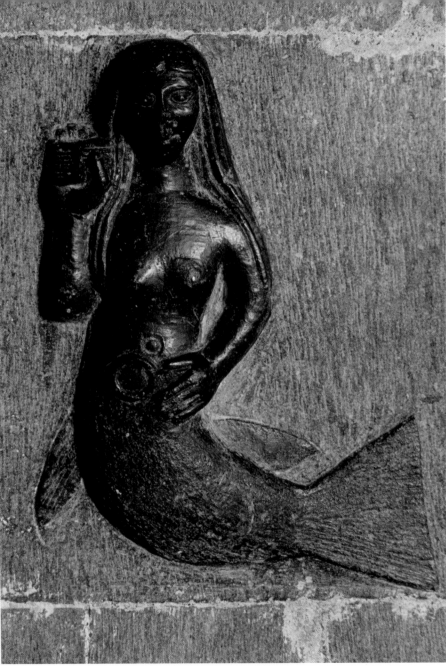

**FAR LEFT:** Clifden is called the "capital of Connemara" and is some 50 miles west of Galway. It isn't an old town: it was "founded" in the early 19th century by John Darcy of Killtullagh who is also responsible for the "castle." It is said that it was founded to provide lawless Connemara with an island of respectability. Today, it is a much-visited tourist center.

**LEFT:** Clonfert Cathedral in County Galway was founded as a monastery by St. Brendan in 563. The cathedral does not have the most glorious of settings and it has a tough history: it was ravaged by Vikings in 844 and 845; destroyed by fire in 749, 1016, 1164, and 1179; wrecked in the 16th century; and then dreadfully "restored" in the 18th and 19th centuries. Surprisingly, what remains is worth seeing—a veritable jewel of Irish Romanesque architecture. This beautiful mermaid is a detail on a 15th century chancel arch.

**OVERLEAF:** Clonfert Cathedral in County Galway was founded as a monastery by St. Brendan in 563. The cathedral does not have the most glorious of settings and it has a tough history: it was ravaged by Vikings in 844 and 845; destroyed by fire in 749, 1016, 1164, and 1179; wrecked in the 16th century; and then dreadfully "restored" in the 18th and 19th centuries. Surprisingly, what remains is worth seeing—a veritable jewel of Irish Romanesque architecture. This beautiful mermaid is a detail on a 15th century chancel arch.

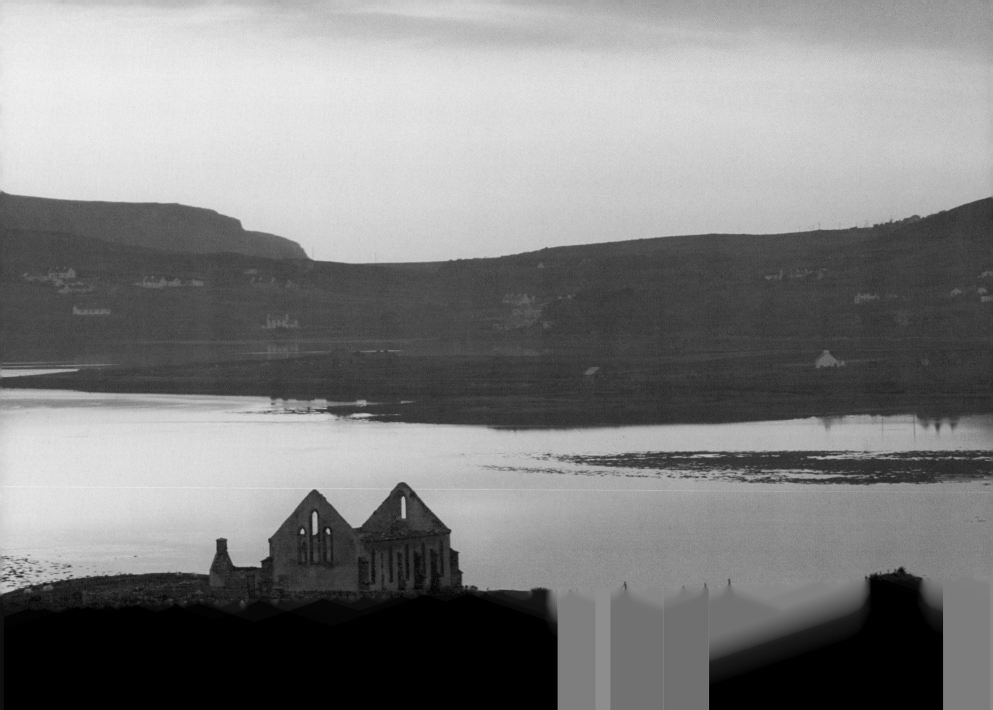

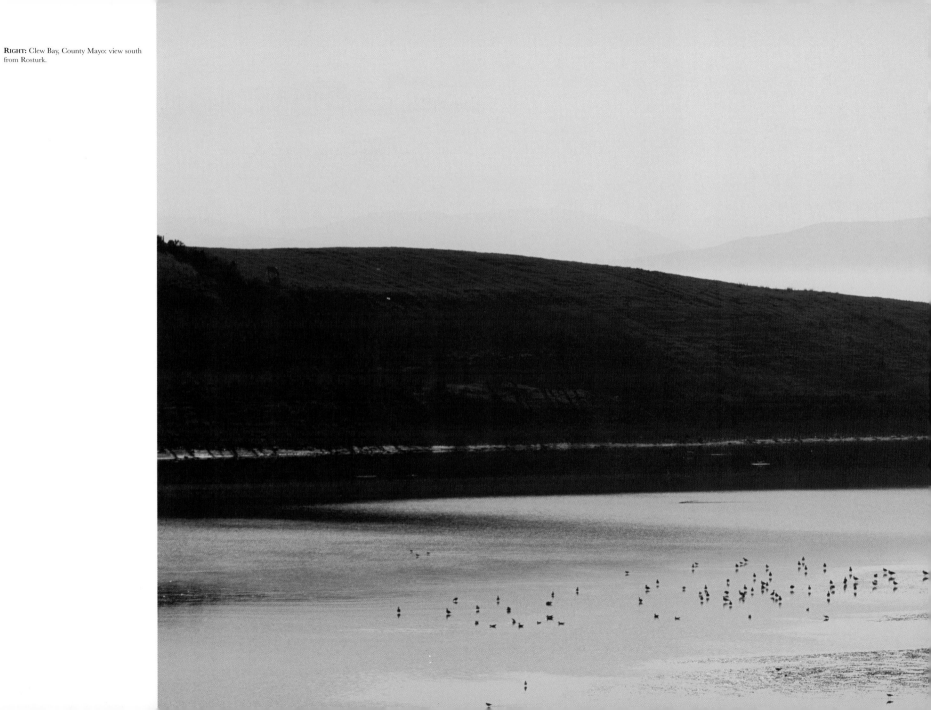

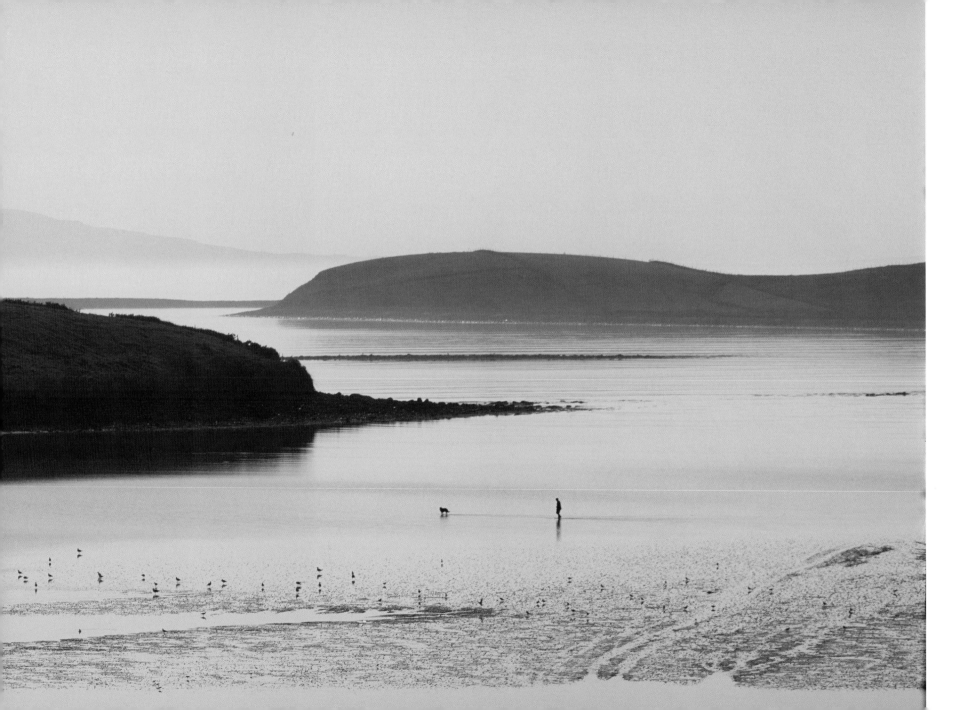

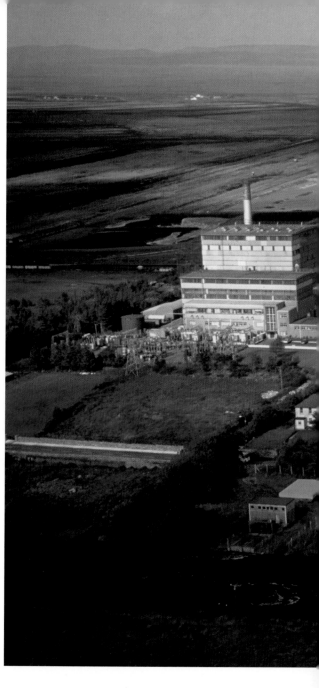

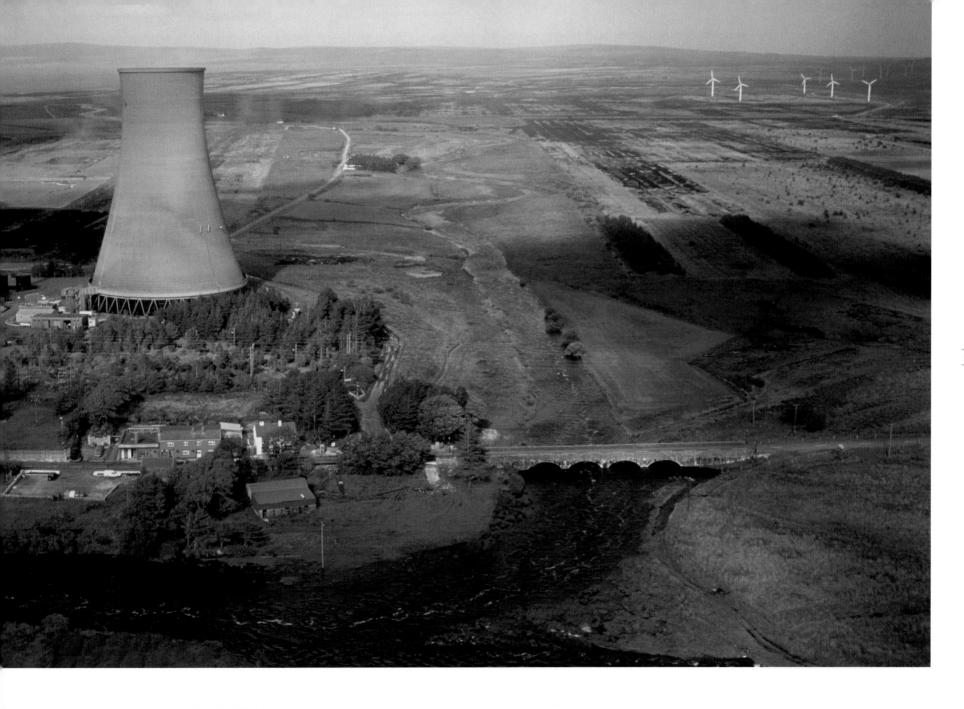

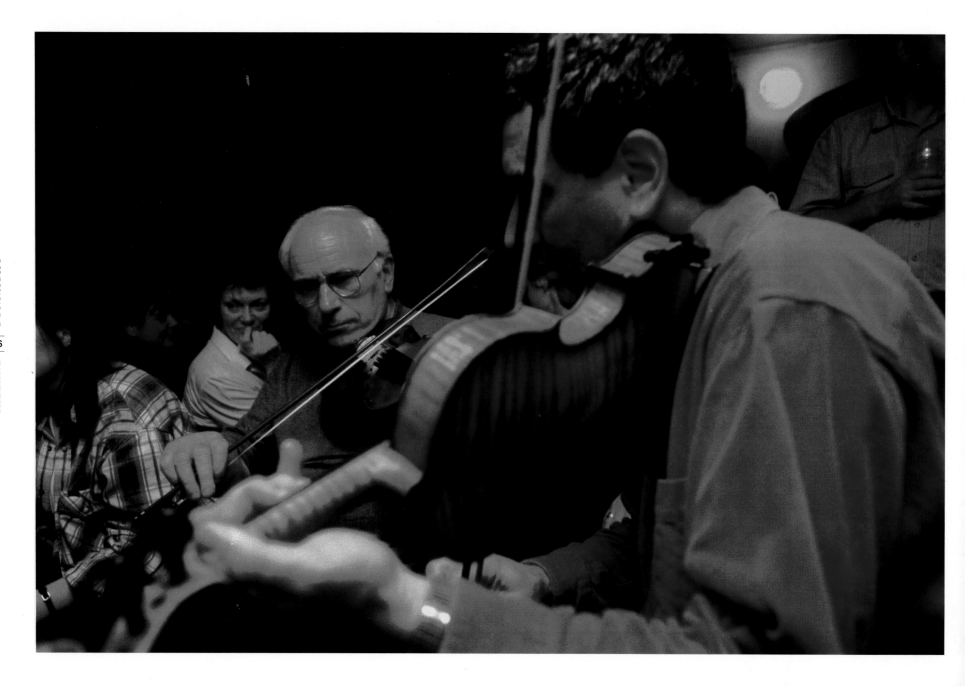

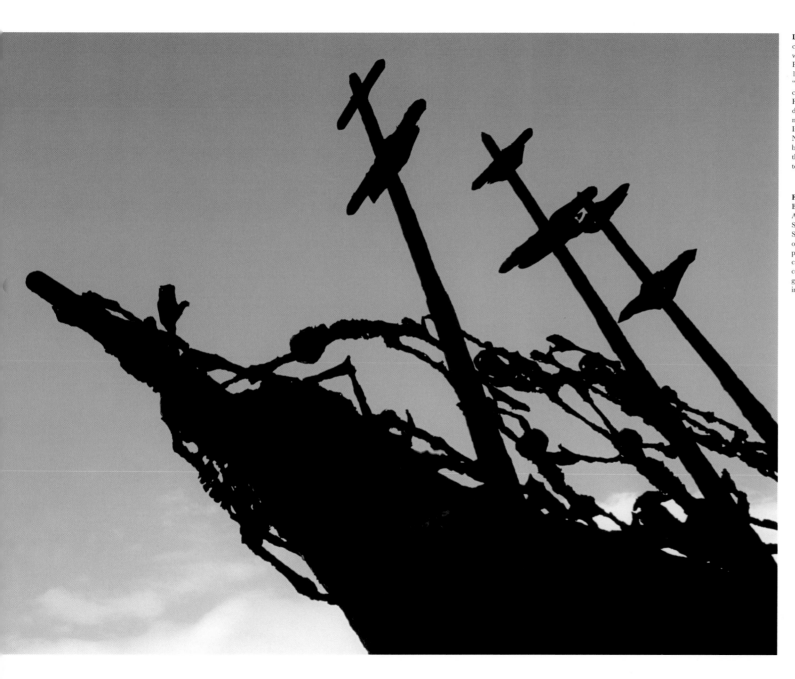

**LEFT:** The National Famine Monument—close to the Croagh Patrick Visitor Centre—was unveiled by Mary Robinson, the President of Ireland at the time, on July 20, 1997. The sculpture by John Behan depicts a "Coffin Ship" with skeleton bodies and commemorates the anniversary of the Irish Famine 150 years ago, when the population declined from 8 million to 4 million. The monument is the largest bronze sculpture in Ireland. A similar sculpture was unveiled in November 2000, outside the United Nations building in New York City, representing those immigrants who survived the journey to America.

**FAR LEFT:** Musicians in the bar of the Clew Bay during the annual music festival, Scoil Acla, on Achill Island, County Mayo. Started in 1910, *Scoil Acla* was a Summer School for the teaching of Irish; the teaching of piping (Irish war pipes) and the promotion of music, dance, song, and culture generally. Wearing of the national costume was encouraged. The school gradually went into decline until relaunched in 1985.

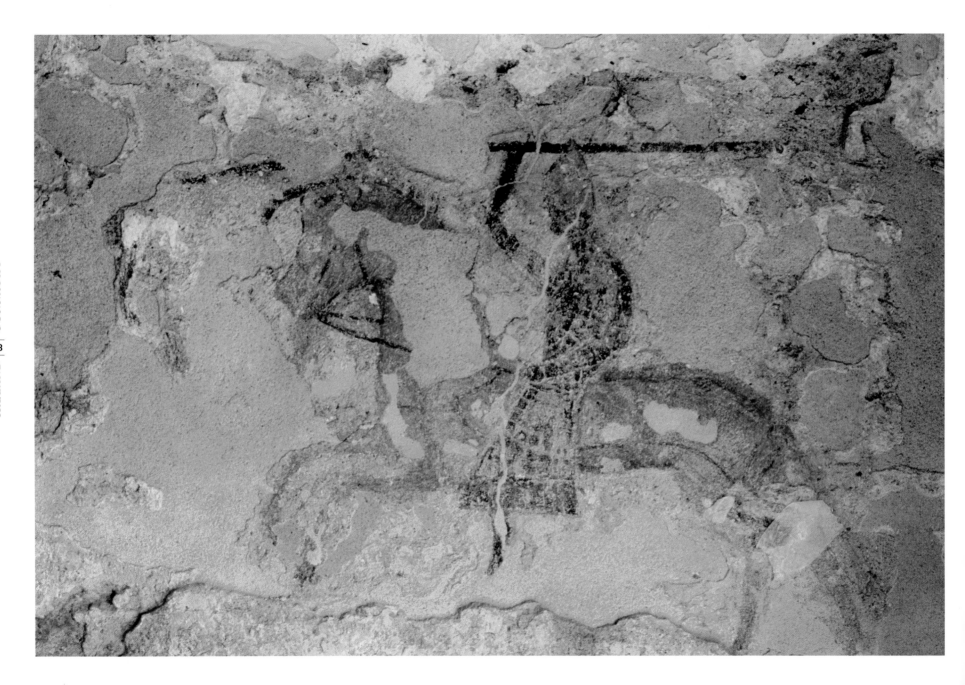

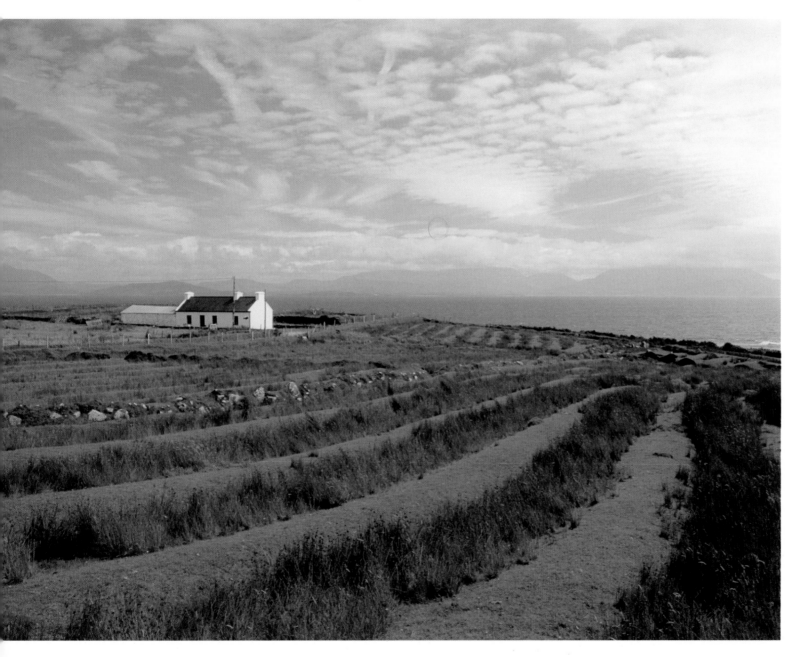

**LEFT:** Old ridge and furrow cultivation near Kill, Clare Island, County Mayo. The hills of South Mayo can be seen in the distance.

**FAR LEFT:** Fresco detail in the 13th century Carmelite friary on Clare Island, County Mayo. A mountainous island at the mouth of Clew Bay, Clare was the stronghold of Grace O'Malley (1530–1600), the famous pirate.

**OVER PAGE:** The deserted village of Slievemore, Achill Island, County Mayo.

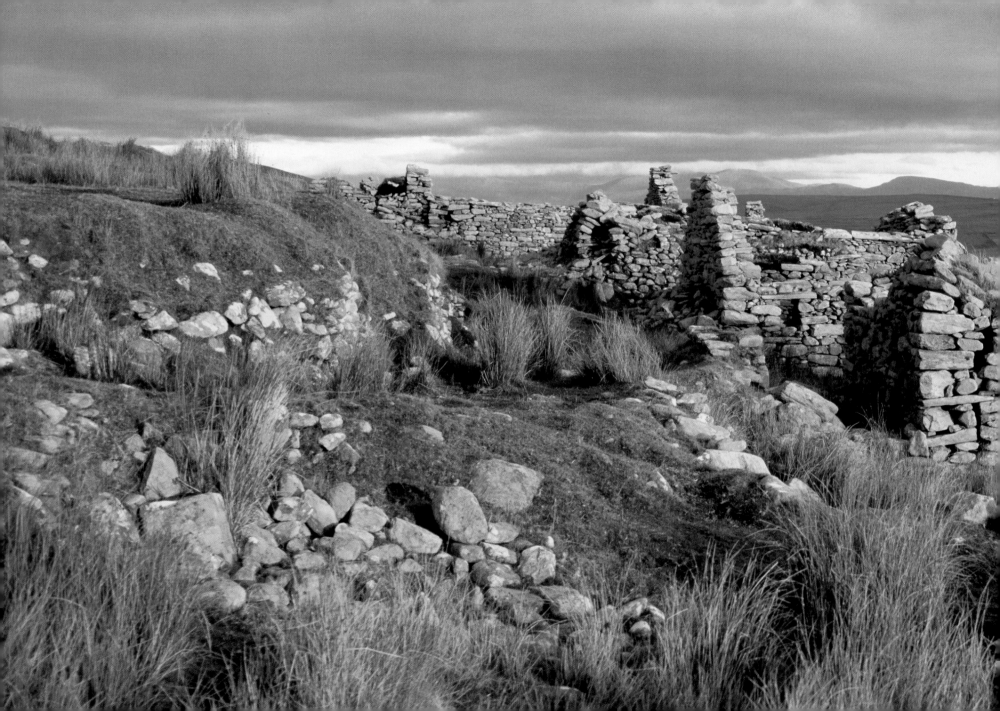

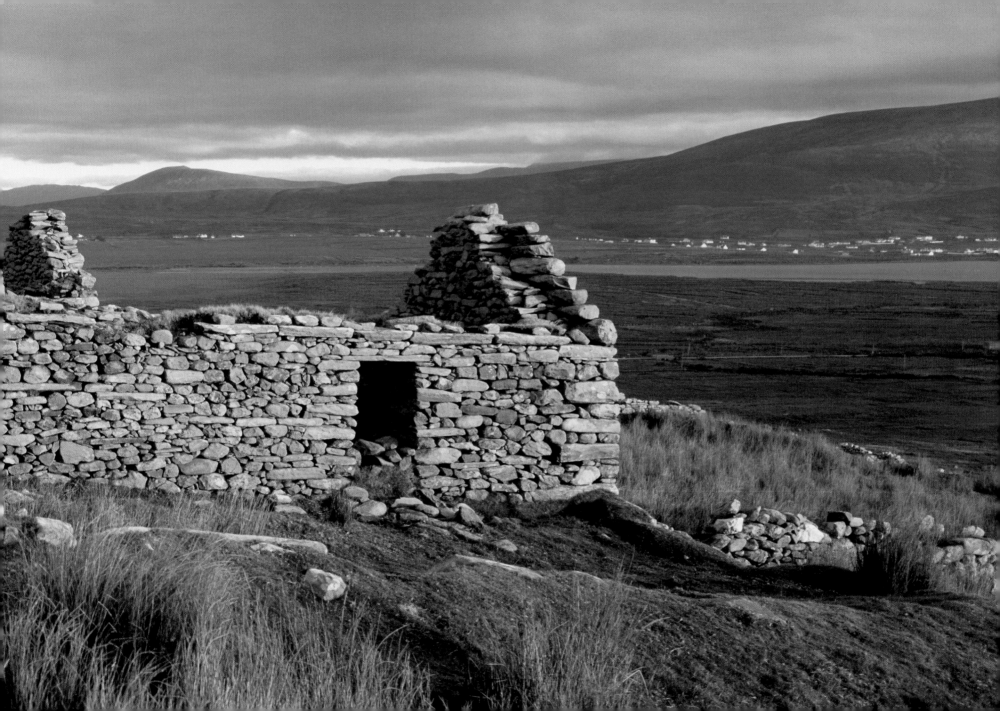

RIGHT: Stone Age farm walls revealed from the covering peat, Ceide Fields, County Mayo.

FAR RIGHT: Rosserk Friary, County Mayo, was founded for the Franciscan Order in 1440. It was destroyed by Queen Elizabeth's governor of Connacht, Sir Richard Bingham, the bitter enemy of Grace O'Malley.

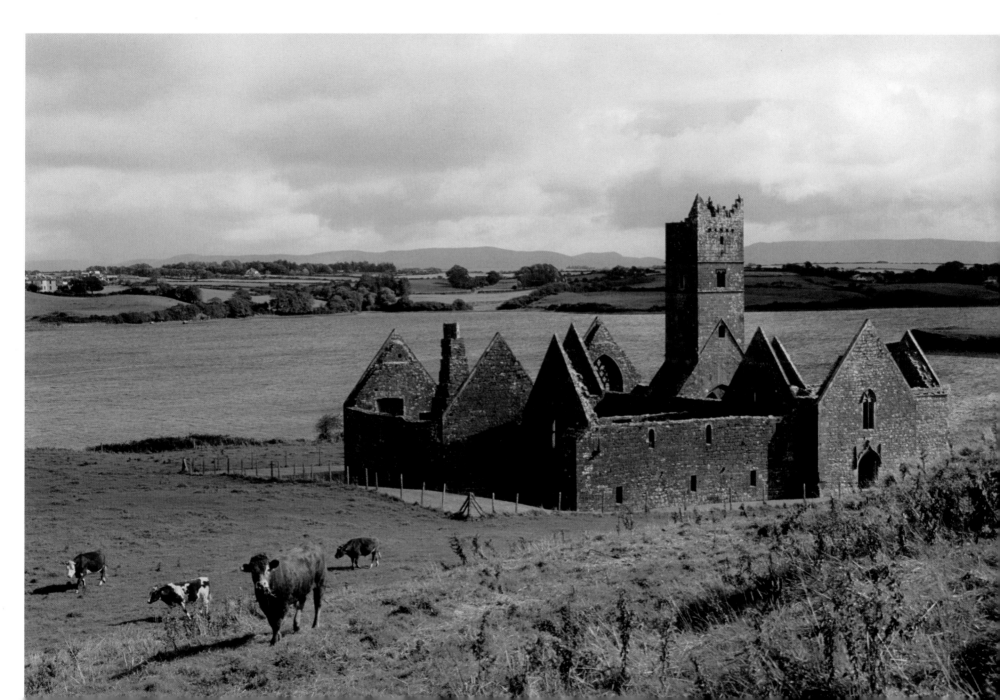

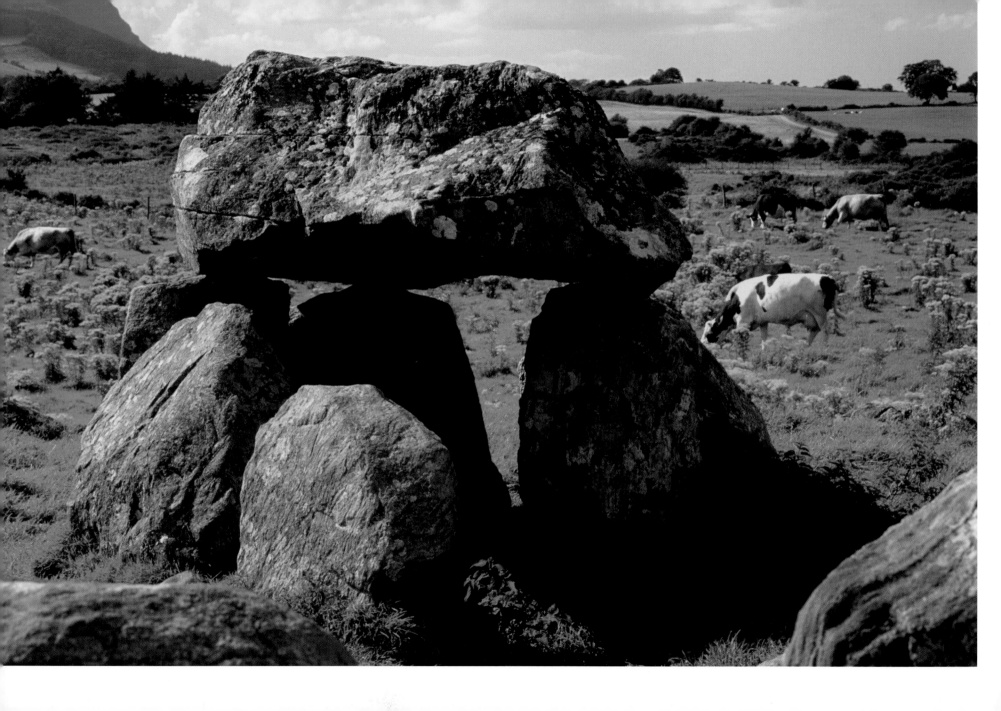

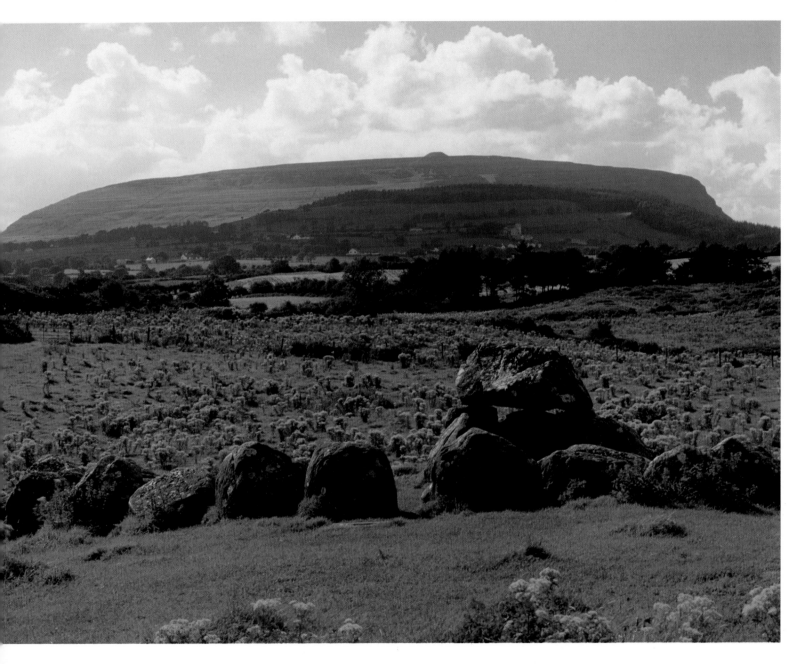

**LEFT:** Another view of Carrowmore megalithic cemetery dominated by the cairn of warrior Queen Maeve (Misgán Méadbha) on the summit of Knocknarea Mountain, near Strandhill, County Sligo.

**FAR LEFT:** Grave 7 of Carrowmore megalithic cemetery, County Sligo. Situated in a dramatic setting overlooking Sligo Harbor and Ballisodare Bay, Carrowmore cemetery is the largest of the most important megalithic sites in Europe with a variety of chambered cairns, passage mounds, dolmens, standing stones, and stone circles.

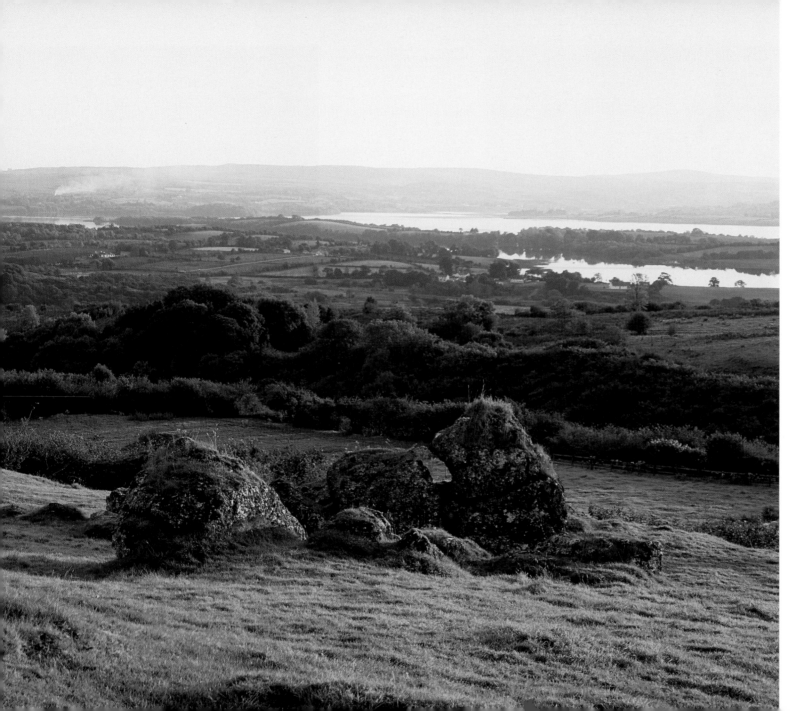

View looking south over the site of the second battle of Moytura in the parish of Kilmactranny, northeast of Lough Arrow, County Sligo. The second Battle of Moytura was, unsurprisingly, the direct result of the first during which King Nuada of the Danaans had his hand removed by the enemy's champion. Because of his wound, he had to resign as king until it was replaced as new made from silver. He took back the throne and Bres, who had reigned in his place, left Ireland. He raised an invasion army and returned to Ireland, where the two armies gave battle. The Danann force won but King Nuada of the silver hand was killed in the fight.

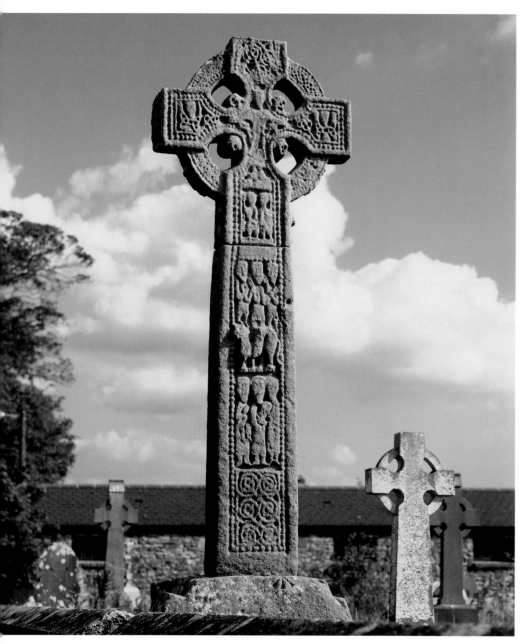

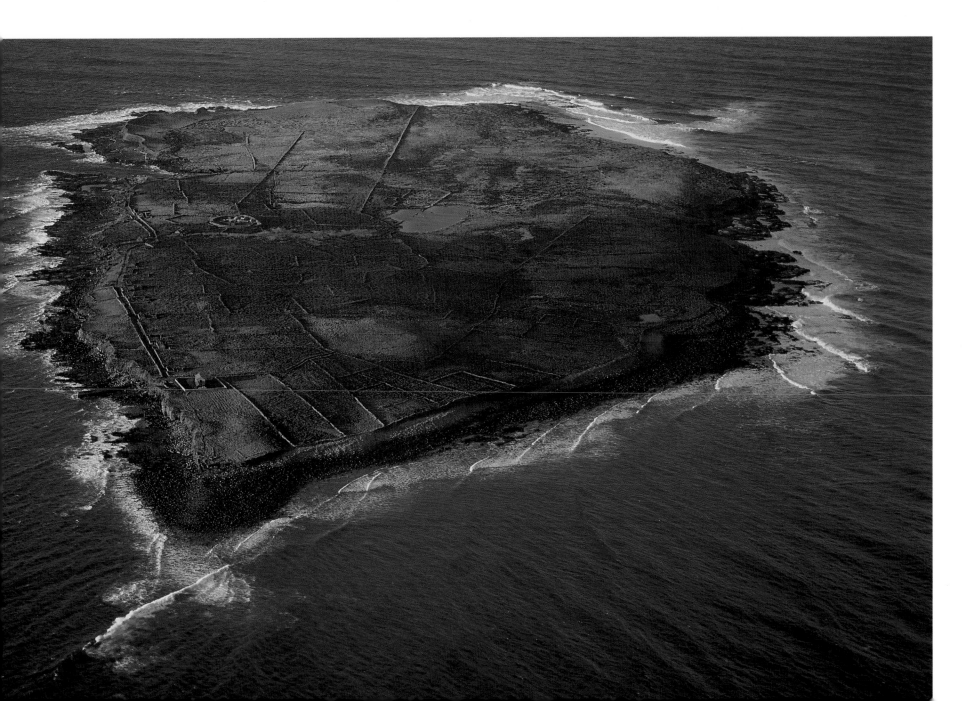

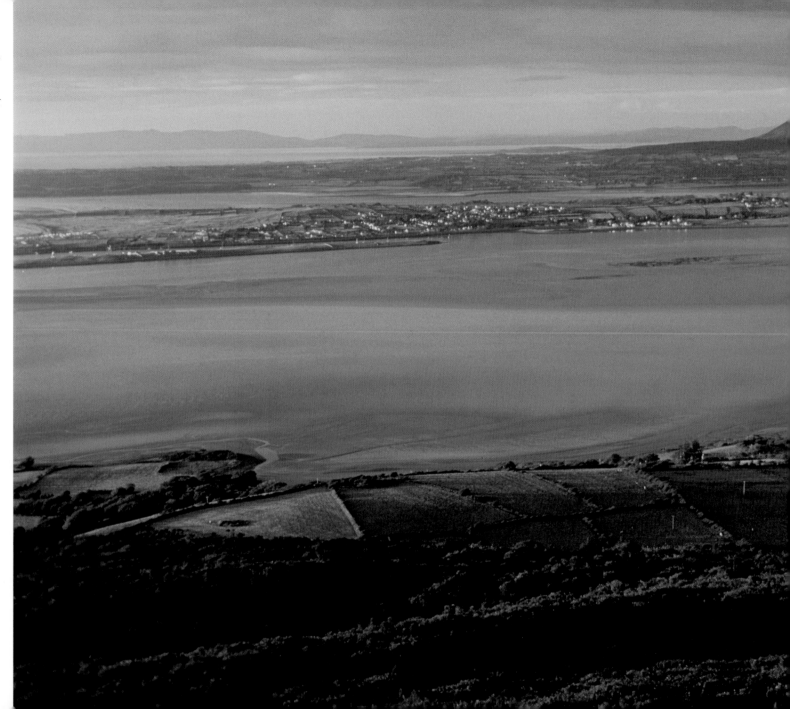

**RIGHT:** Maeve's realm from the sea: the view north to Ben Bulben from Knocknaren, County Sligo. In the Irish kingdom of Connacht, sovereignty of the land passed to a woman, Queen Maeve, in approximately the 1st century BC. She is most famous as a protagonist in the story of the Cattle Raid of Cooley (The *Táin Bô Cuailnge*) and adversary of Cúchulainn, the legendary Celtic hero.

**OVERLEAF:** Ballinafad Castle in County Sligo is also known as "the castle of the Curlews." It was built in 1590 to protect the Curlew Hills pass.

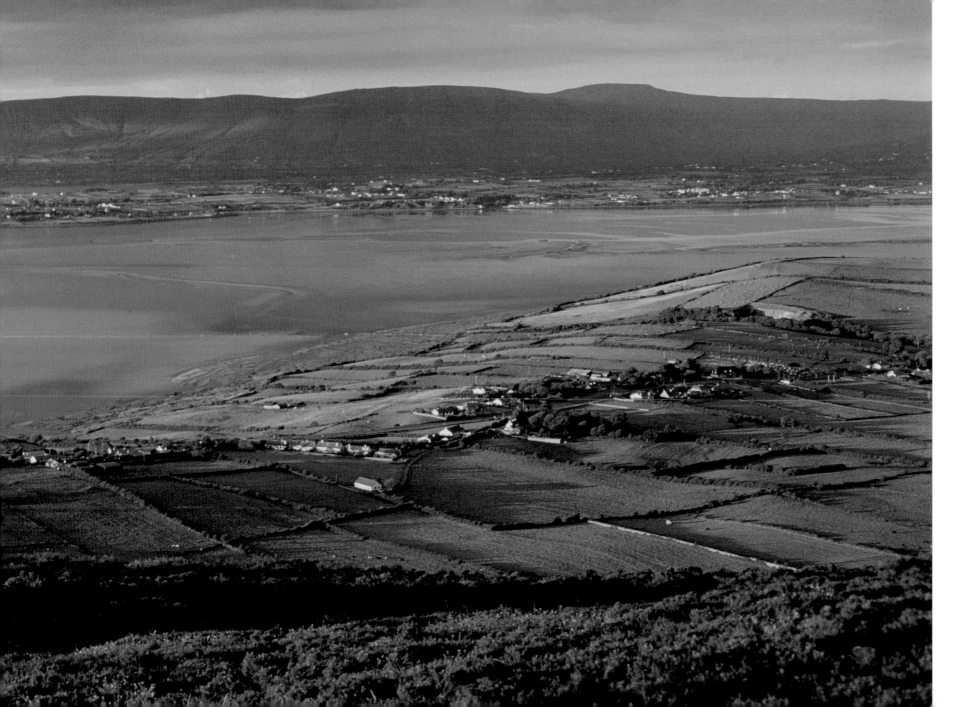

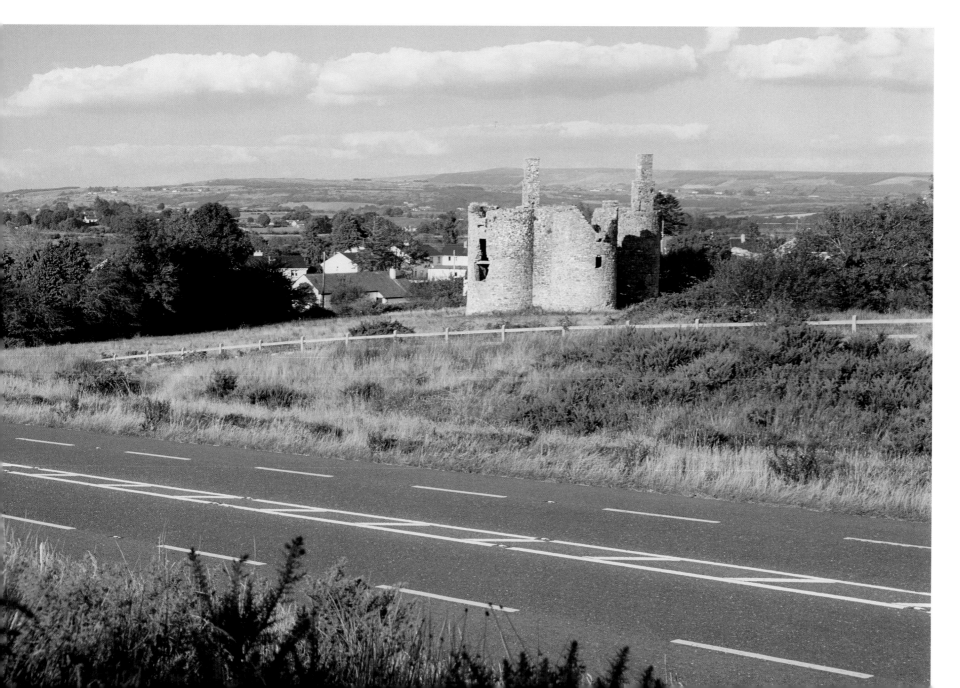

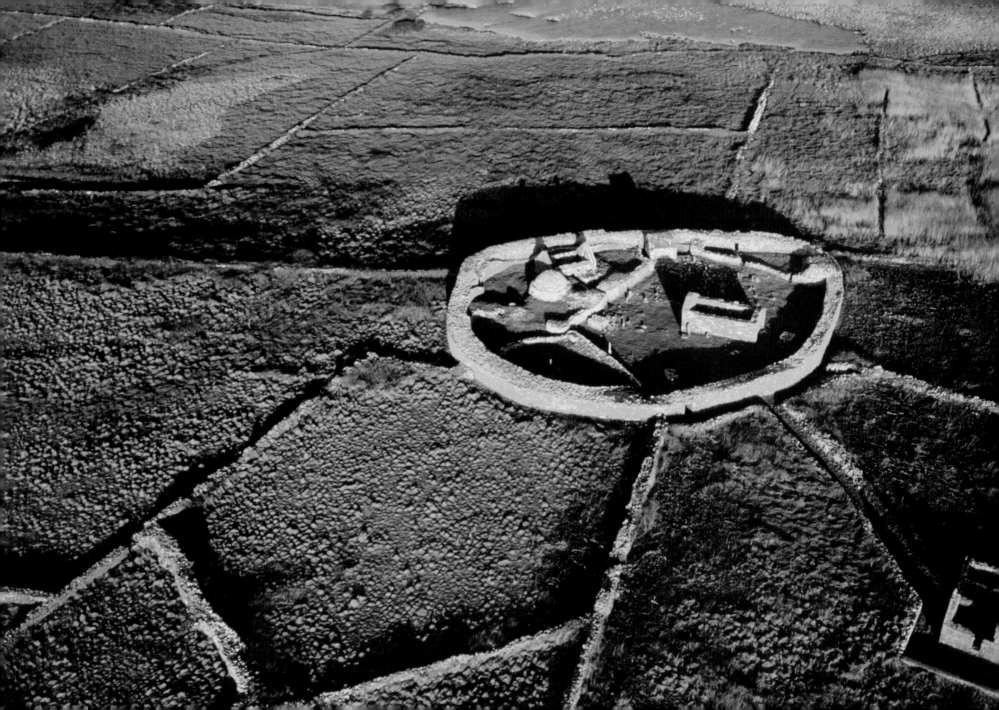

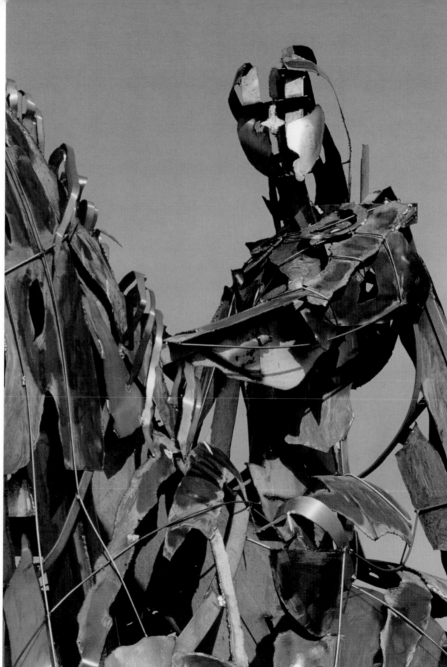

**LEFT:** "The Gaelic Chieftain," a statue by Maurice Harron inspired by the Battle of the Curlews in 1599. It is 15ft high stands in the Curlew Mountains, County Roscommon, overlooking Lough Key. It was unveiled on April 12, 1999, by Irish Minister of the Environment and Local Government, Noel Dempsey.

**FAR LEFT:** Bird's eye view of the cashel and the early monastic settlement at Inishmurray, County Sligo.

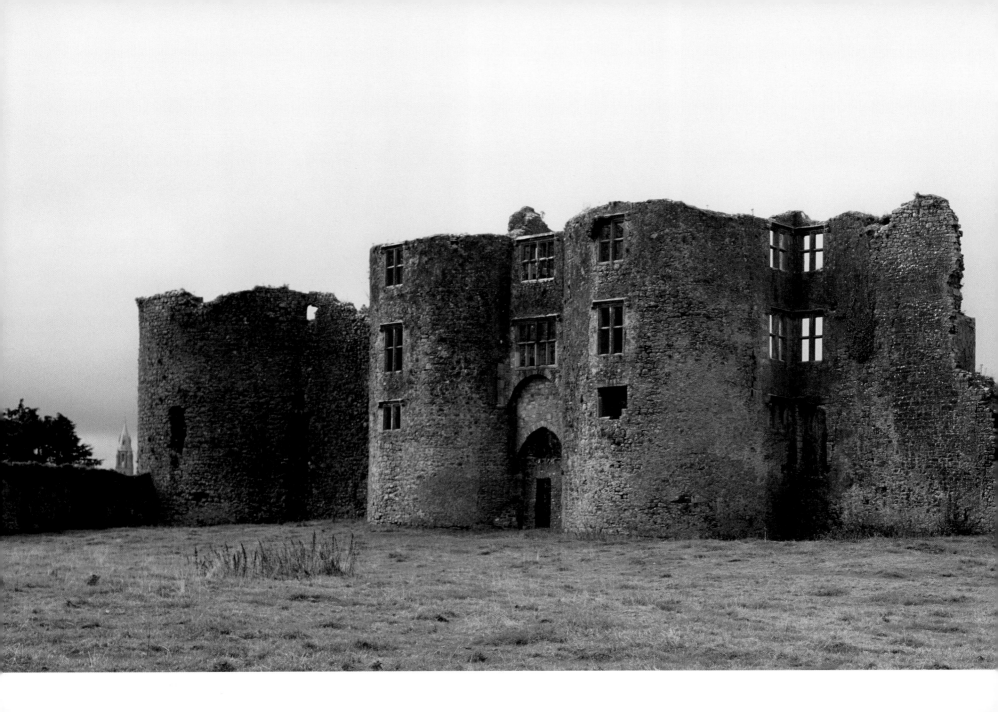

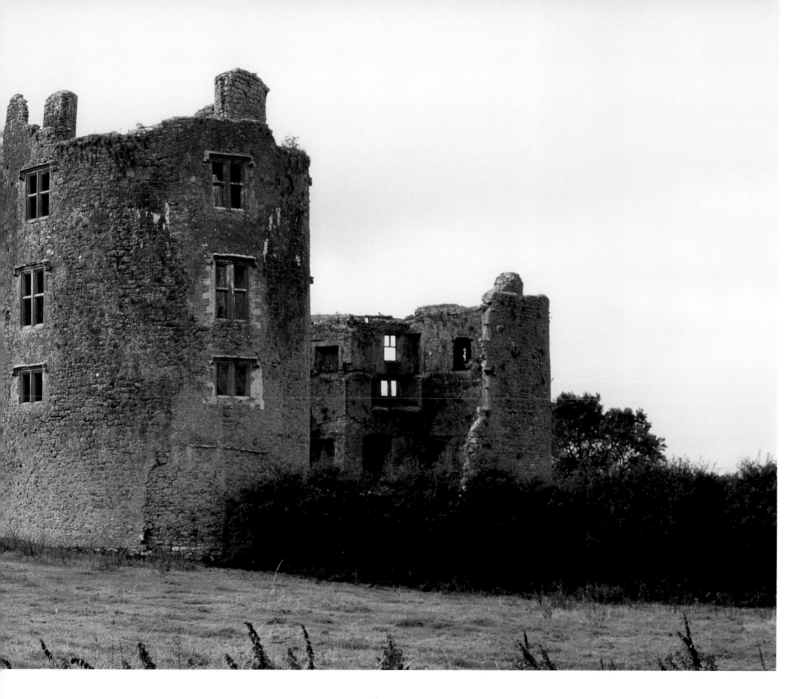

# Munster

**M**unster occupies the far southwest of Ireland and comprises the counties of Clare, Cork, Kerry, Limerick, Tipperary, and Waterford. All except Tipperary have dramatic coastlines lashed by the Atlantic Ocean but also warmed by the Gulf Stream.

The biggest city in Munster is Cork, Ireland's second city, the oldest part of which was built on an island in the middle of the River Lee. Its Irish name Coraigh means marsh, which refers to the flat wetlands on which it lies. The first building of importance in Cork was Saint Finbarr's monastery—now the site of St. Finbarr's Cathedral built in 1879—and a wealthy lure for the Vikings who raided here and burned the town in 821, 846, and 1012, before finally settling and starting a trading center on the banks of the river. The inhabitants of Cork have always loved a rebel and have taken many to their hearts, including the pretender to the English throne Perkin Warbeck in 1491, then later the Catholic Confederation, then James II, the Fenians, and many republicans through the ages.

Munster also contains Blarney Castle, the home of the famous Blarney Stone. The stone is reputed to be half of the Stone of Scone given to Cormac MacCarthy by Robert the Bruce in thanks for his support at the Battle of Bannockburn in 1314. MacCarthy took the stone home and placed it in the castle keep just below the battlements. It later came to be associated with magical properties: those brave enough to hang headlong over the castle wall (trusting to others to hold onto their legs) while they kiss the Blarney Stone are said to acquire the power of eloquence.

There are many wonderful parts of Munster that attract tourists from all over the world. One of the most special places is the wild and sparsely populated Dingle Peninsula on the northernmost tip of County Kerry. The entire peninsula is littered with ancient remains from standing stones, early Christian shrines, and mysterious beehive-shaped huts known as Clocháin which were often used as monks' cells and then later as shepherd's huts.

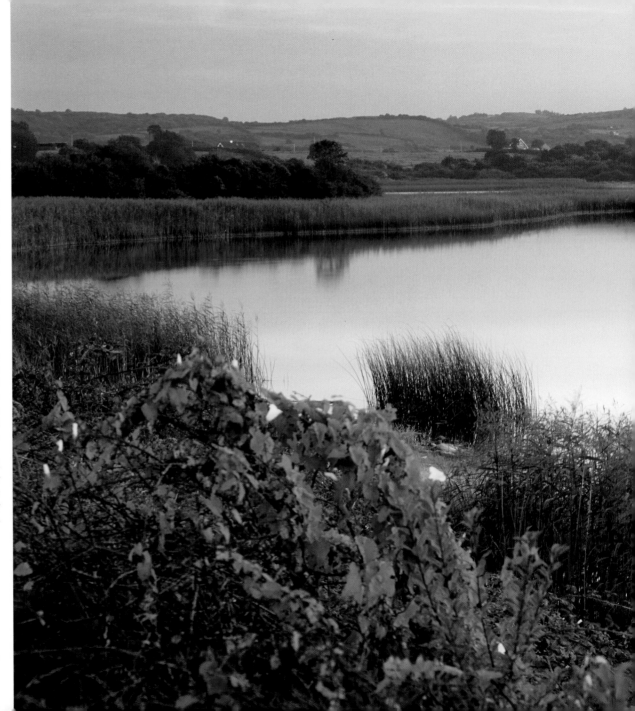

**RIGHT:** The view looking southwest over Ballycullinan Lough from Dysert O'Dea castle, County Clare, towards the site of the battle in 1318 where the Irish beat the Anglo-Normans and killed Richard de Clare.

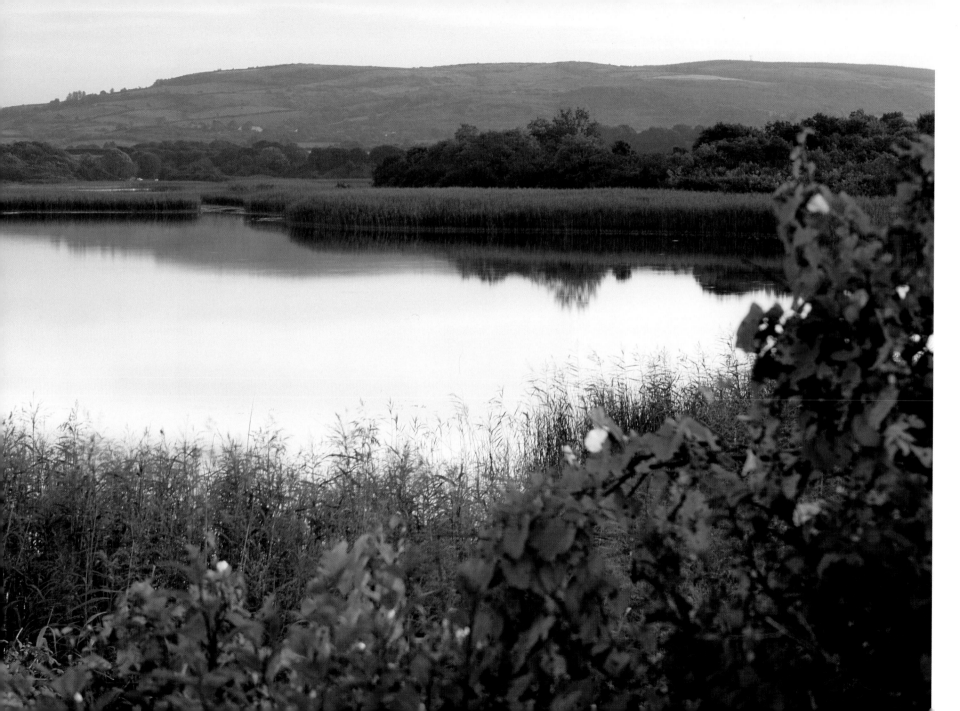

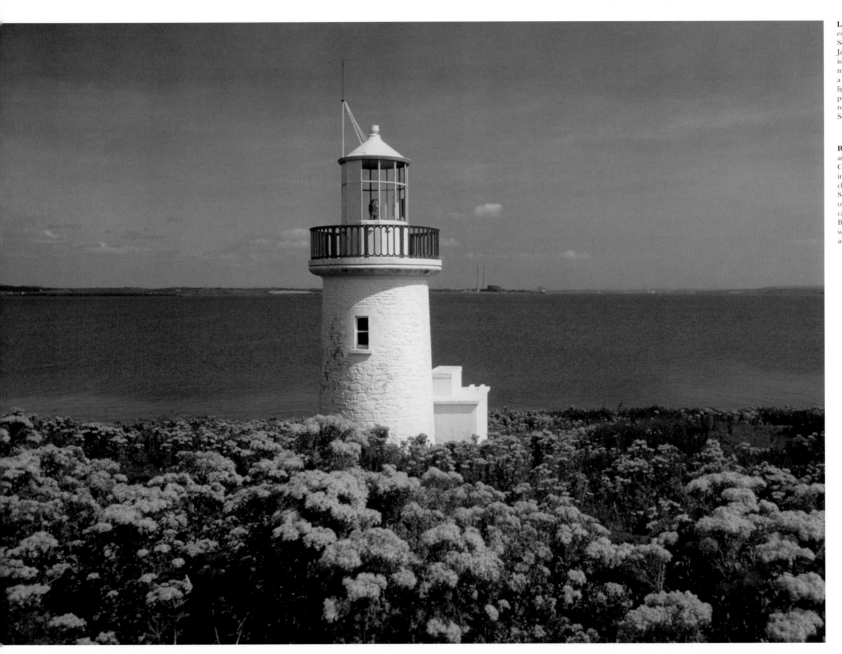

**LEFT:** Scattery Island light and the Shannon estuary. The RNLI identifies the first Scattery Island light as being established on January 12, 1872. It was sited close to the island fort, and placed on rails so it could be moved for firing practice. It was destroyed by a storm in 1868. In more modern times, the light installed in 1933 was converted to propane in February 1982, and then was replaced by a solar-powered version on September 16, 2002.

**RIGHT:** Cathedral church and round tower at St.Senan's monastery, Scattery Island, County Clare. Scattery Island, off Kilrush, in the estuary of the Shannon, has many church and castle ruins. It was the site of St. Senan's monastery founded in the first half of the 6th century AD. Ravaged and captured by Vikings, it was retaken by Brian Boru in around 975. Scattery's churches were destroyed finally in Elizabethan times and a castle was built in 1577.

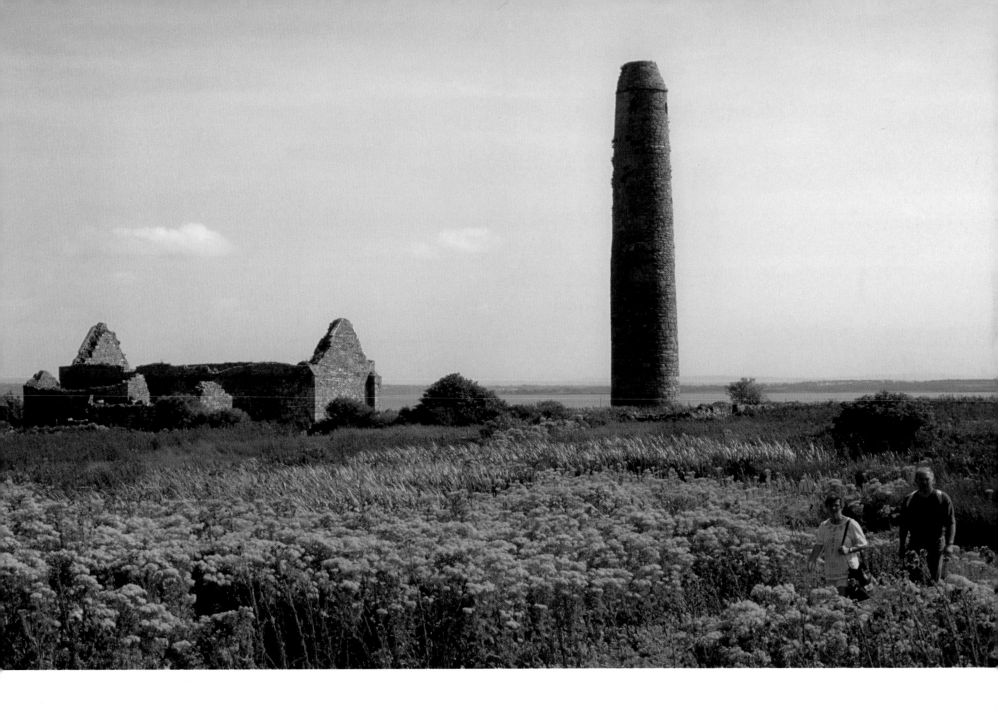

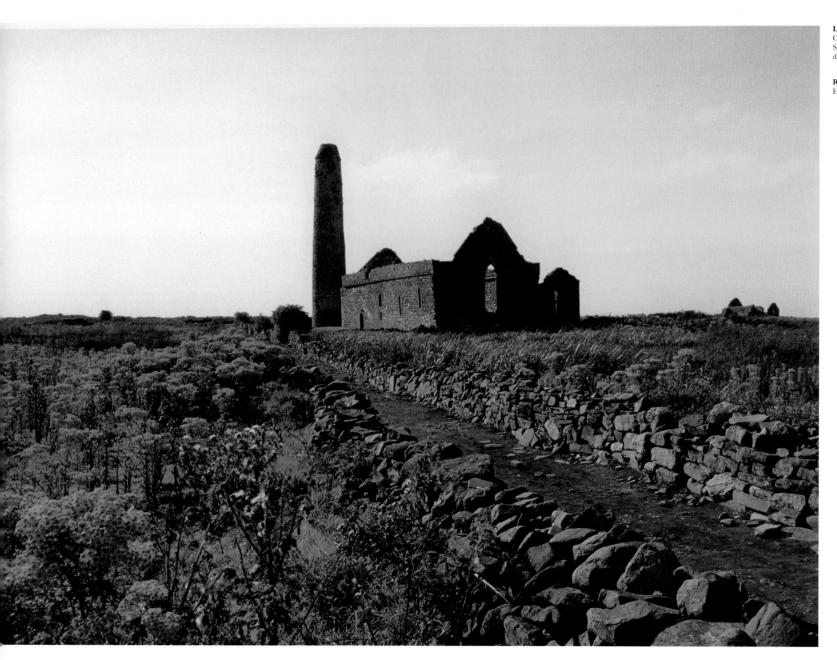

**LEFT:** Another view of St. Senan's Cathedral church and round tower on Scattery Island, County Clare. In the right distance Temple Senan.

**RIGHT:** Musicians in the bar of the Island House, Kilrush, County Clare.

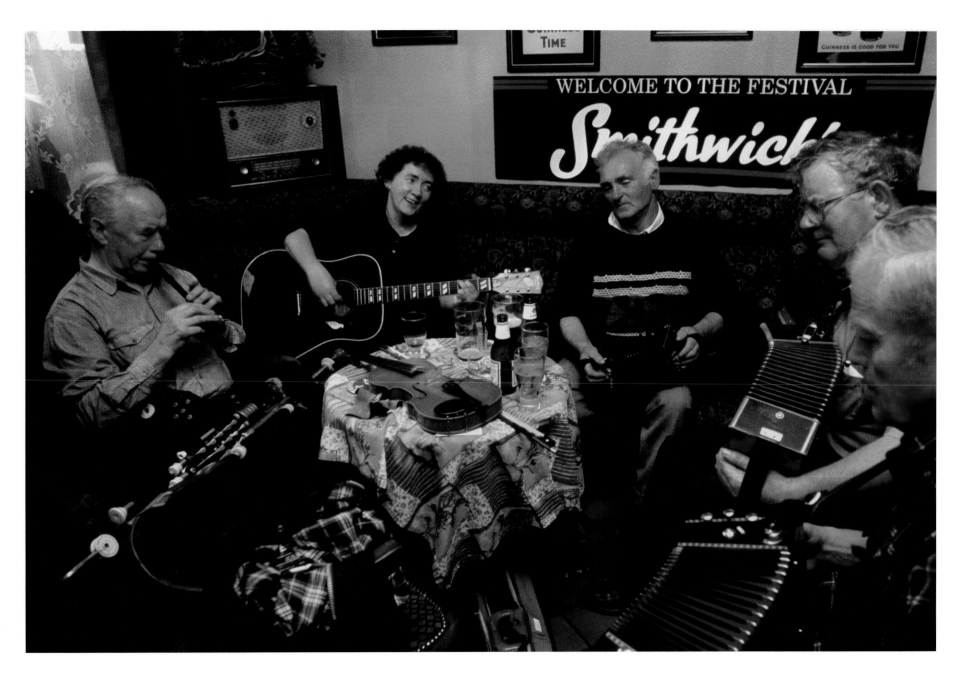

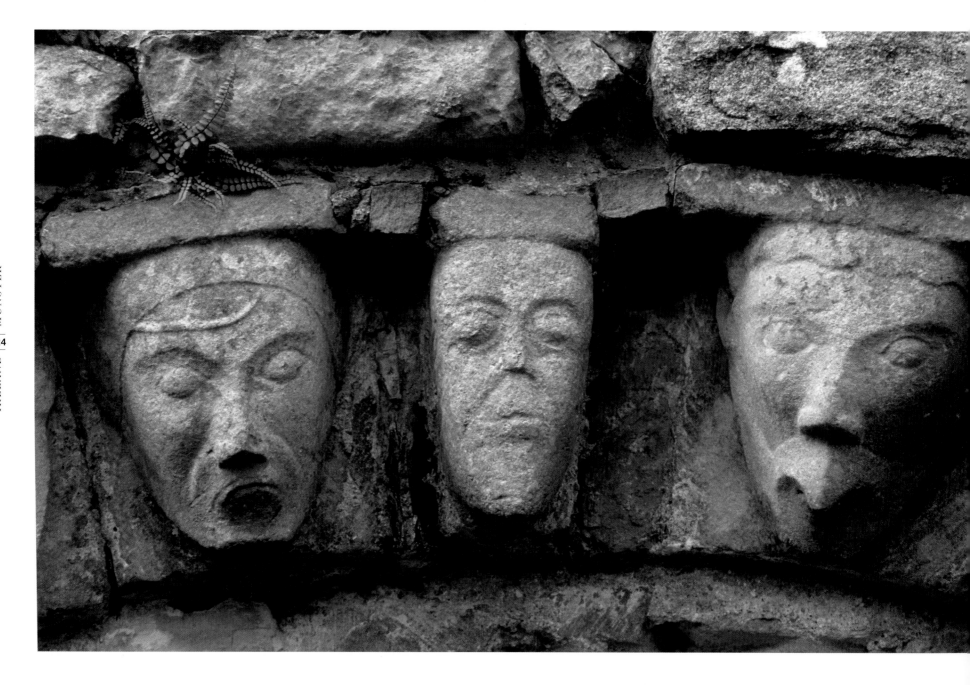

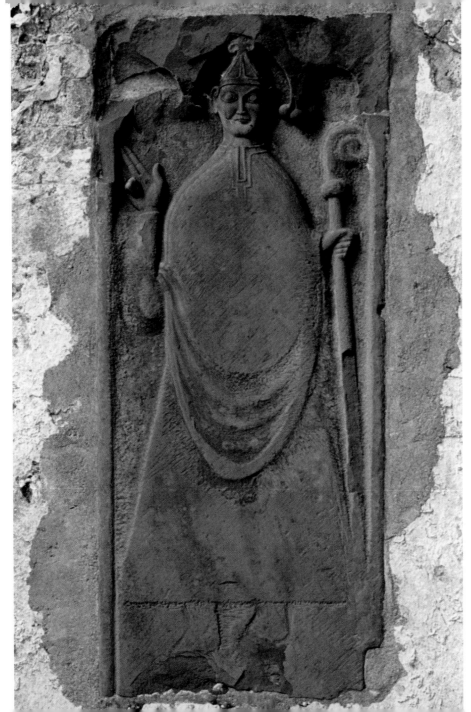

LEFT: Detail in the Romanesque doorway of the church at Dysert O'Dea, County Clare. The church stands on the site of an early Christian monastery founded by St. Tola who died around 735. Originally built in the 12th century, the Romanesque sections were restored in the 17th century.

LEFT: Effigy of a bishop in the choir of Corcomroe Abbey, County Clare. A Cistercian Abbey founded in 1195 by Donat Mor O'Brian with monks from Inishlounaght, County Tipperary—although tradition has it that it was Donat's father Donal who founded the abbey ten years earlier. It lasted well into the 17th century.

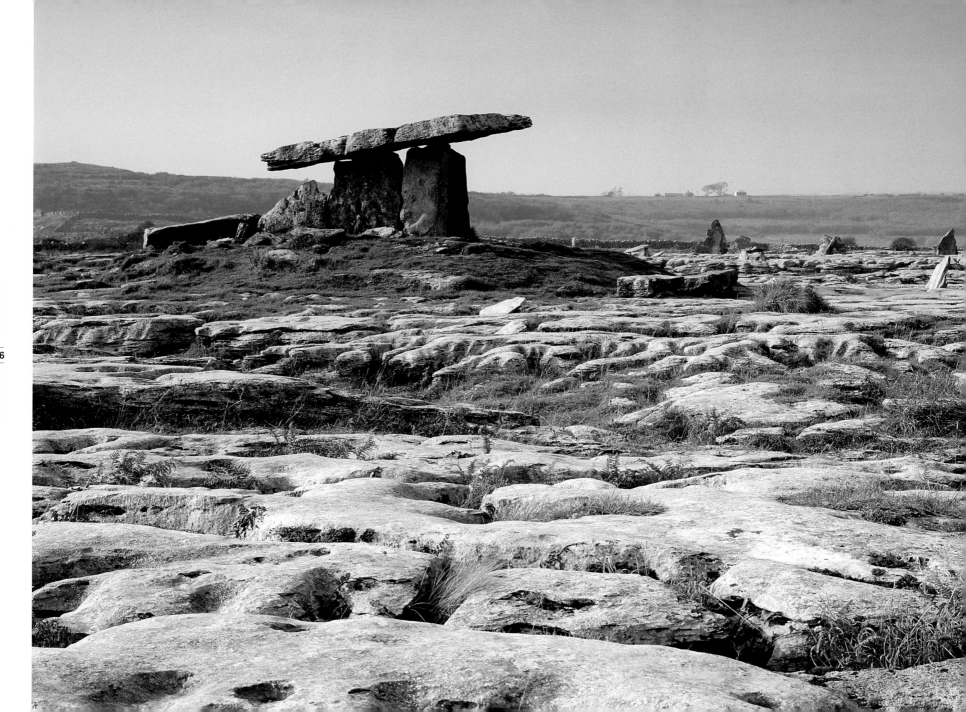

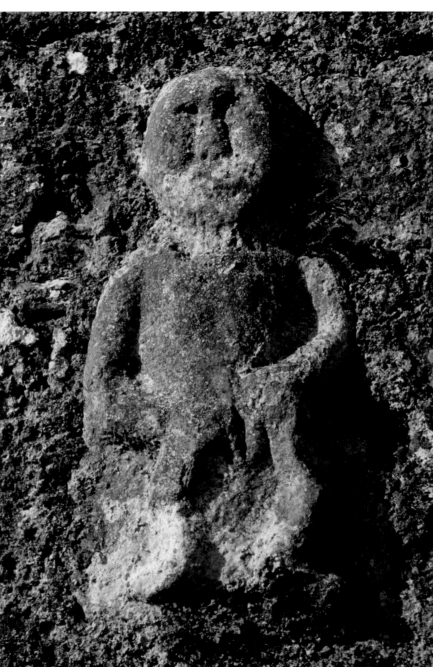

**LEFT:** Poulnabrone prehistoric dolmen is situated in the middle of the limestone pavement of the Burren, County Clare. The word "Burren" derives from the Gaelic boireann—rocky land. And so it is: the area is noted for its exposed limestone pavement and the fantastic ecosystems and plants that live in the "grykes"—the crevices gouged out by water.

**FAR LEFT:** Killinaboy in County Clare is the site of a 16th century church and round tower. Over the doorway of the church is this Sheela-na-gig—a grotesque or lewd small sculpture.

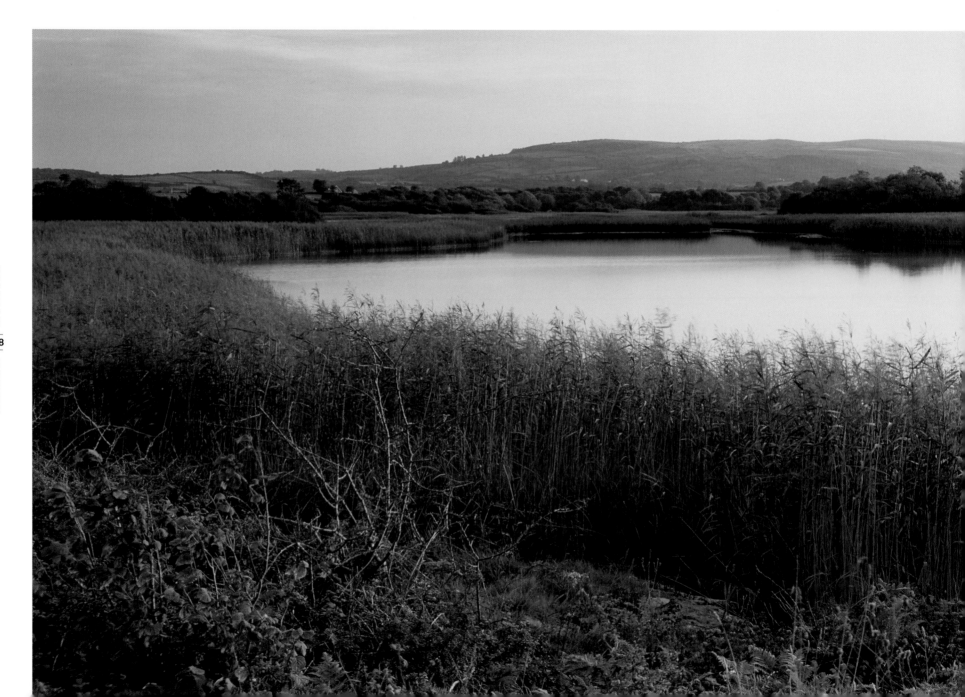

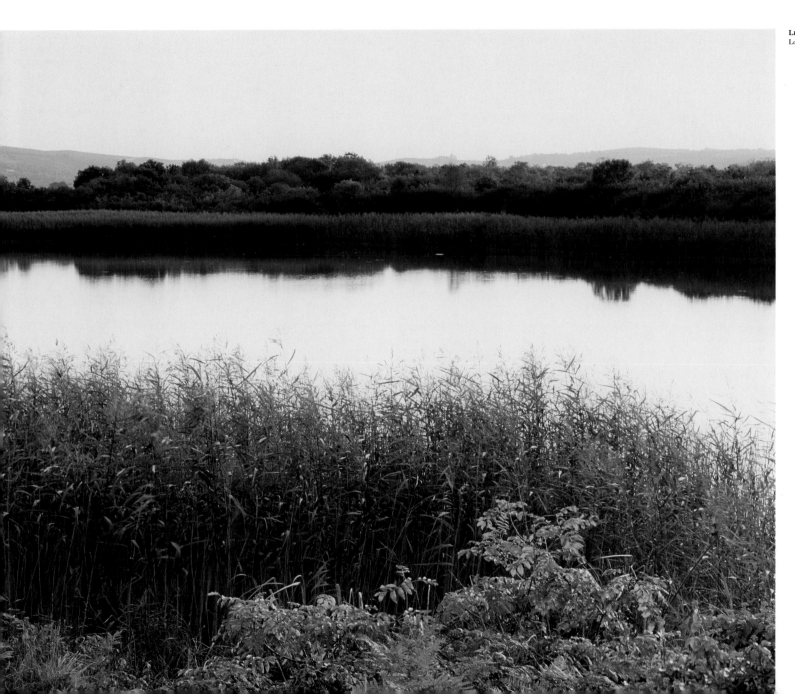

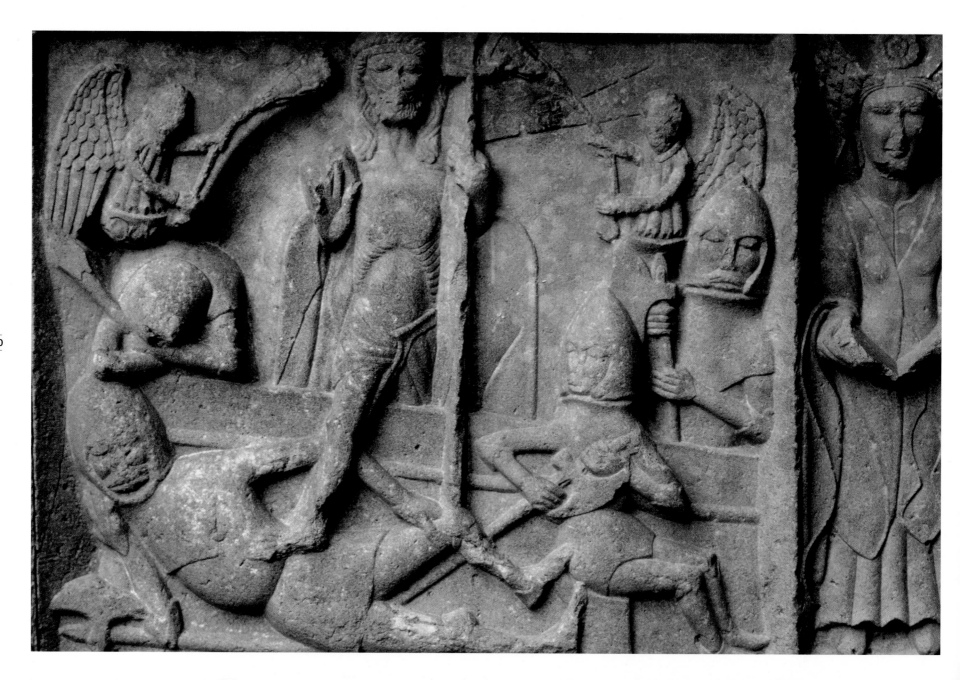

**LEFT:** The Franciscan friary at Ennis, County Clare, was founded by Donchad Cairbreach O'Brien, King of Thomand, in around 1240. By 1375 there were as many as 350 friars and a school with 600 pupils. This panel from the MacMahon tomb (built around 1475) shows the arrest of Christ: Malchus lies prostrate at his feet with St. Peter holding Malchus's severed ear.

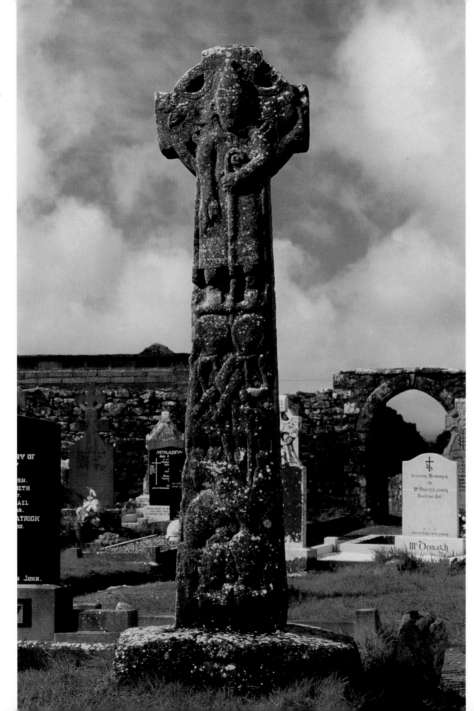

**LEFT:** East face of the Doorty Cross, Kilfenora, County Clare which has images of three bishops with different croziers and a double-headed bird which appears to be devouring sculls.

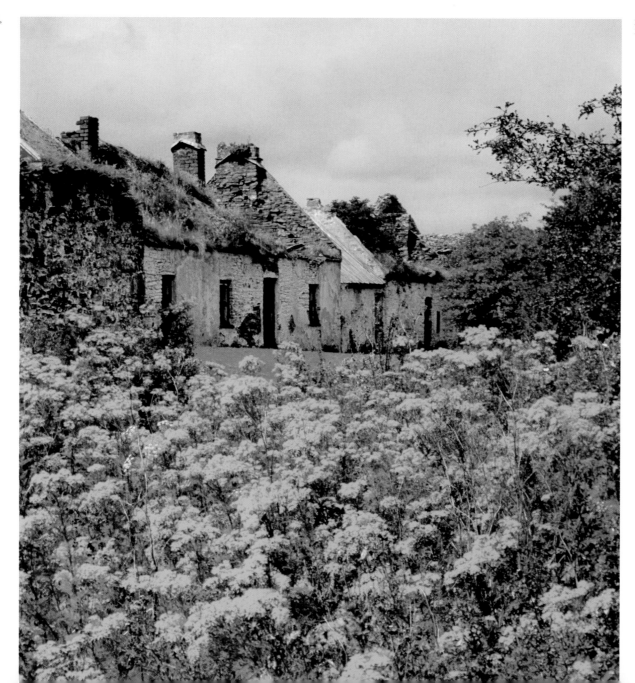

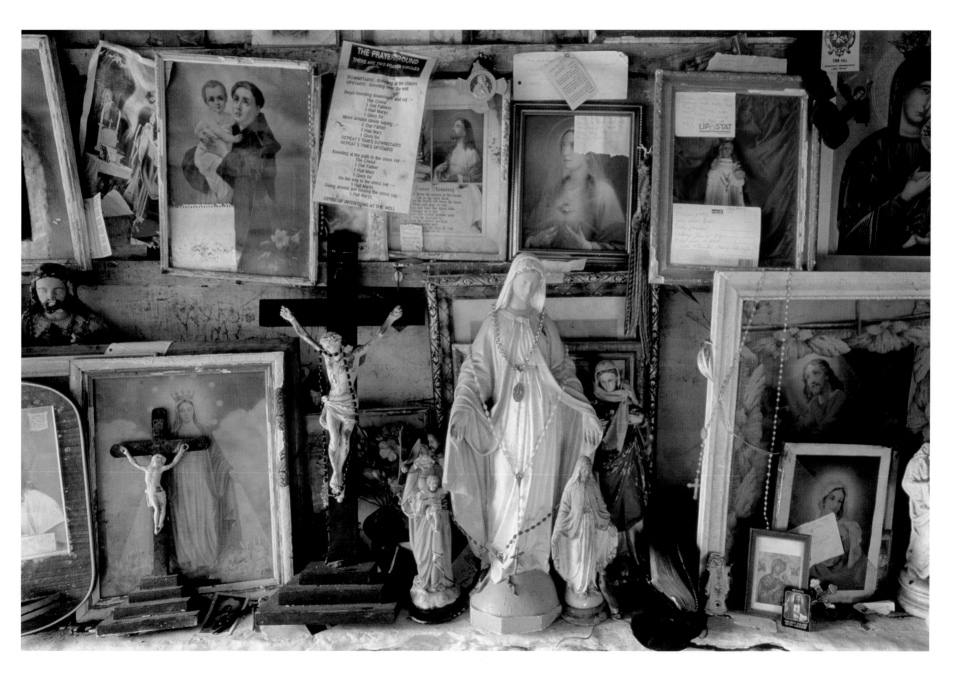

**RIGHT:** Born near Tralee, Co. Kerry, St. Brendan the Navigator established a number of monasteries in Ireland—the most famous being Clonfert in County Galway. Brendan's reputation as a traveler rests on the Navigatio Sancti Brendani, an account written by an Irish monk in the 9th or 10th century in which Brendan and his followers sailed a coracle of wood and leather to America, thus preceding Christopher Columbus by several centuries. More recently a statue of St. Brendan and his boat—as seen here—was erected in Wolfe Tone Square, Bantry and to mark the millennium the Church of Ireland.

**FAR RIGHT:** Traditional musicians at Bantry, County Cork.

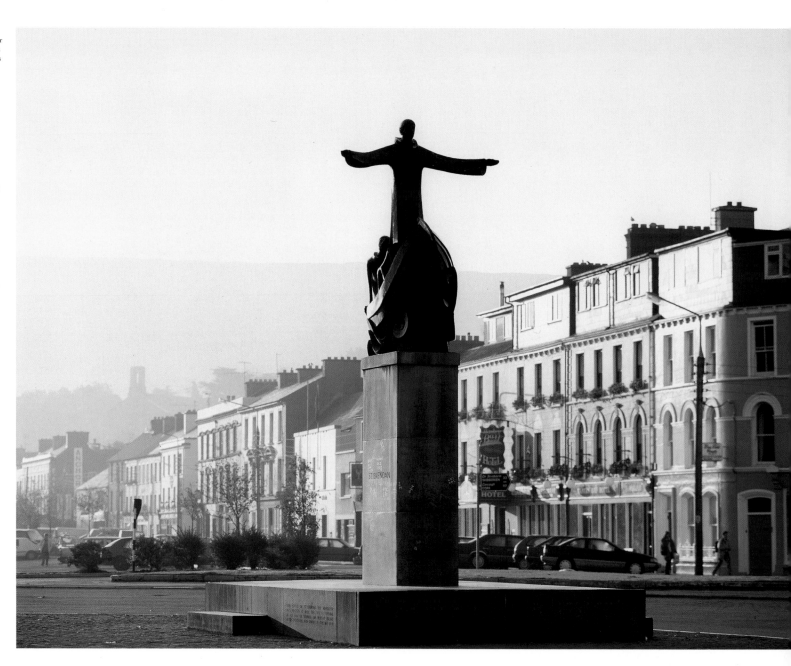

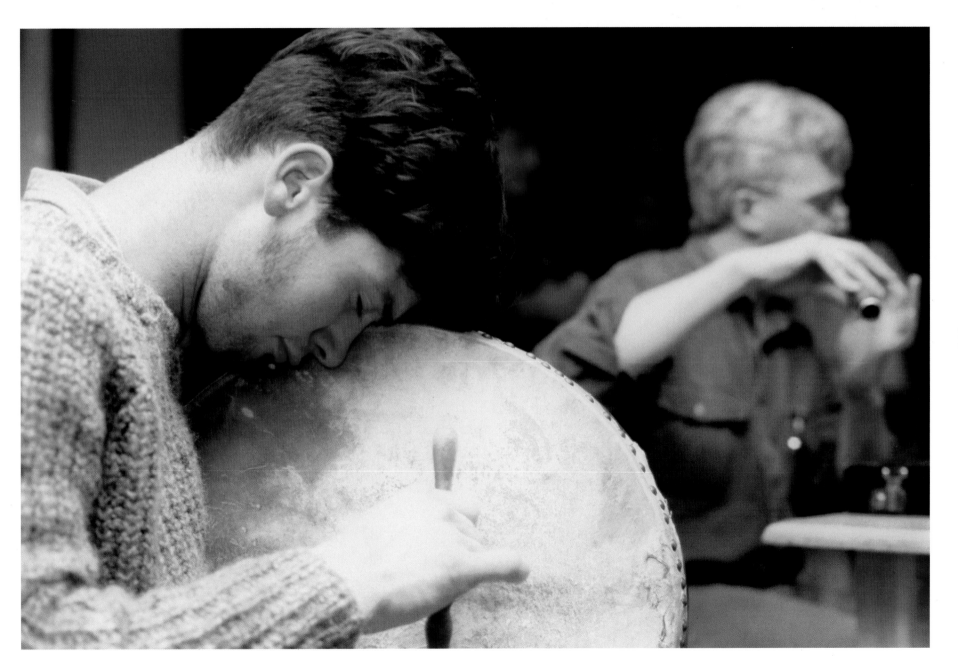

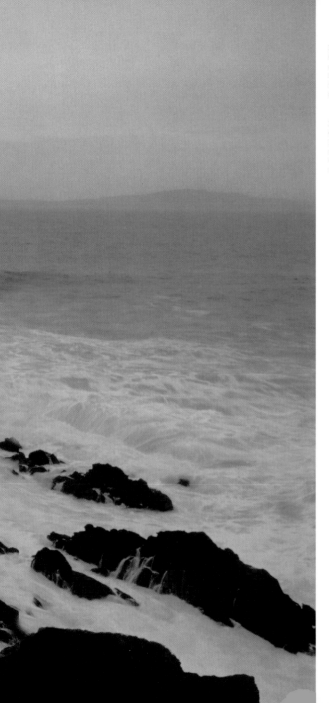

**LEFT:** Southwest of Sherkin is the larger Cape Clear Island on whose northwest coast are the ruins of Dunamore Castle—a stronghold of the once powerful rulers of the island. To the southwest is Ireland's most southerly point, the Fastnet Rock.

**RIGHT:** Looking west beyond the cliffs of Cape Clear Island to the Fastnet Lighthouse. Local folklore relates how a giant picked up the rock that is now the Fastnet from Mount Gabriel near Ballydehob and hurled it into the sea.

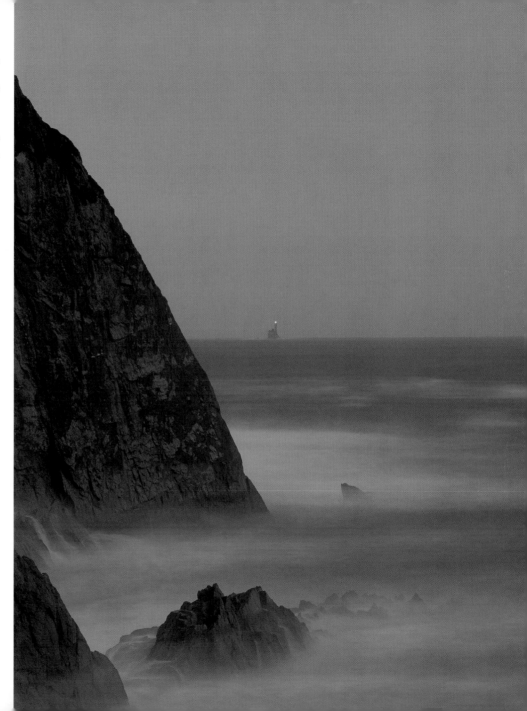

**RIGHT:** Looking across the northern shore of Cape Clear Island at Cnocán nam Bairneach.

**FAR RIGHT:** Fastnet Lighthouse, County Cork. The first lighthouse—made of cast iron—was built there in 1854 but had been damaged by the ocean by 1865. In 1896 granite blocks were shipped in from Cornwall to build a new one—but it took ten years to build. However it got there, the Fastnet is invaluable as a mark for large ships following Atlantic routes, and it is also useful to locals who judge what the weather is about to do by checking on the rock's visibility.

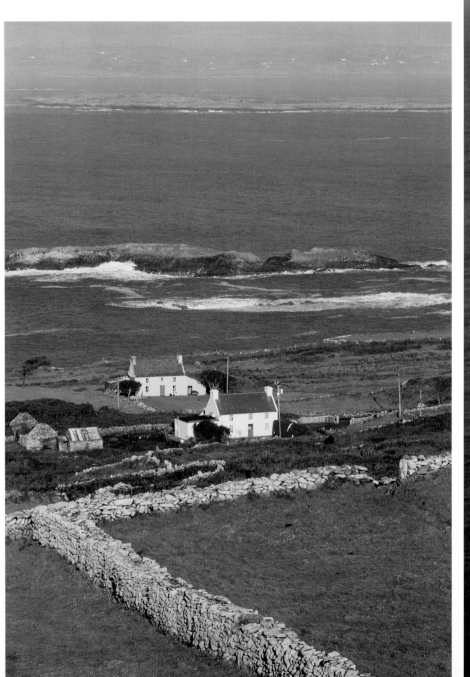

**OVERLEAF:** Sherkin Island in County Cork looking north over Kinish Harbour.

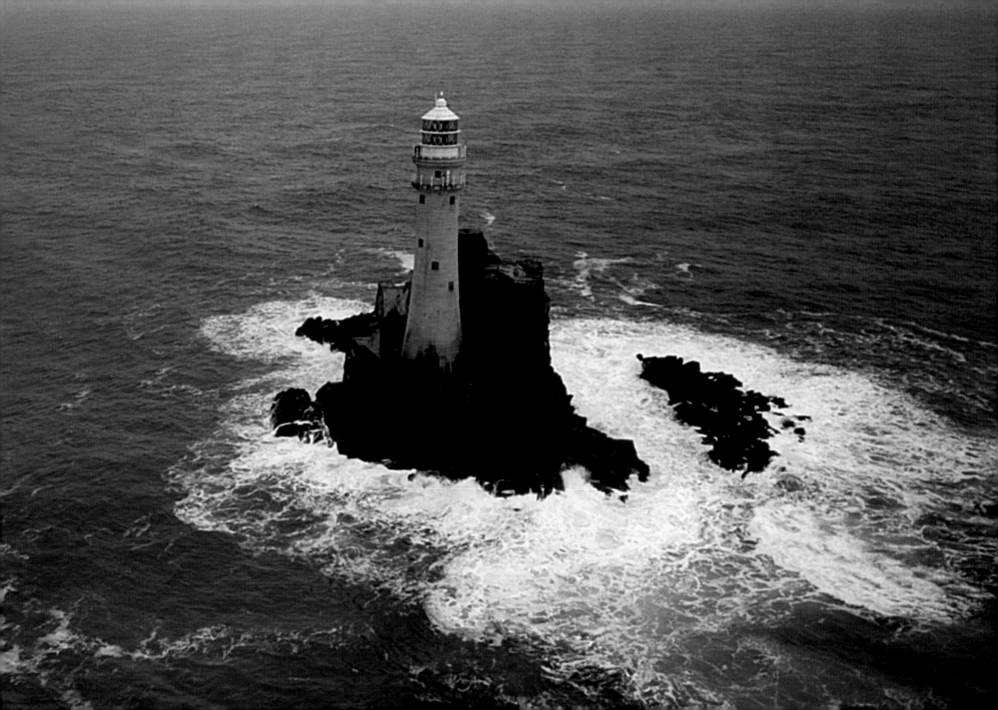

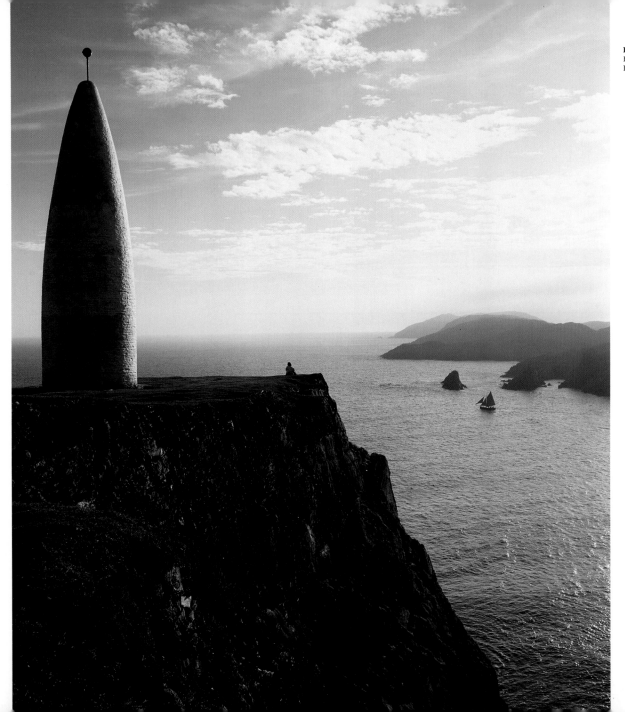

**LEFT:** Looking across the south entrance of Baltimore Harbour, County Cork, from the Beacon to Sherkin Island.

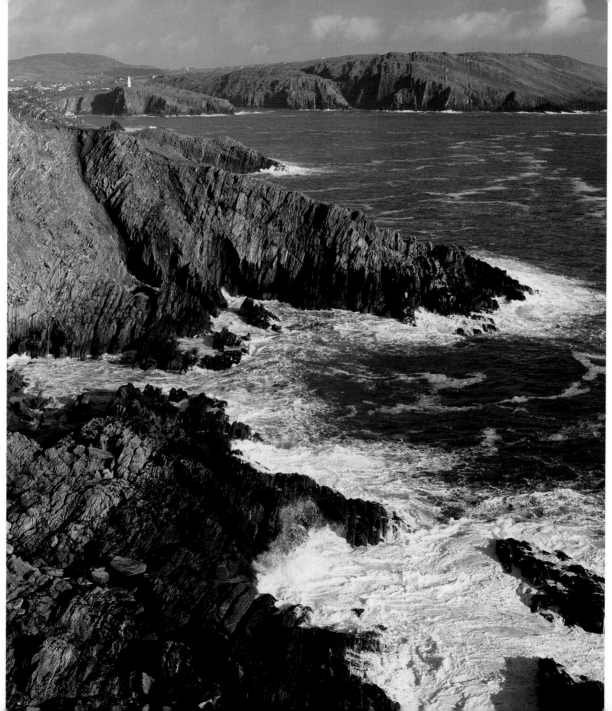

**RIGHT:** View from Sherkin Island, looking northeast over Ordree Point toward Baltimore and the Beacon.

**OVERLEAF:**
**LEFT:** Landscape near Mizen Head, County Cork.

**RIGHT:** Kinsale, County Cork: the entrance to the inner harbor is guarded by the 1549 blockhouse (left). Kinsale was an important English naval base and it was here that a combined Spanish and Irish force under de Aguila, O'Neill, and O'Donnell was routed in 1601 by the English under Mountjoy.

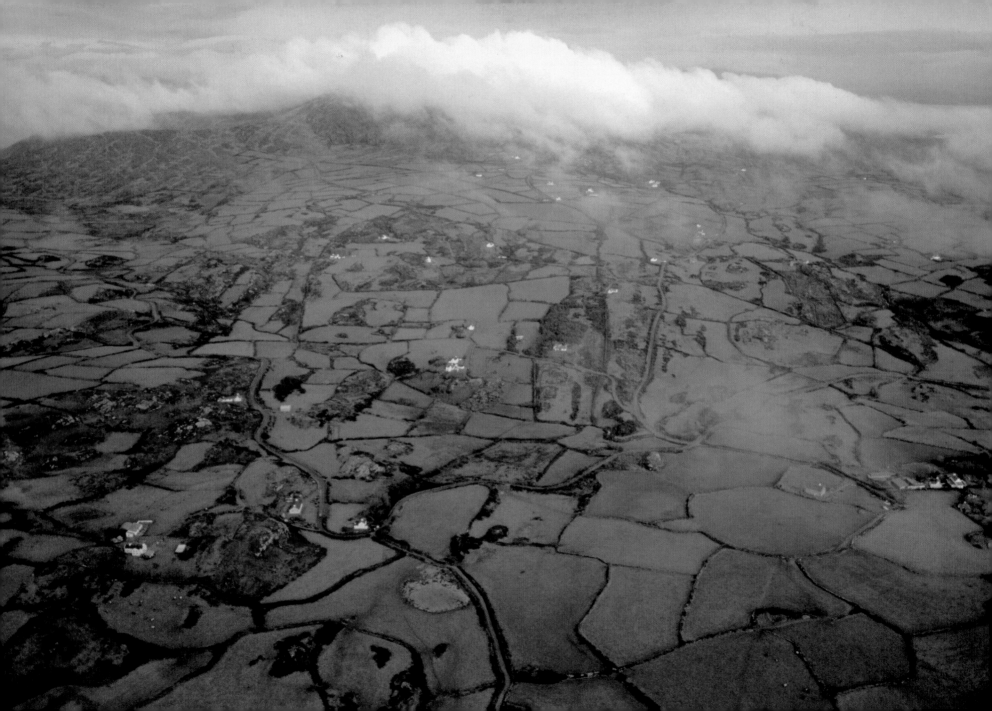

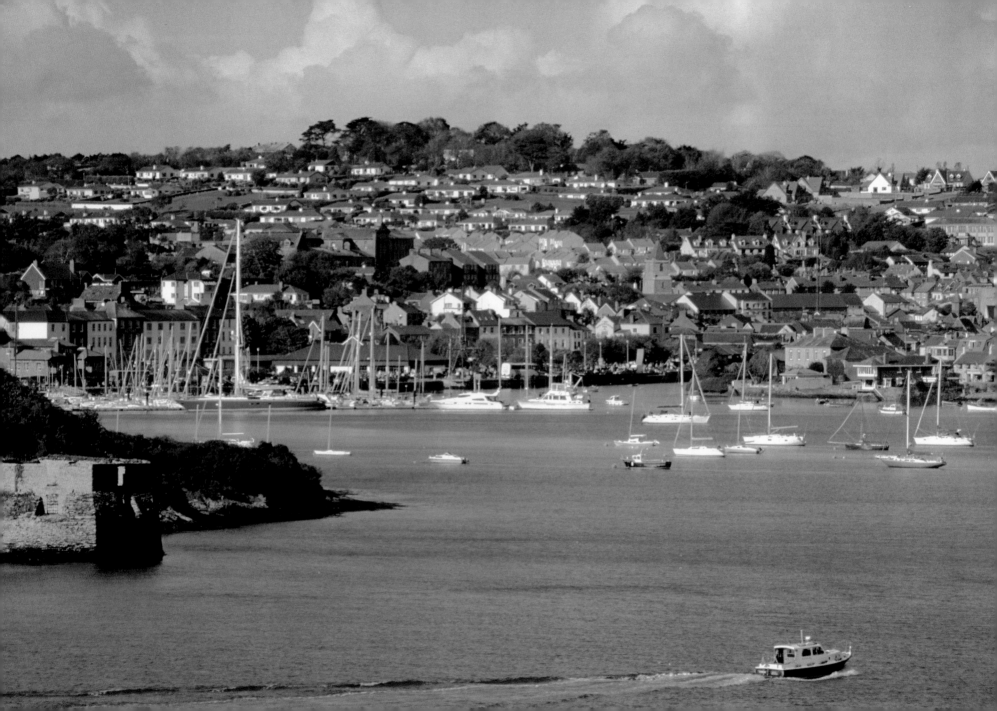

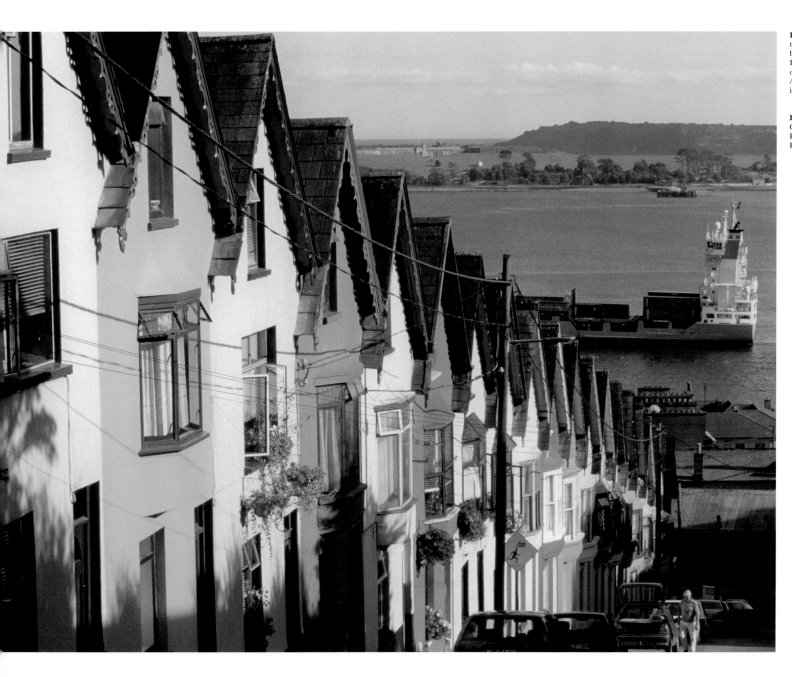

**LEFT:** Kinsale, County Cork: the entrance to the inner harbor is guarded by the 1549 blockhouse (left). Kinsale was an important English naval base and it was here that a combined Spanish and Irish force under de Aguila, O'Neill, and O'Donnell was routed in 1601 by the English under Mountjoy.

**FAR LEFT:** Sherkin Island National School, County Cork. From left to right: William, Rowan, Michael, teacher Câit O'Reilly, Kian.

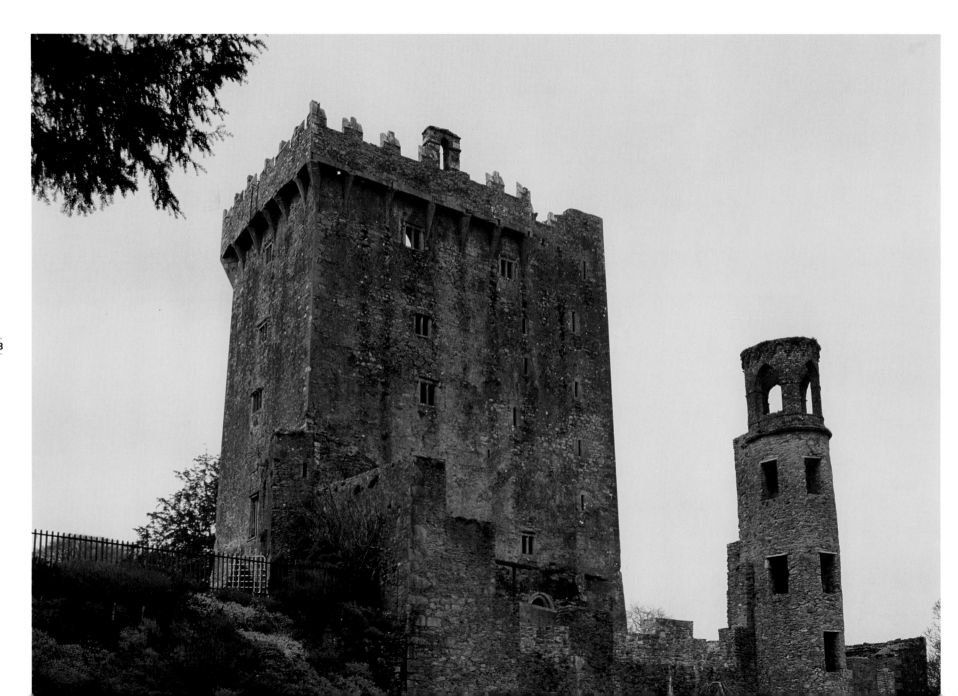

**LEFT:** Blarney Castle, County Cork. Who hasn't heard of the castle and its famous Blarney stone that has the power to give all that kiss it the gift of the gab? With its origins in 1446, the tower in whose machiolations the stone rests is one of the biggest in Ireland.

**RIGHT:** Prehistoric stone alignment—known as the marriage stones—at the northeast end of Cape Clear Island, County Cork.

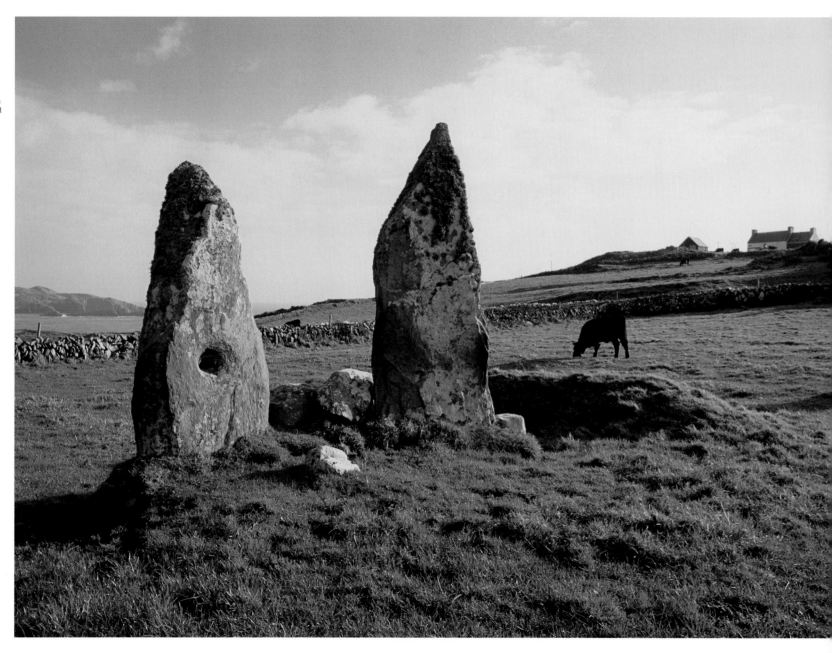

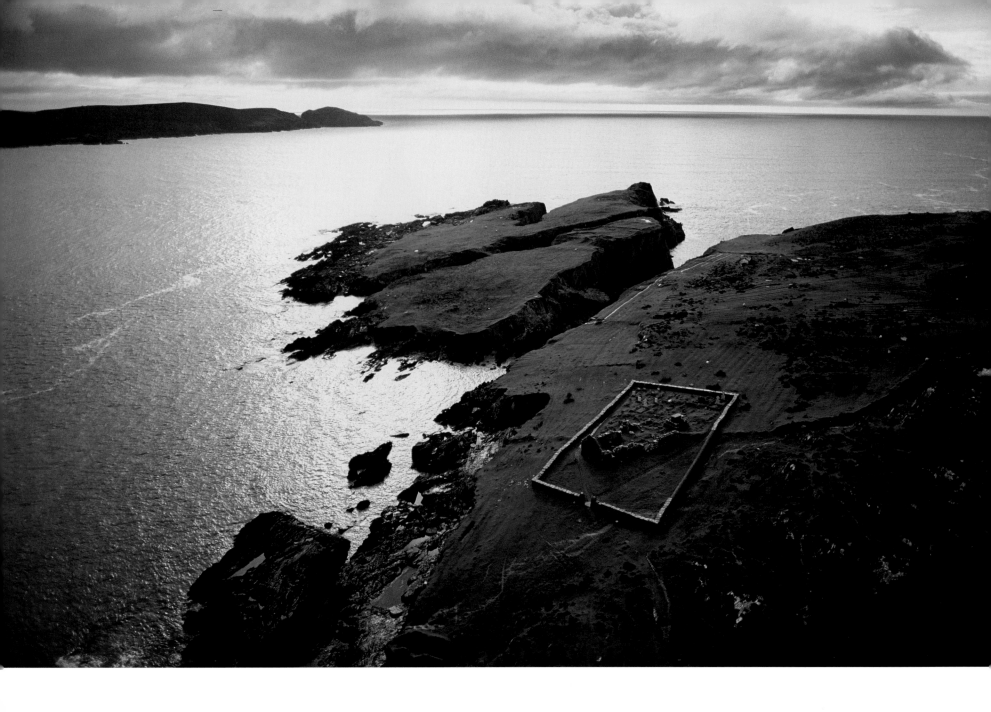

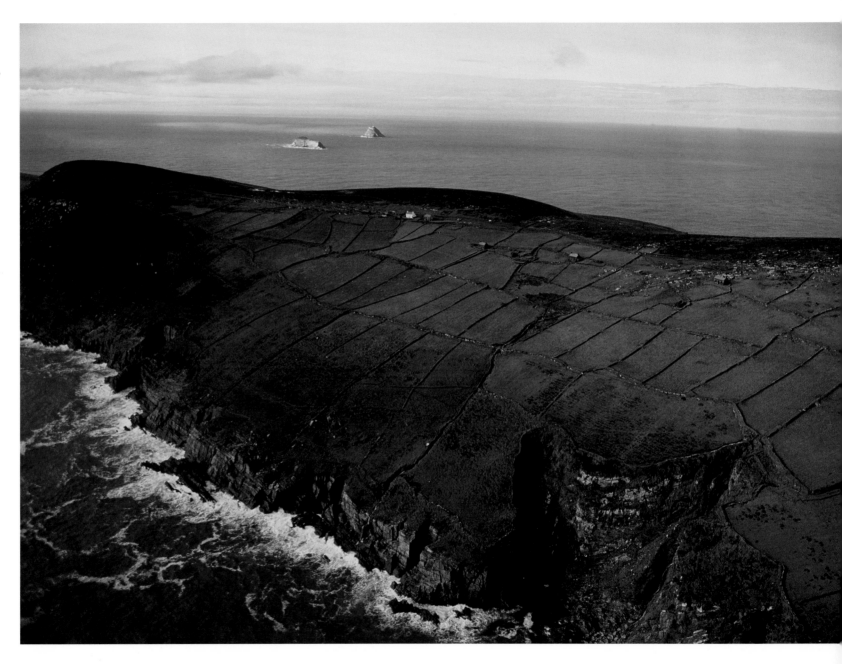

**LEFT AND RIGHT:** Two views of Dursey Island, County Cork. With its monastery ruin, crop ridges, deserted villages, and Oiléan Beag promontory fort, it is one of the quietist places in the county. Dursey today has few inhabitants, no pubs, and no shops. It does, however, boast a cable-car service connecting the island to the mainland and unrivaled birdspotting.

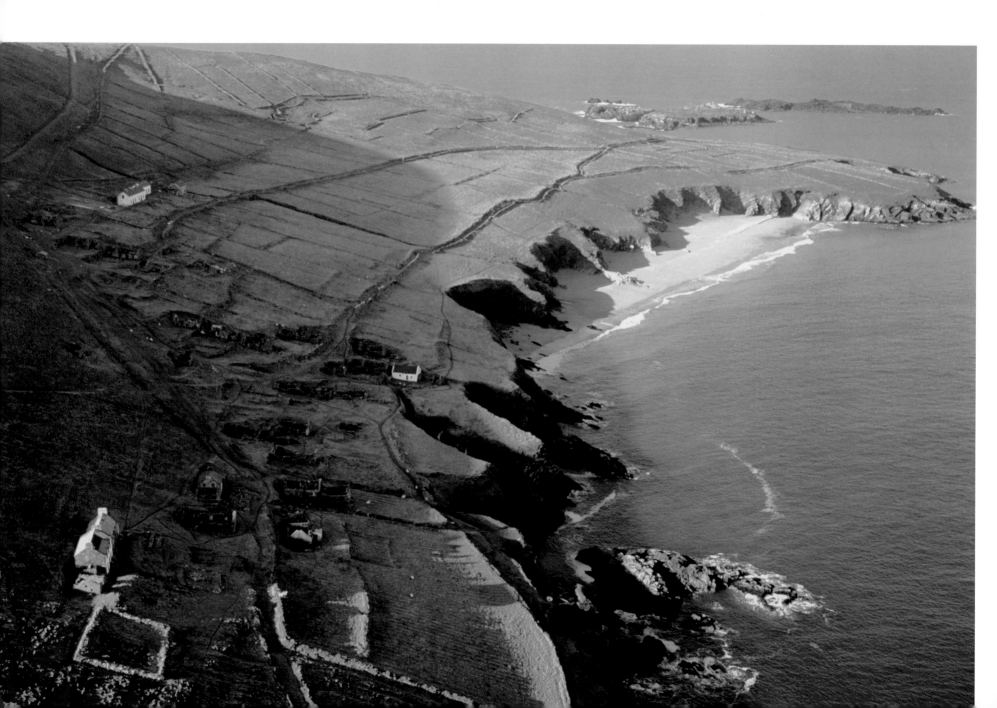

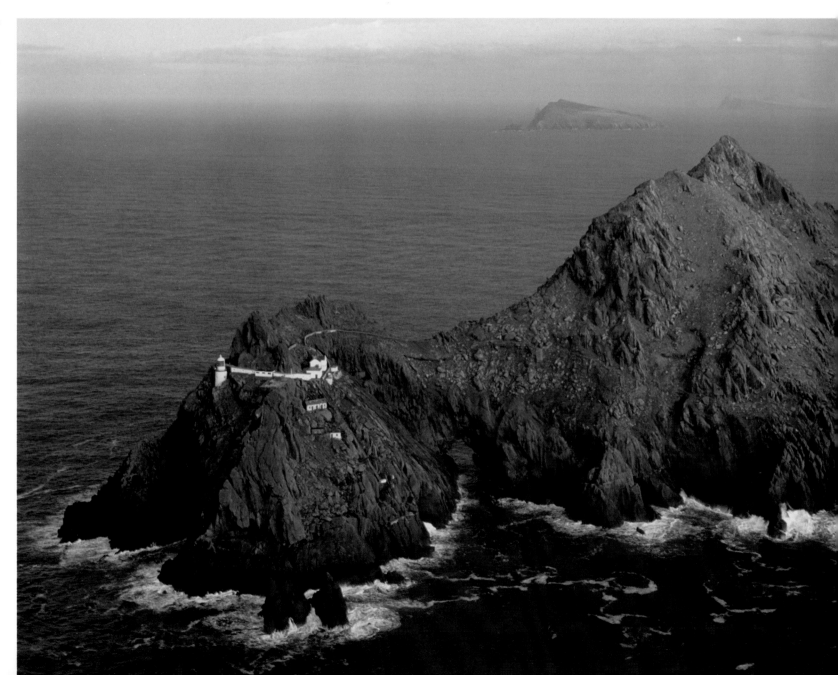

**LEFT AND RIGHT:** Two views of the Blasket Islands, off the Dingle peninsula, County Kerry. The first is an aerial view (**LEFT**) of the ruins of a village on Great Blasket (the island is uninhabited today) with An Tráigh Bhán beach at top. The second (**RIGHT**) shows Inish Tearaght—the most westerly island.

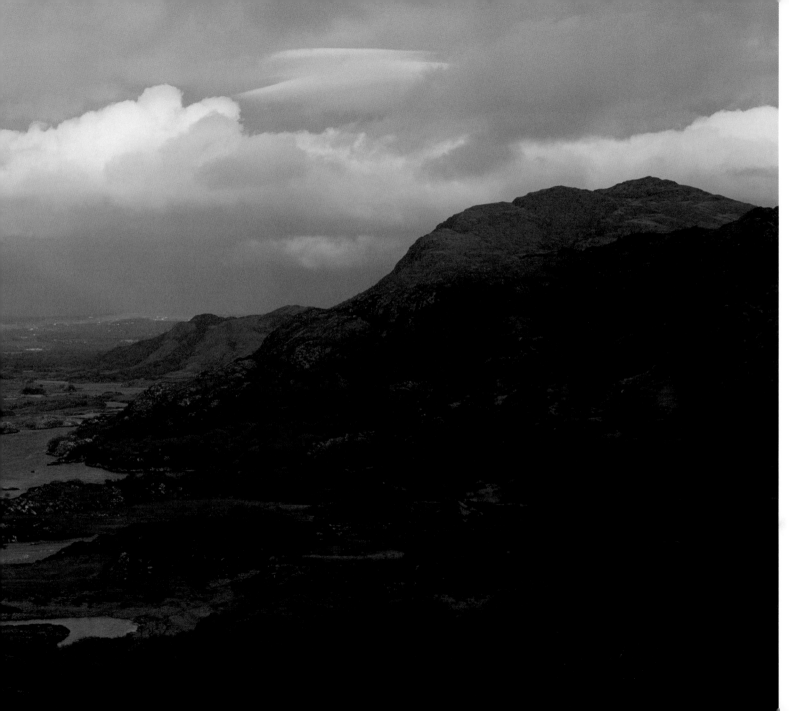

**LEFT:** Killarney has three lakes—Upper, Muckross, and Lough Leane. This photograph shows the view northeast over Upper Lake, Killarney from Ladies' View, as seen in fall. It is called Ladies' View because of an 1861 association with Queen Victoria's ladies-in-waiting.

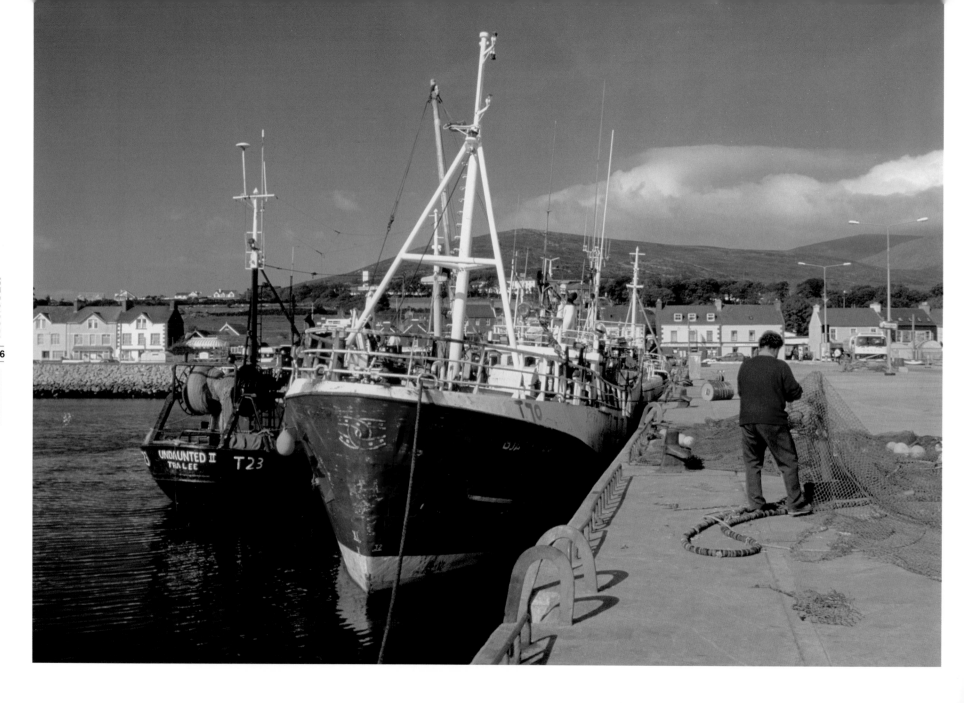

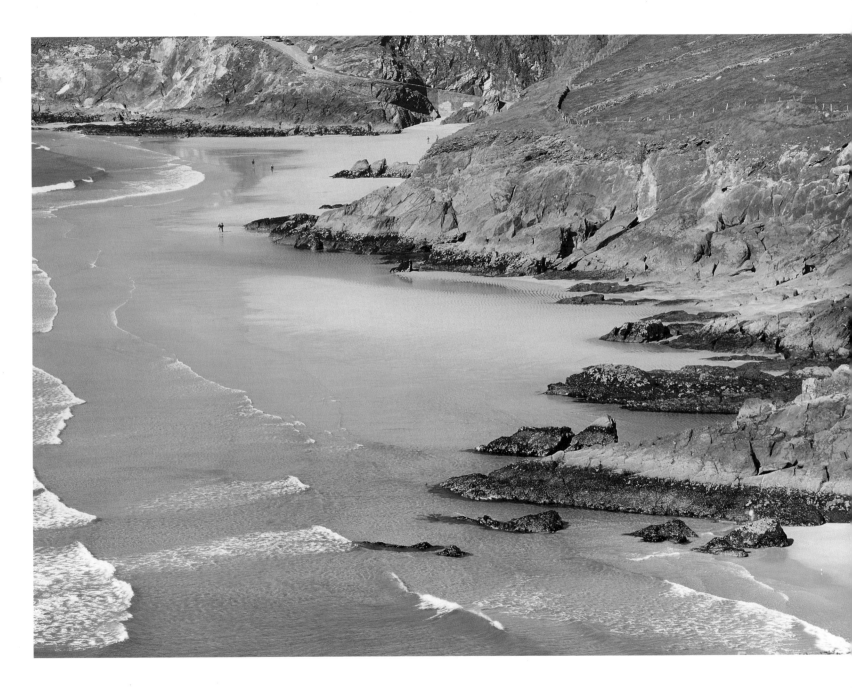

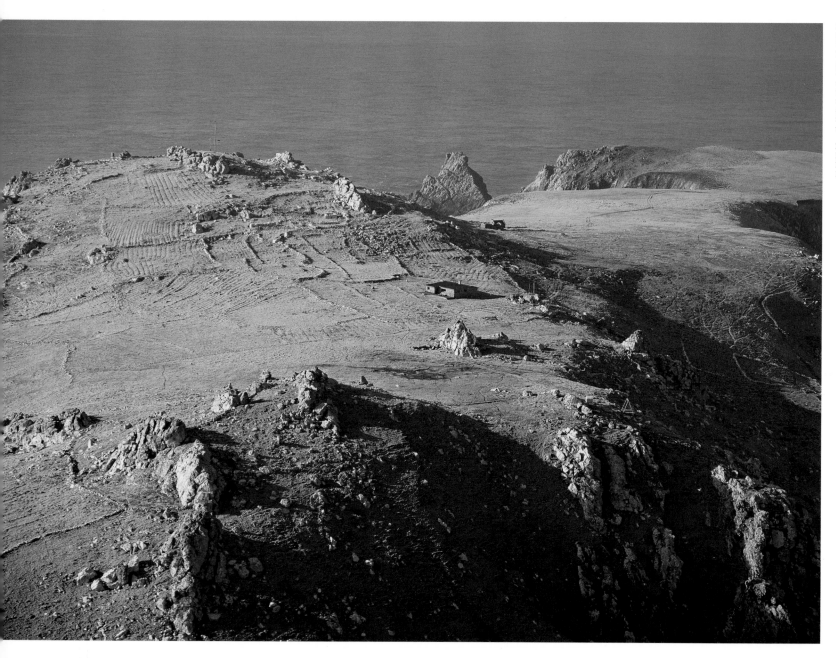

**LEFT:** The house of Charles Haughey on the summit of Inishvickillane, Blasket Islands, County Kerry. Charles James Haughey (born September 16, 1925) was the sixth Taoiseach (prime minister) of the Republic of Ireland. He served three periods as Taoiseach: 1979 to 1981, 1982, and 1987 to his retirement in 1992. He is credited with reforming the economy in the late 1980s and early 1990s, however, allegations about financial dealings and corruption have weakened his popularity in recent years.

**RIGHT:** Killarney National Park, County Kerry—looking across Long Range between Muckross Lake and Upper Lake toward the Eagle's Nest.

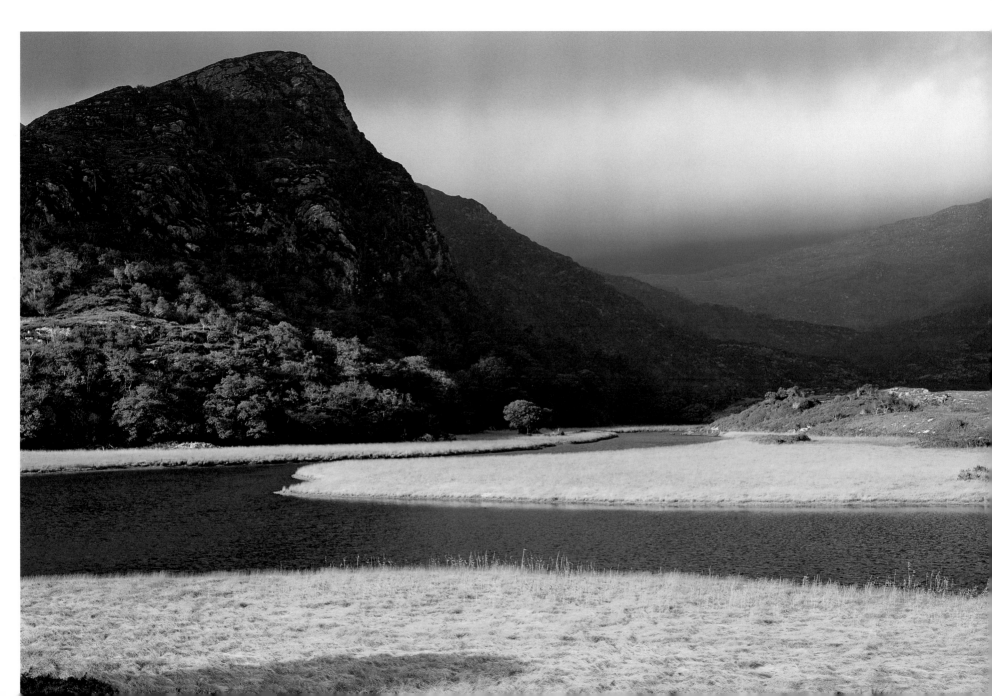

**RIGHT:** The Gallarus Oratory, County Kerry, is an early Christian church in the shape of an upturned boat. Built between the 6th and 9th centuries, it is a remarkable feat of dry-stone walling.

**FAR RIGHT:** Waiting for passengers, Ross Castle, Killarney, County Kerry. Built on the edge of Lough Leane, Ross Castle was the last Irish stronghold taken by Cromwell's forces in 1653. It was built in 1420.

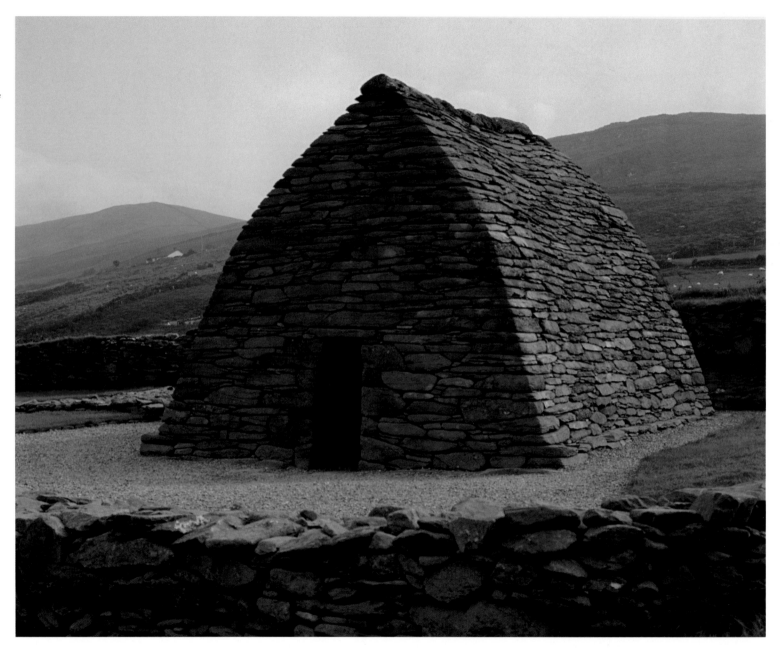

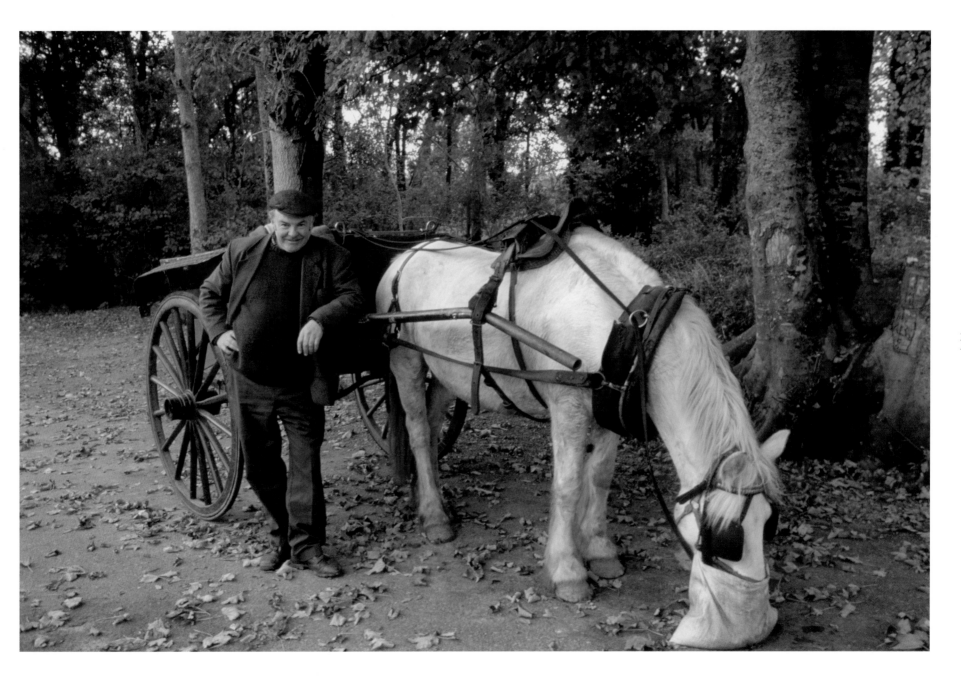

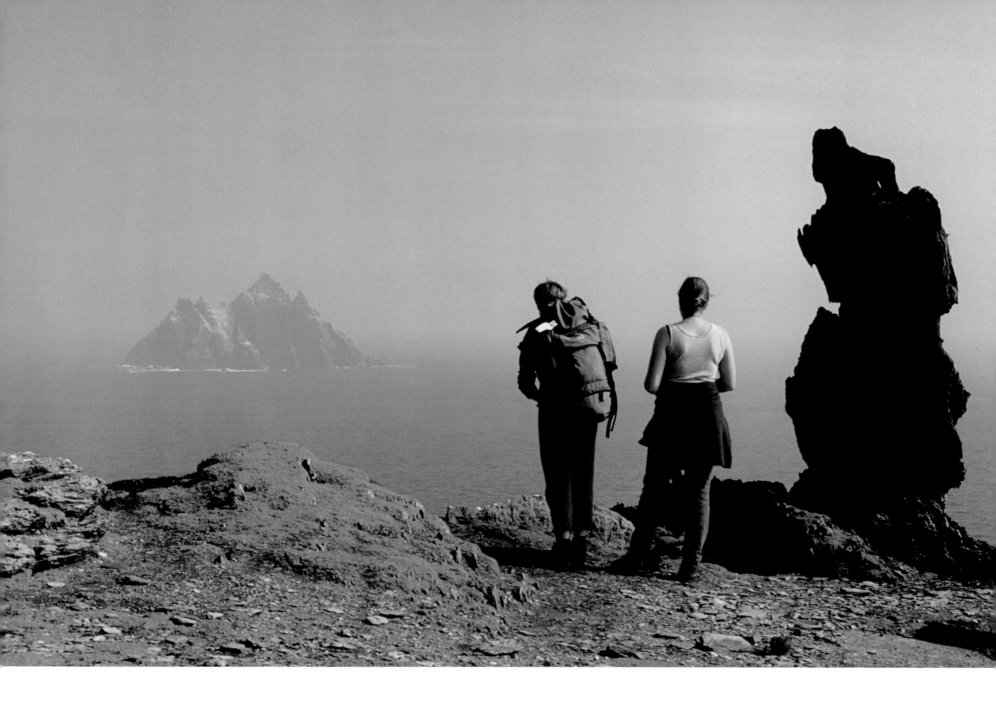

**LEFT:** Little Skellig seen from Skellig Michael, County Kerry. The Skelligs are a group of rocky islets off Bolus Head, County Kerry. The cliffs that rise to 715ft on Skellig Michael swoop down into the ocean where basking sharks and turtles can be found. The Skelligs were home to lighthousekeepers and monks: today humans have gone and only the seabirds remain—in their thousands. The Skelligs are the home of some 27,000 pairs of gannets—the second largest colony of such seabirds in the world.

**RIGHT:** Skellig Michael showing the two lighthouses and monastery site on right-hand pinnacle. Originally, two lighthouses were established in 1826; the upper was discontinued as early as 1870. The other, on Skellig Michael's southwestern extremity, was completely rebuilt, modernized, and reestablished in May 1967 and subsequently made automatic in 1987.

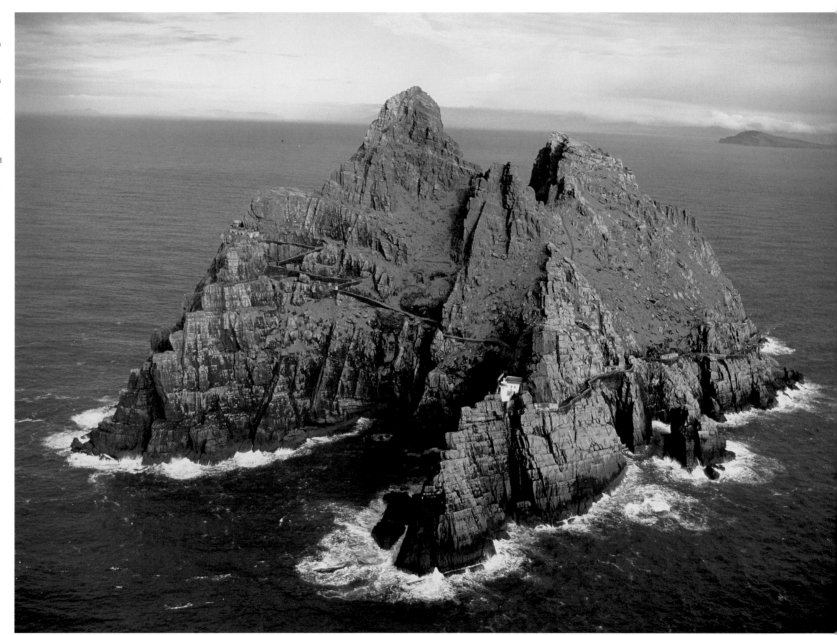

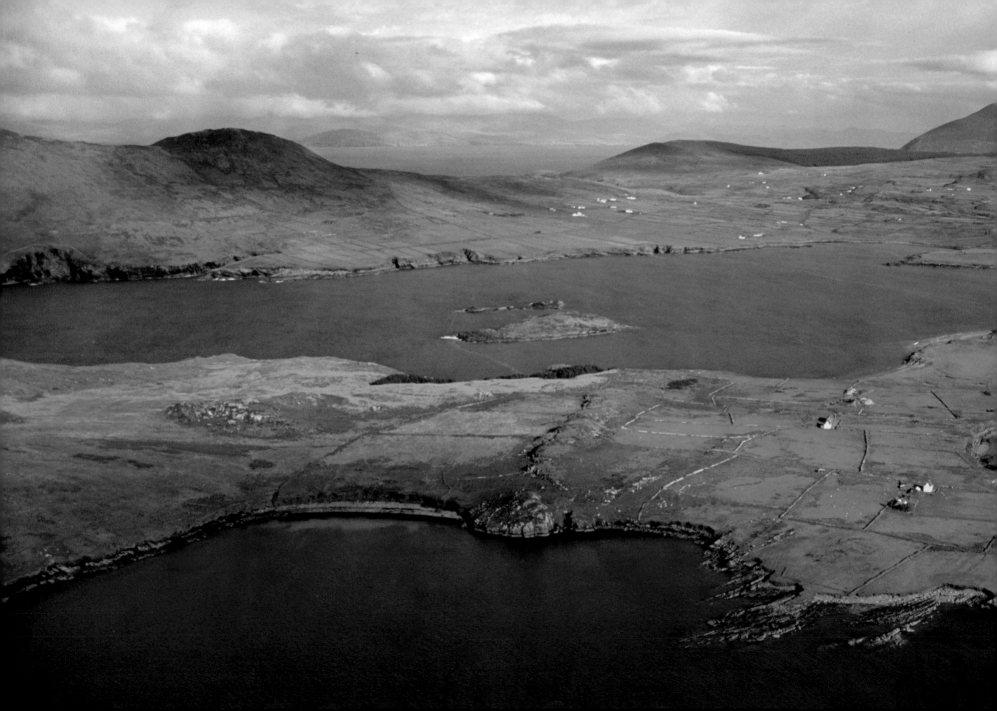

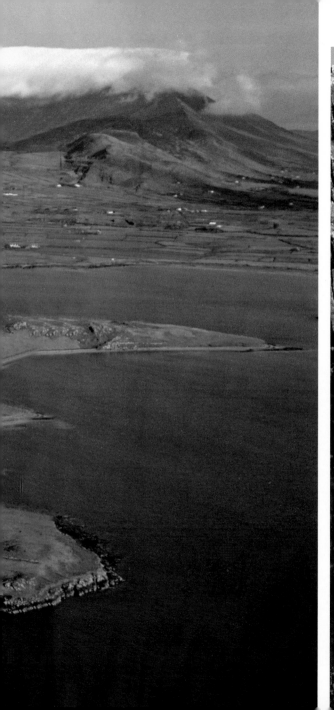

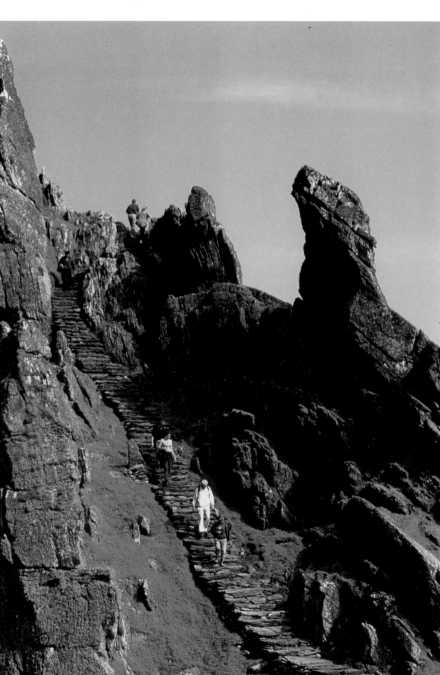

**LEFT:** Ancient steps lead to the early Christian monastery on Skellig Michael, County Kerry. Traditionally founded by St. Finan, the monastery lasted until the 12th or 13th century when the monks transferred to the mainland at Ballinskelligs.

**FAR LEFT:** View east over Beginish Island to Cahersiveen, County Kerry, a small market town the main town on the Iveragh Peninsula. Beginish Island lies in Valentia Harbour and is now uninhabited. The route around the peninsula is called the Ring of Kerry and encircles the wonderfully named Macgillycuddy's Reeks, The Reeks are the east-west backbone of the peninsula. At 3,414ft Carrauntoohil is Ireland's highest peak, and of the 13 Irish mountains above 3,000ft, ten are located in the Reeks, including the eight highest mountains of Ireland.

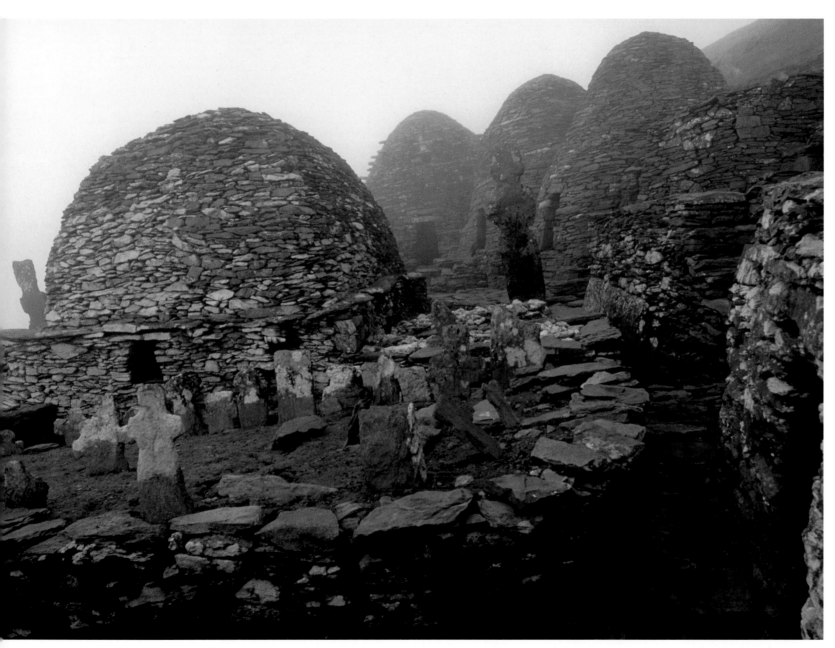

**LEFT AND RIGHT:** Two views of the beehive cells in the monastic enclosure on Skellig Michael. The monastery grouping—now designated a World Heritage Site—includes six beehives, two rectangular oratories, St. Michael's Church, and an area called the "Monk's Garden."

**OVERLEAF RIGHT:** Another atmospheric view of the Skelligs.

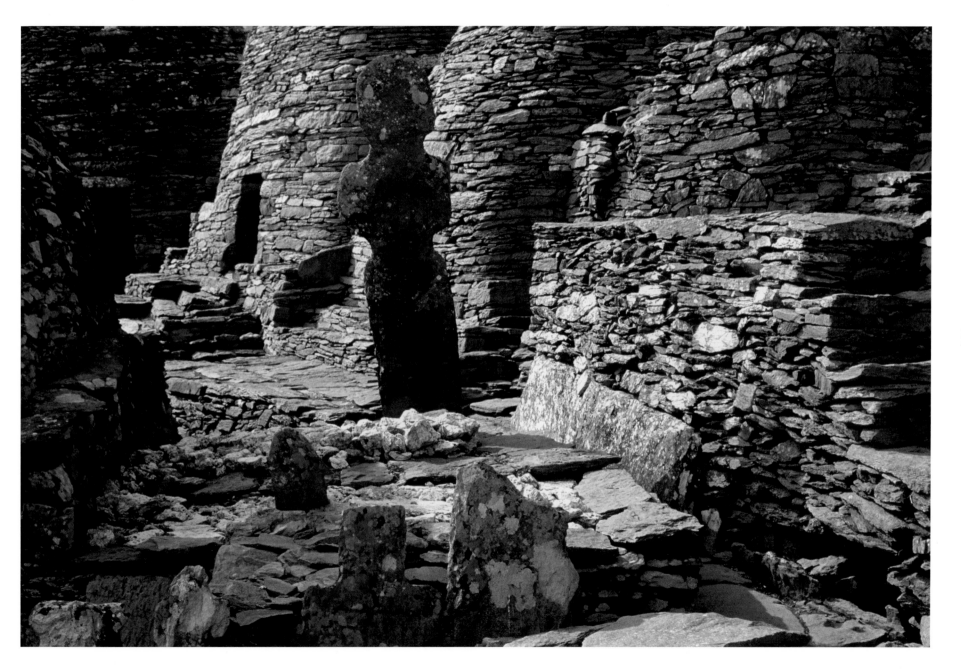

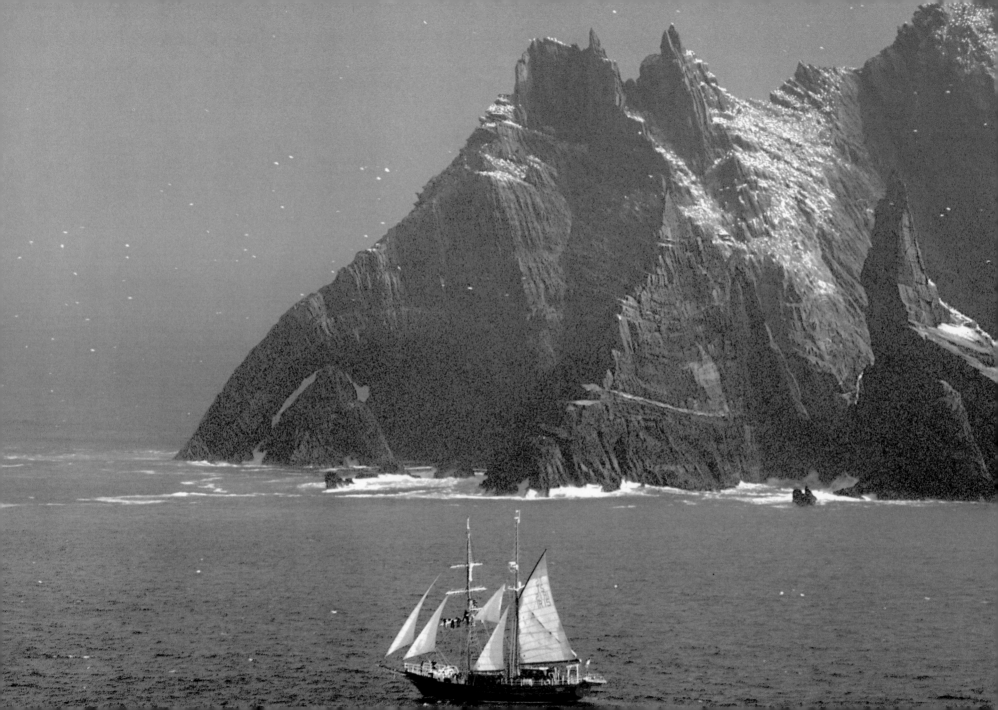

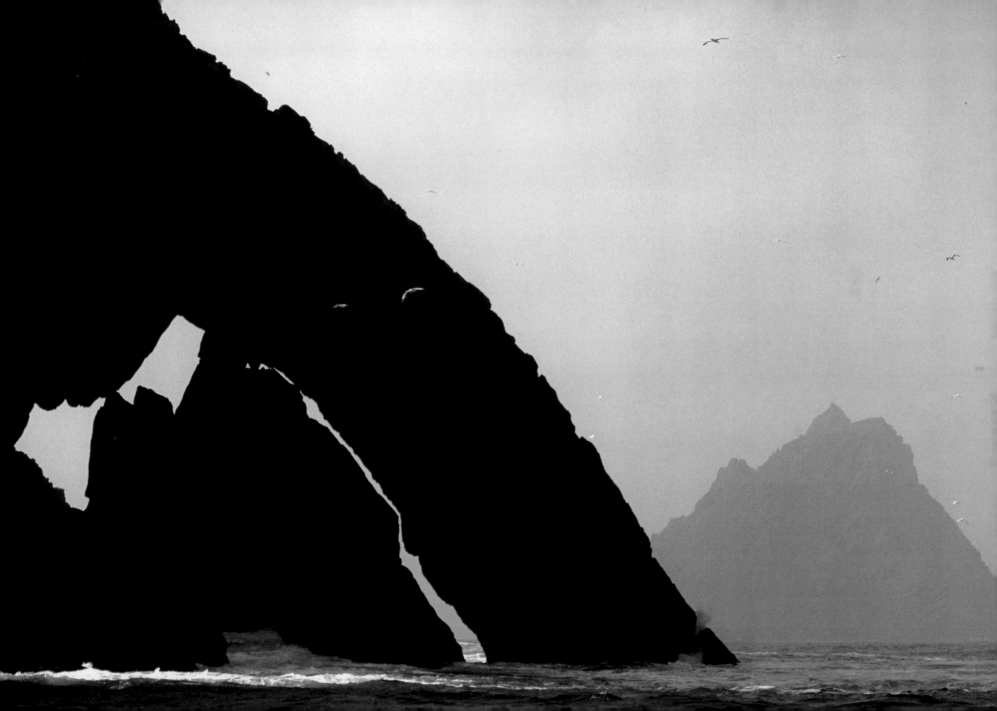

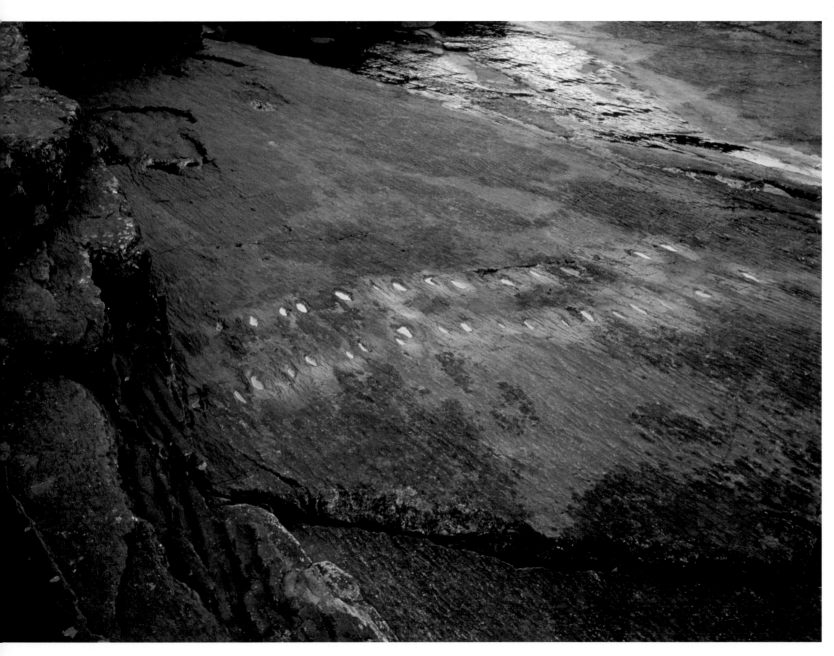

**LEFT:** Fossil footprint of a very early four-footed amphibian (the earliest in Europe, some 400 million years old) in Devonian slate, Valentia Island, County Kerry.

**RIGHT:** Muckross House, County Kerry, is on the lakes of Killarney. A 19th century manor house, it was completed in 1843 for Henry Arthur Herbert. The house and estate were donated to the nation in 1932. In the mid-1960s the house, which has since been magnificently restored, was opened to the public.

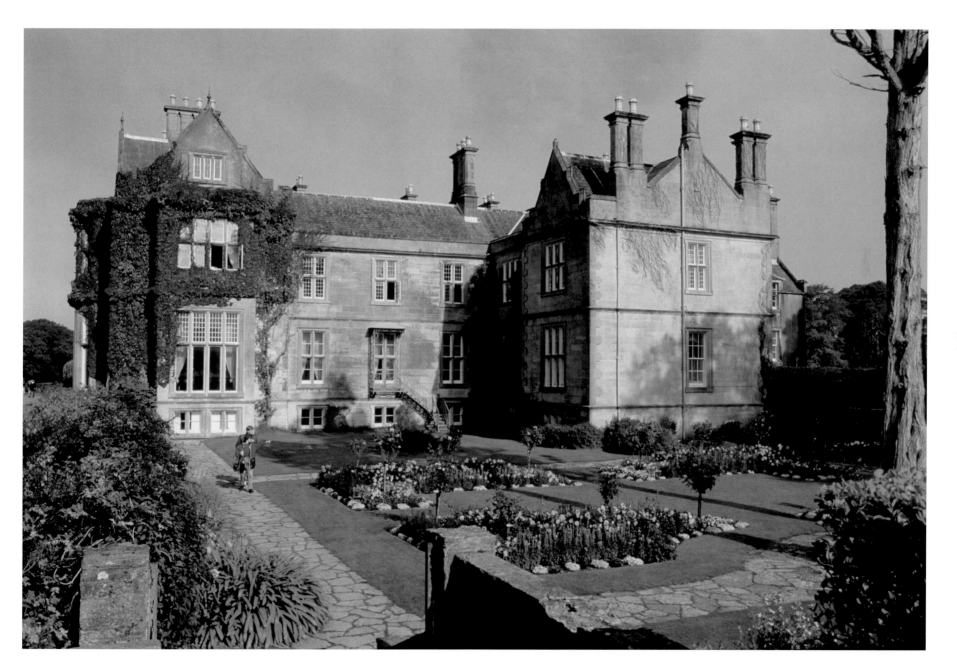

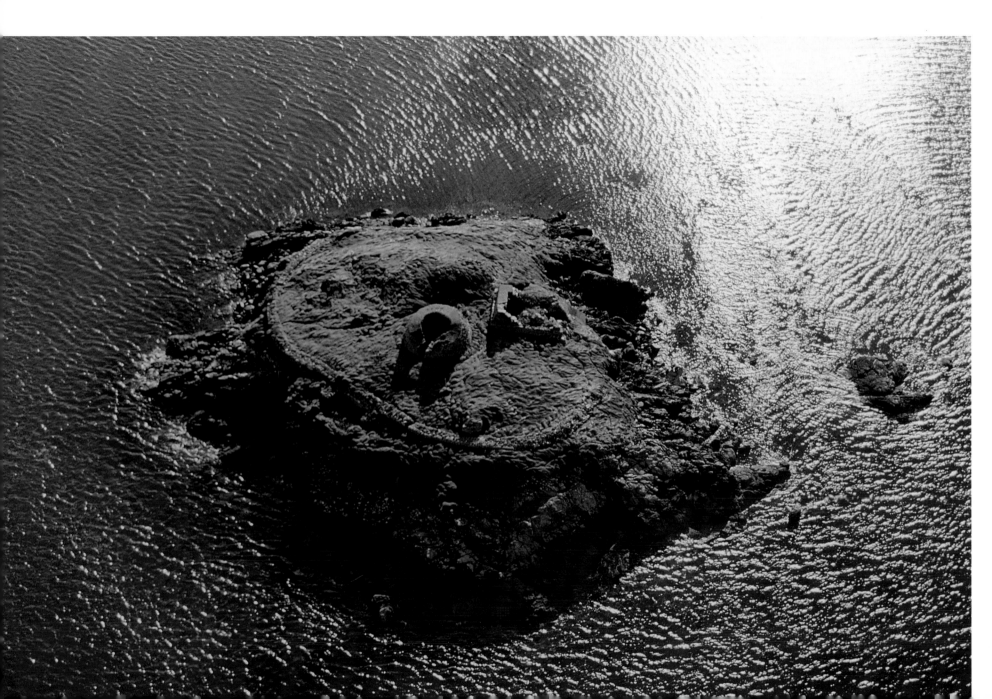

**LEFT:** Cahergall stone fort in County Kerry has stairs on the inner wall. 20ft high and 12ft thick, this substantial construction has a beehive hut and a rectangular stone building inside.

**FAR LEFT:** Early monastic site on Church Island off the east coast of Beginish Island, County Kerry.

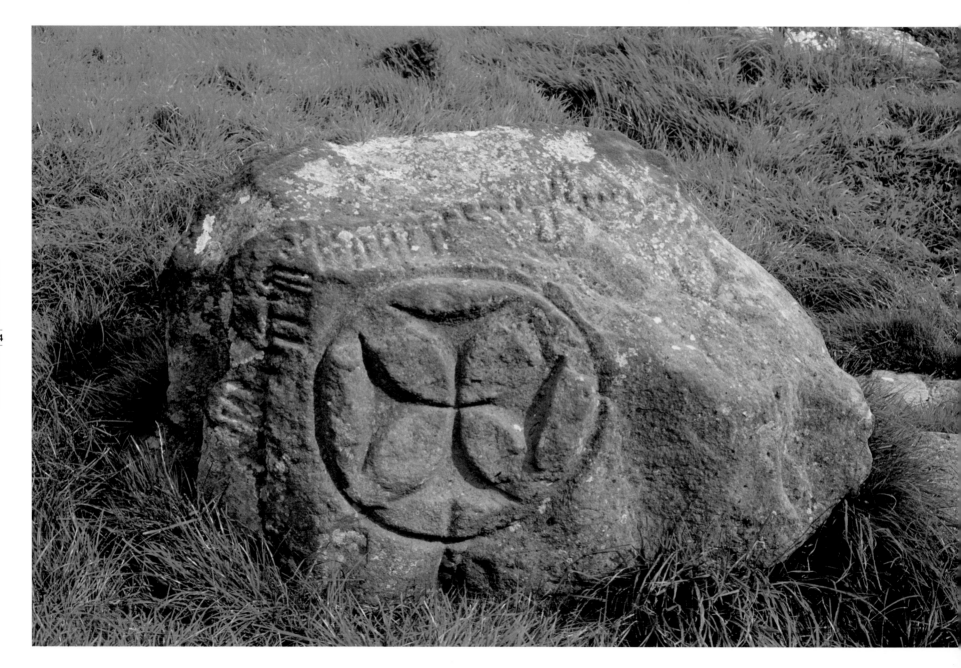

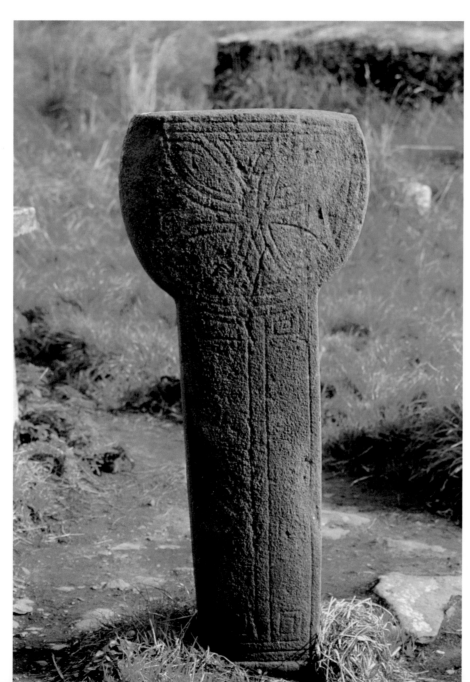

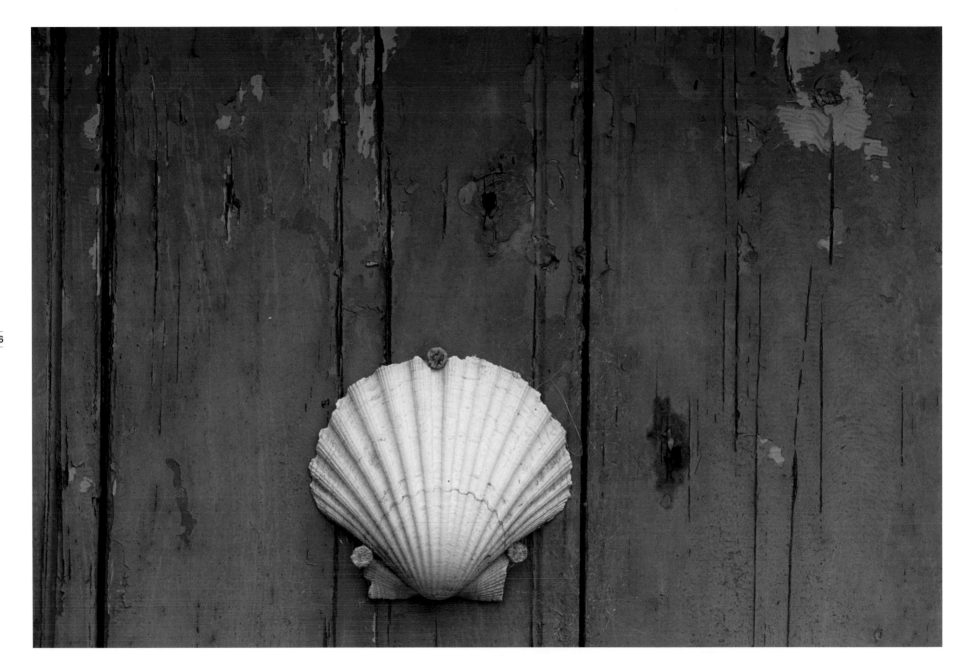

OVERLEAF: Valentia Island, County Kerry. View southwest from Geokaun Hill across the center of the island to Portmagee. Skellig is in the distance. Valentia was the terminal of the first transatlantic cable.

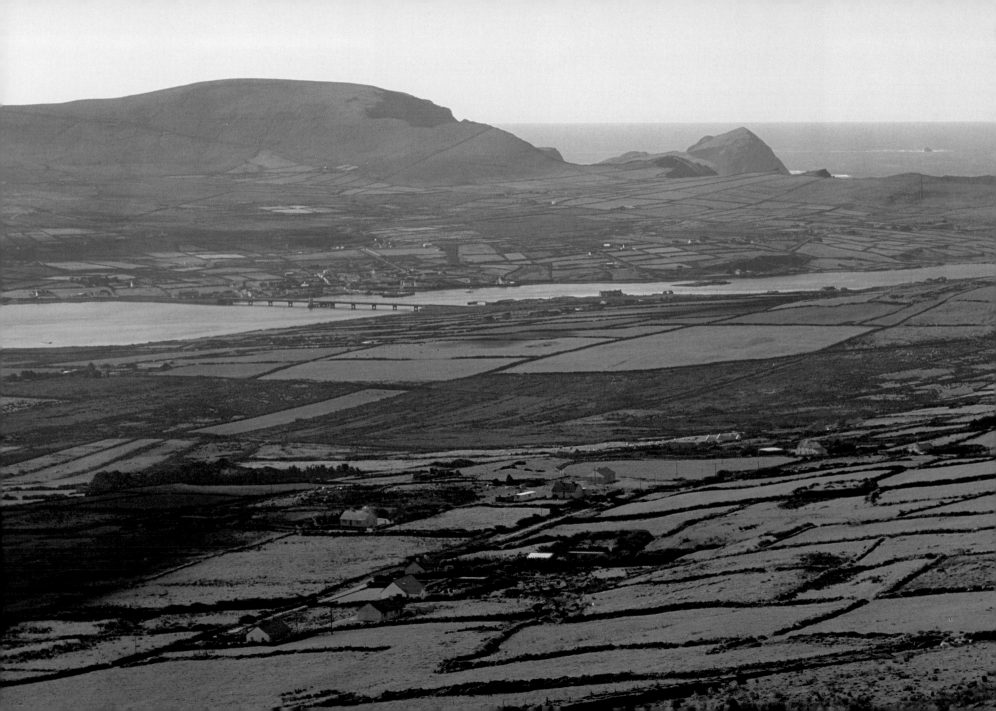

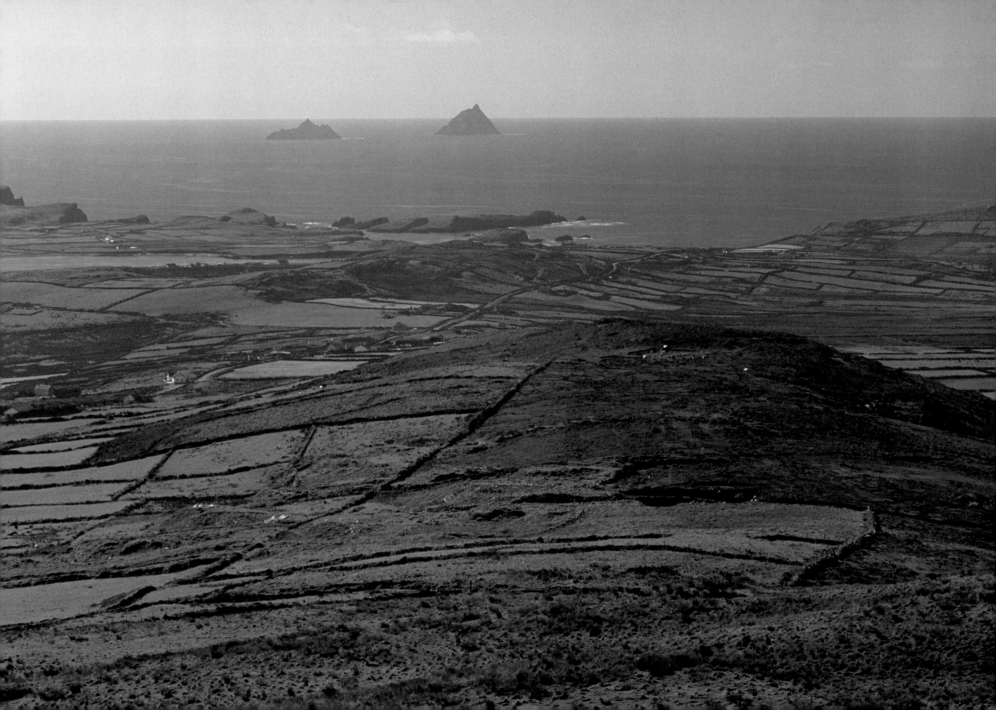

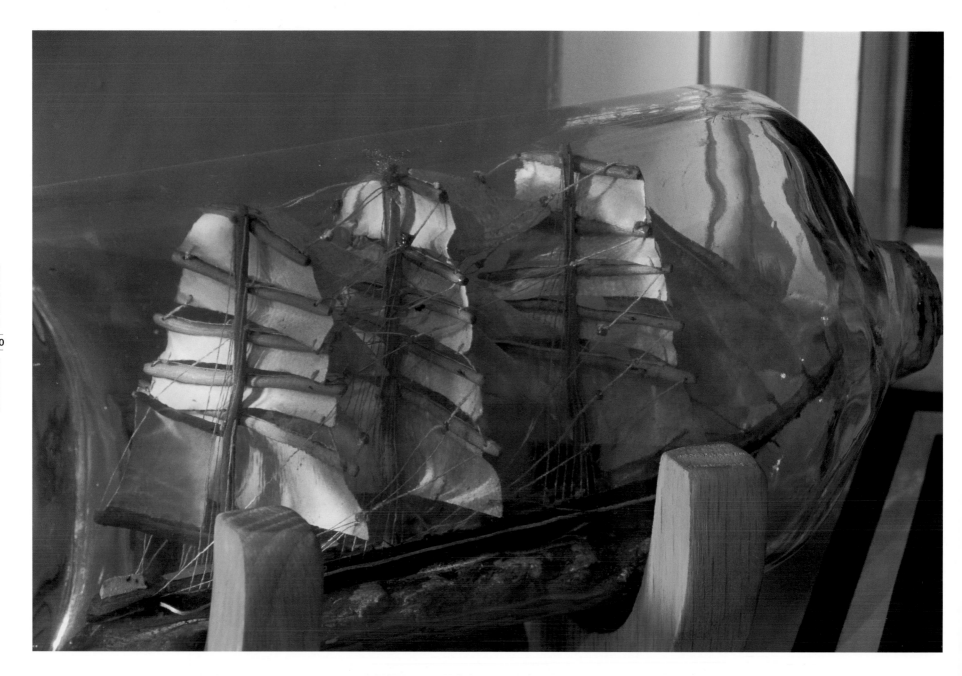

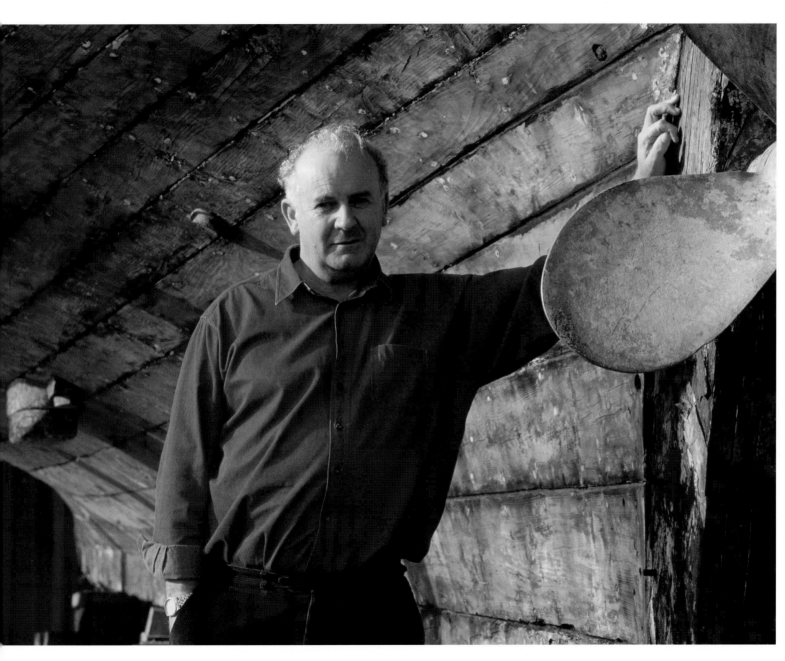

LEFT: Pat Curtin of Valentia Marine, County Kerry.

FAR LEFT: Ship in a bottle made by Thomas King, a Skellig lightkeeper 1896–99.

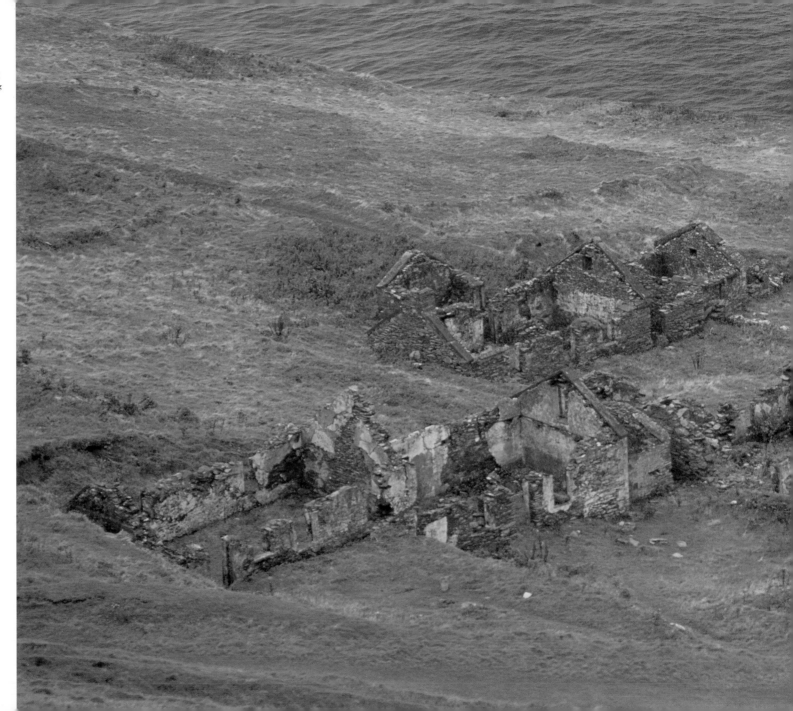

**RIGHT:** Village ruins on Great Blaskett, County Kerry. Lying off Dunmore Head, the Blaskett Islanders moved to the mainland in 1953 leaving behind sheep and ruined churches that pay testament to a long religious history.

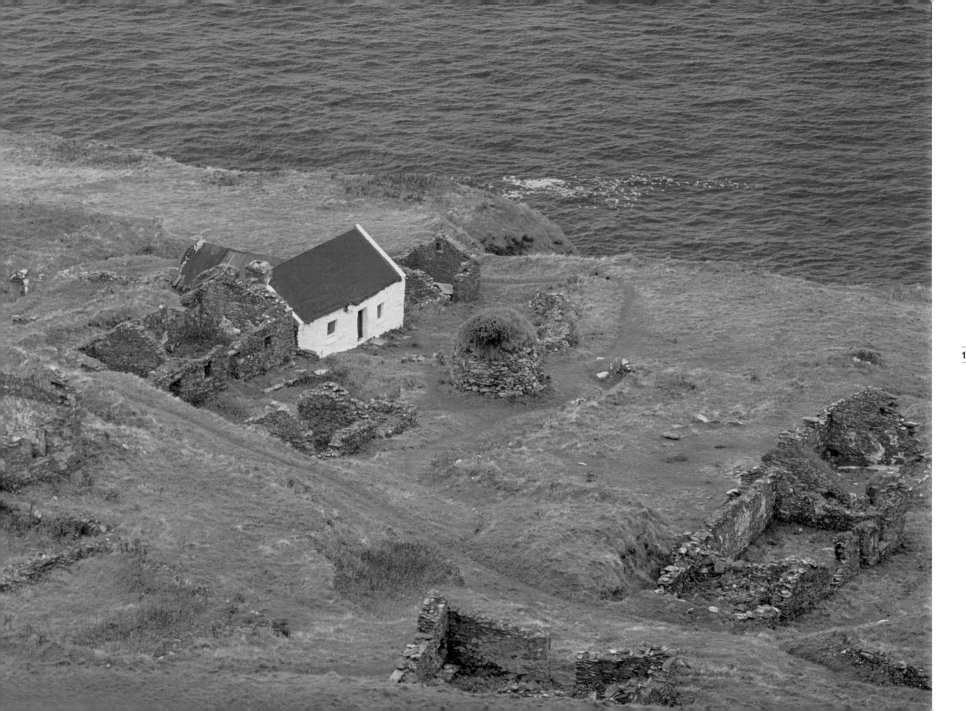

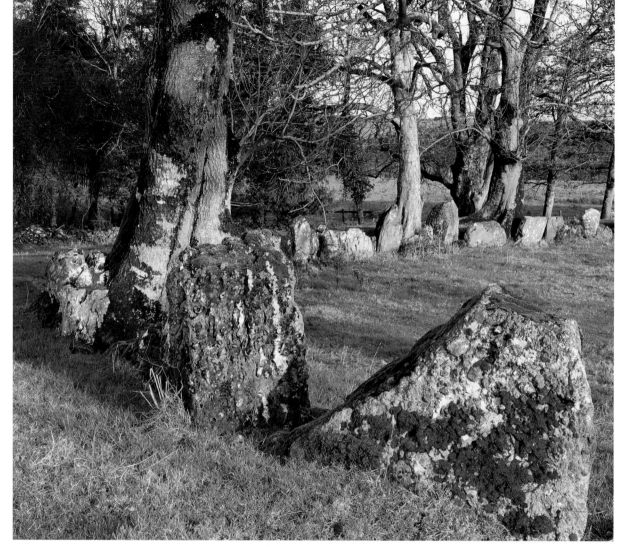

**ABOVE:** Part of the great prehistoric stone circle on the west side of Lough Gur, County Limerick. The Stone Age dwellings that are scattered on the banks of the horseshoe-shaped lough have contributed considerably to our understanding of the way of life of that period.

**RIGHT:** Carrigogunnel Castle, County Limerick, sitting on a volcanic rock above the Shannon. Started in the 13th century, the main works were undertaken in the 14th and 15th centuries, with more in the 16th. It was slighted in the war between William III and James II after its garrison surrendered in 1691.

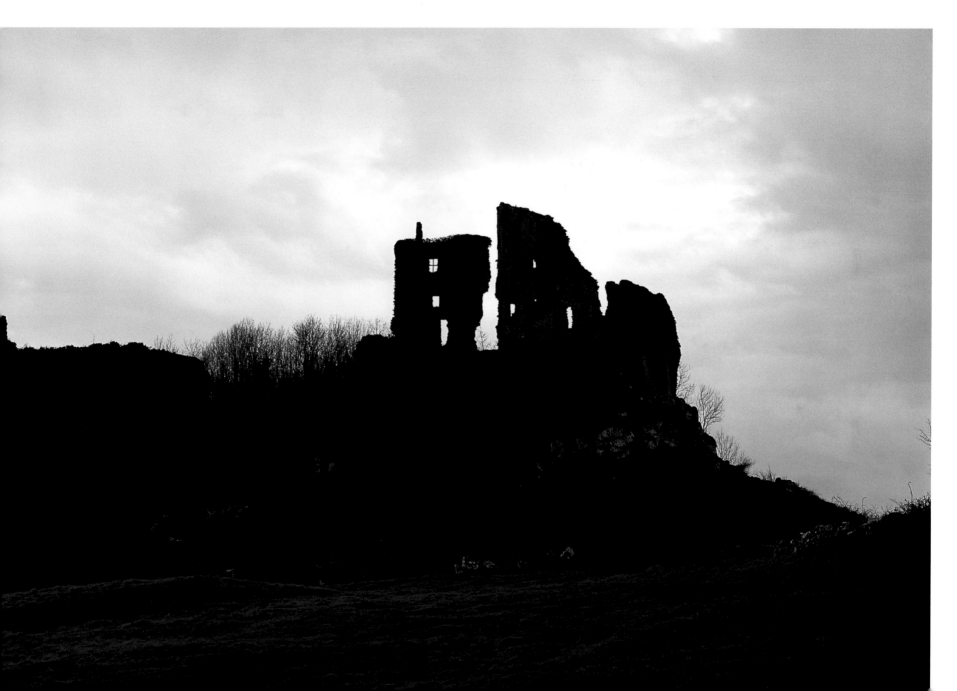

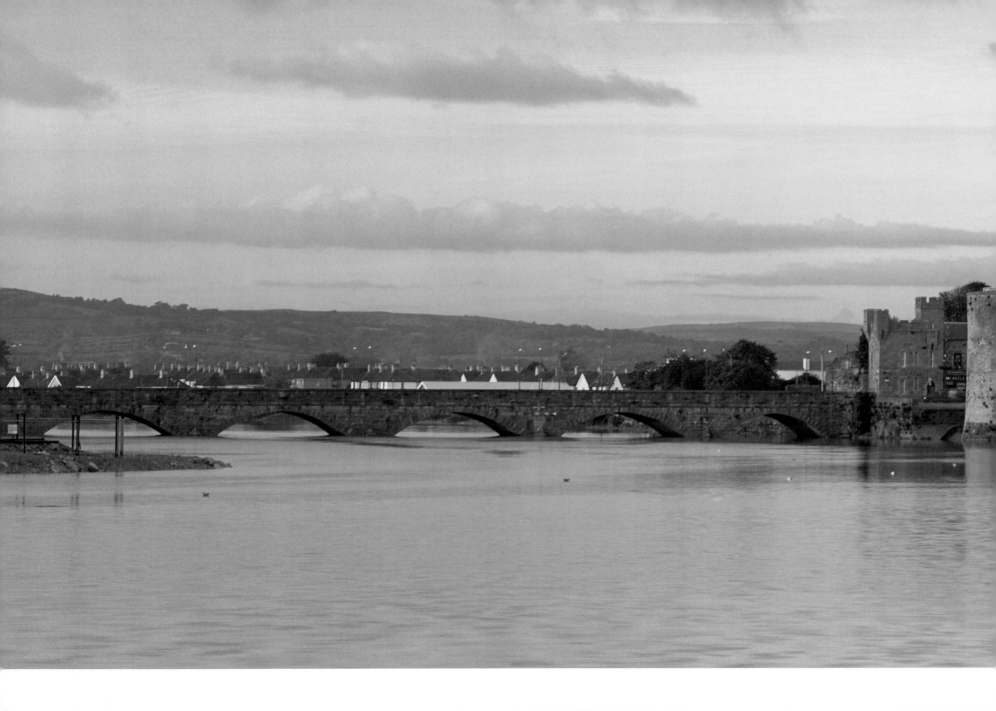

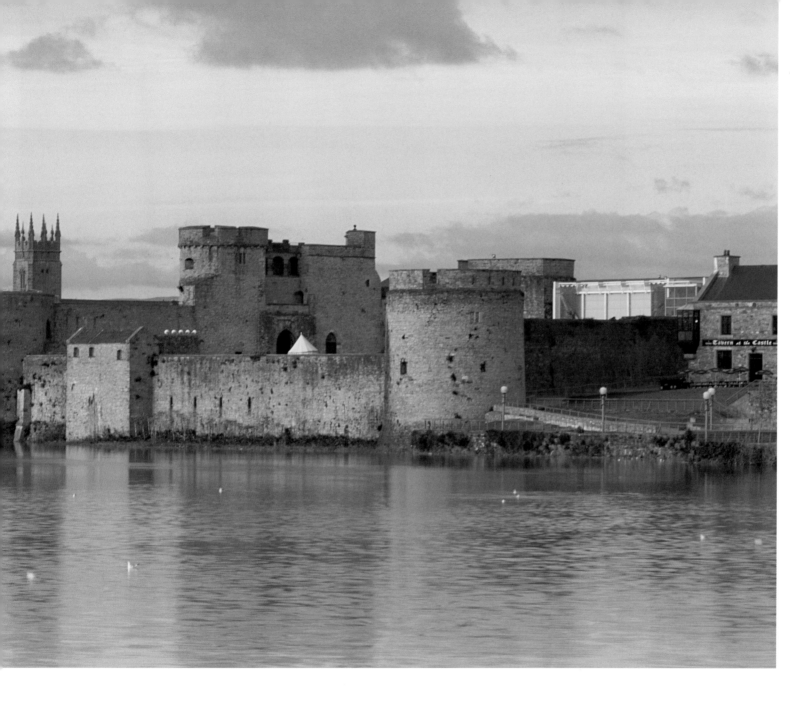

IRELAND | MUNSTER

**RIGHT:** One of the Ahenny high crosses, County Tipperary. Ahenny boasts two crosses, among the earliest in Ireland, each filled with geometrical motifs so similar to the Book of Kells that they are attributed to the same period—the 8th century.

**FAR RIGHT:** Tympanum above the north door of Cormac's Chapel, Cashel, County Tipperary. In it, the Norman centaur kills the Celtic Christian lion. Cormac's Chapel was built 1127–34 and many regard it as the most remarkable Romanesque church in Ireland.

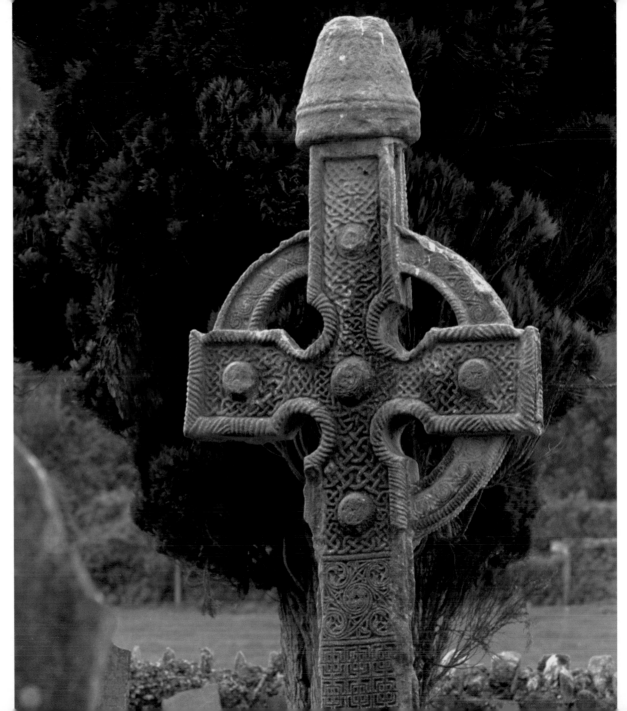

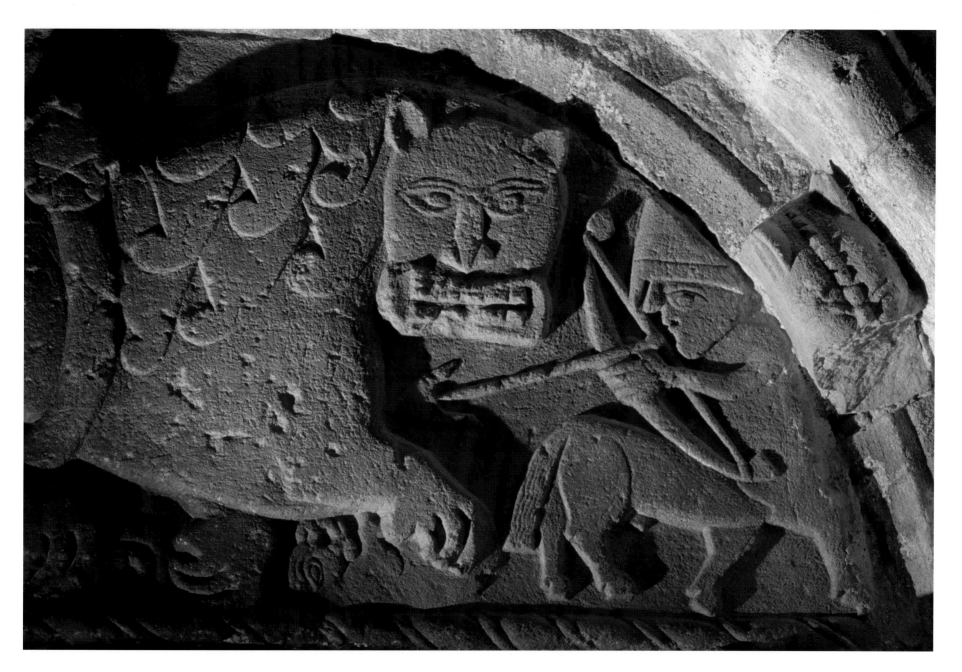

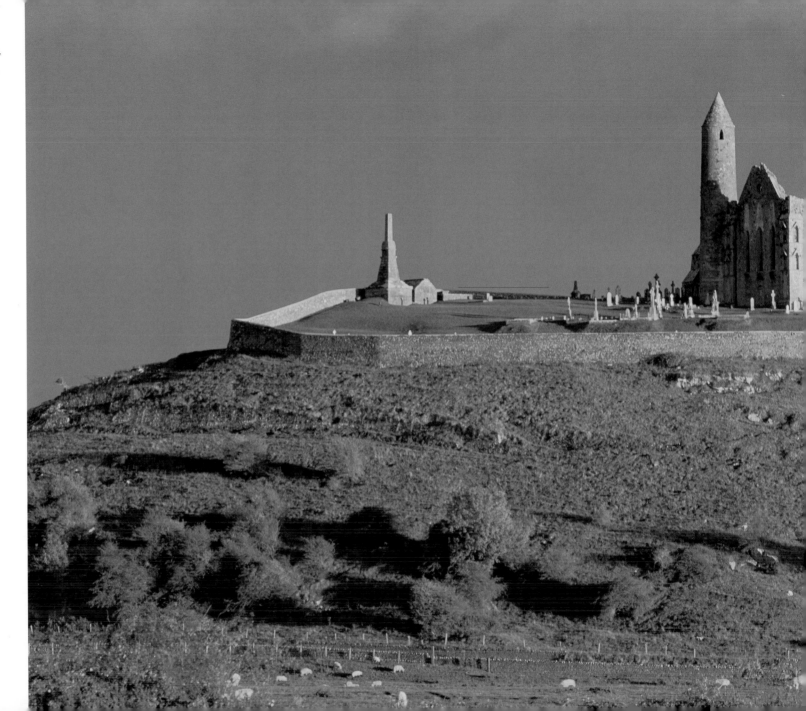

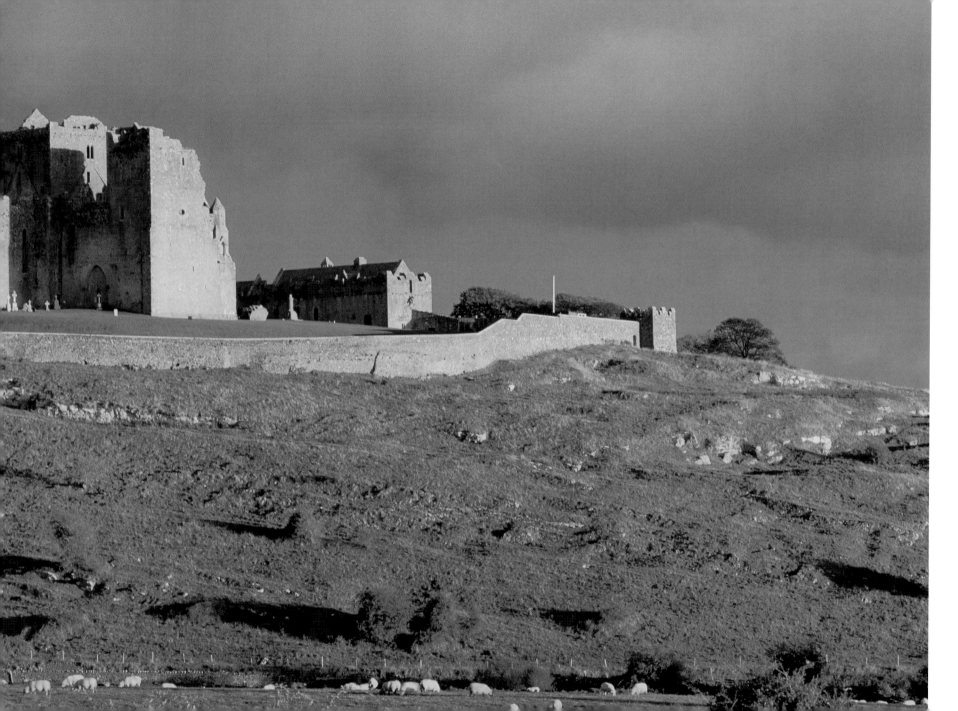

# Leinster

Leinster comes from the name Laighin, the name of one of the earliest Celtic tribes to invade Ireland who occupied most of what have become the counties of Wexford, Kilkenny, and Carlow. Leinster is a region not an administrative area and includes the counties of Dublin, Carlow, Kildare, Kilkenny, Laois, Longford, Louth, Meath, Offaly, Westmeath, and Wicklow.

Leinster occupies the central eastern portion of Ireland, it includes the capital city of Dublin which was probably first settled by the Vikings in 841. Dublin on the River Liffey is acknowledged as one of the finest Georgian cities in the British Isles. Almost a third of the entire population of Ireland live in and around Dublin. Leinster as a whole has for several centuries been the most prosperous heart of Ireland and with the recent economic boom it has become even more populous and wealthy. Thanks to its relative wealth Leinster was not as badly hit by the Great Famine as other places and consequently the area as a whole was not depopulated through death and emigration as much as the rest of Ireland was during the 19th and early 20th centuries.

In County Meath lies the Hill of Tara, the seat of the High Kings of Ireland. This low hill, anciently called Cathair Crofinn, contains the Mound of the Hostages, a Bronze Age passage grave. Later Tara became a place of pagan worship and then later the source of royal power where High Kings were crowned on the Lia Fáil (the coronation stone) which legend says would ring out if it approved of the nominee.

County Meath includes the World Heritage Site of the Brú na Bóinne complex, a collection of prehistoric sites beside the River Boyne, about 30 miles north of Dublin. The three principal sites are Newgrange, Knowth, and Dowth, which together make up Europe's largest and most important concentration of prehistoric megalithic art.

**RIGHT:** View north from James's Camp at the old church of Donore across the Boyne Valley to King William's Camp, County Meath.

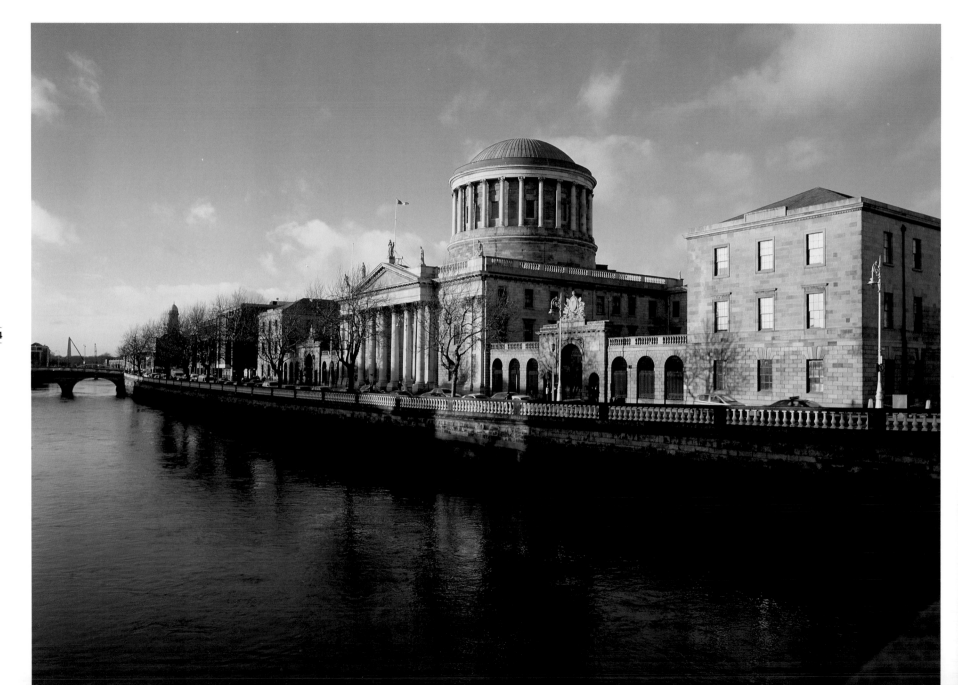

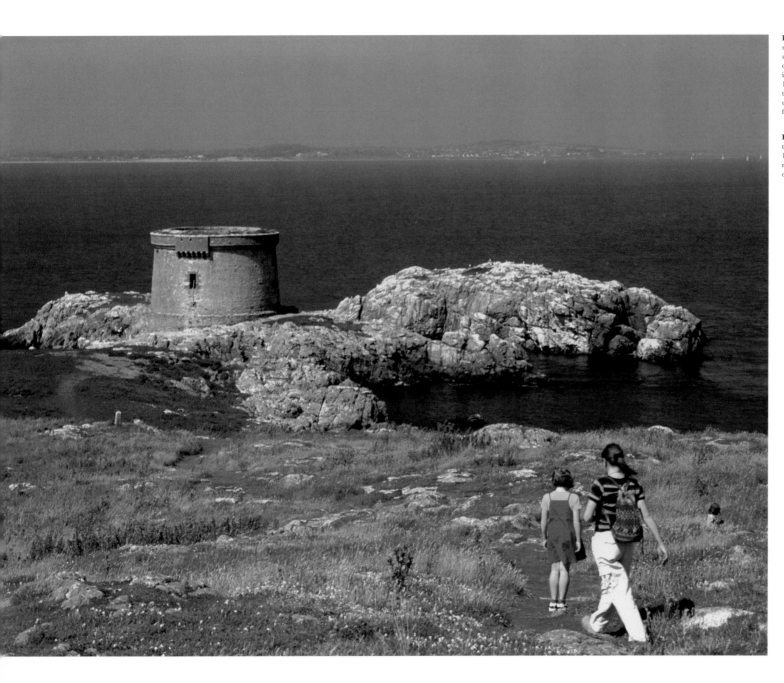

**LEFT:** Martello Tower on Ireland's Eye, a small islet just out of Howth, today a bird sanctuary. The Martello towers were defensive measures against a possible French invasion set up in the late 18th and early 19th centuries. The name comes from a tower on Mortella Point, Corsica, that put up a good fight when British sea and land forces were sent to take it in 1794.

**FAR LEFT:** James Gandon's Four Courts on the River Liffey in Dublin was completed in 1802. Gutted during the Civil War, it was restored in the 1930s using Gandon's designs.

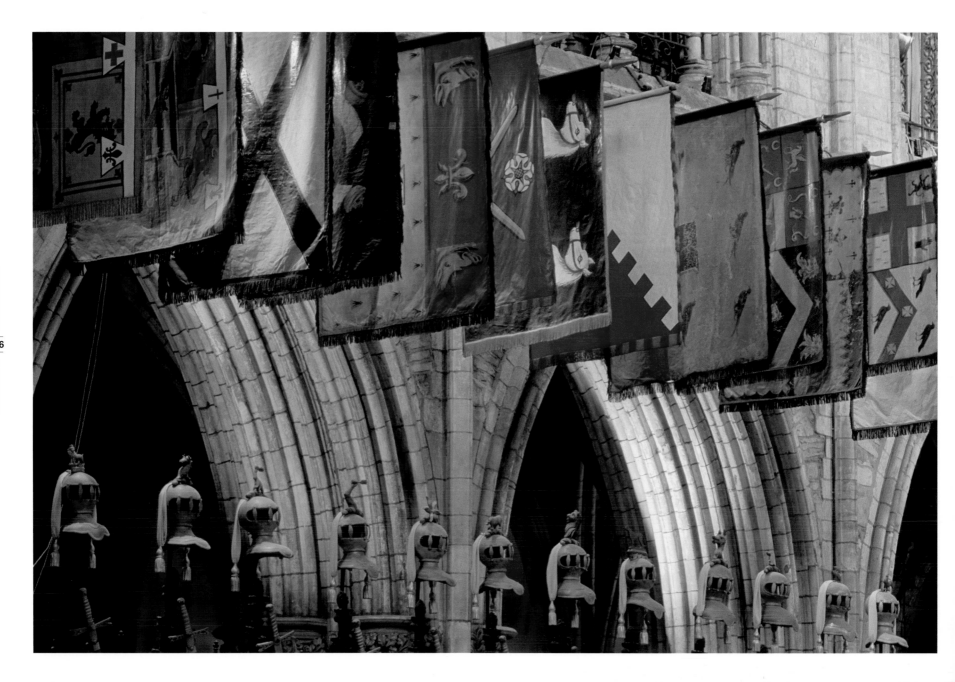

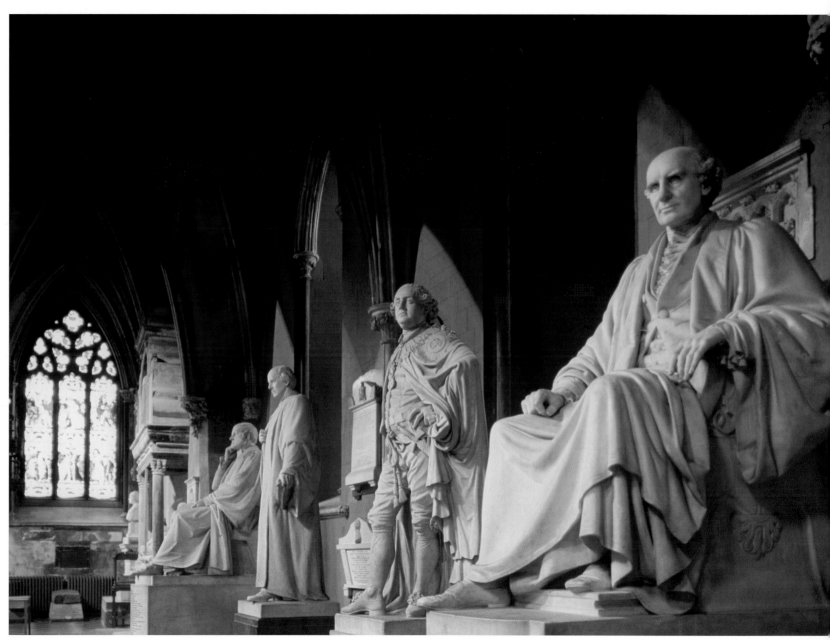

**LEFT:** The choir of St. Patrick's Cathedral, Dublin. The cathedral is the largest church in Ireland and has its origins in 450 when it is said that the saint baptized converts around here. Today, it is the national cathedral of the Protestant Church of Ireland. The banners, symbolic swords, and helmets are those of the Order of St.Patrick. This was founded in 1783 to reward Irish peers and those in high office in Ireland—as the Garter did in England and the Thistle in Scotland. The order effectively went into abeyance with the establishment of the Irish Free State in 1922 and lapsed completely in 1974 with the death of the last surviving recipient, Prince Henry, Duke of Gloucester.

**RIGHT:** Statues in the North Aisle of St. Patrick's Cathedral, Dublin. From left to right: Archbishop Jones, Dean Dawson, Buckingham, Whiteside. St. Patrick's was started in the late 12th and early 13th centuries and most of it was built between 1254 and 1270. The spire was added in the 18th century. Jonathan Swift, author of *Gulliver's Travels*, was dean here from 1713 to 1745.

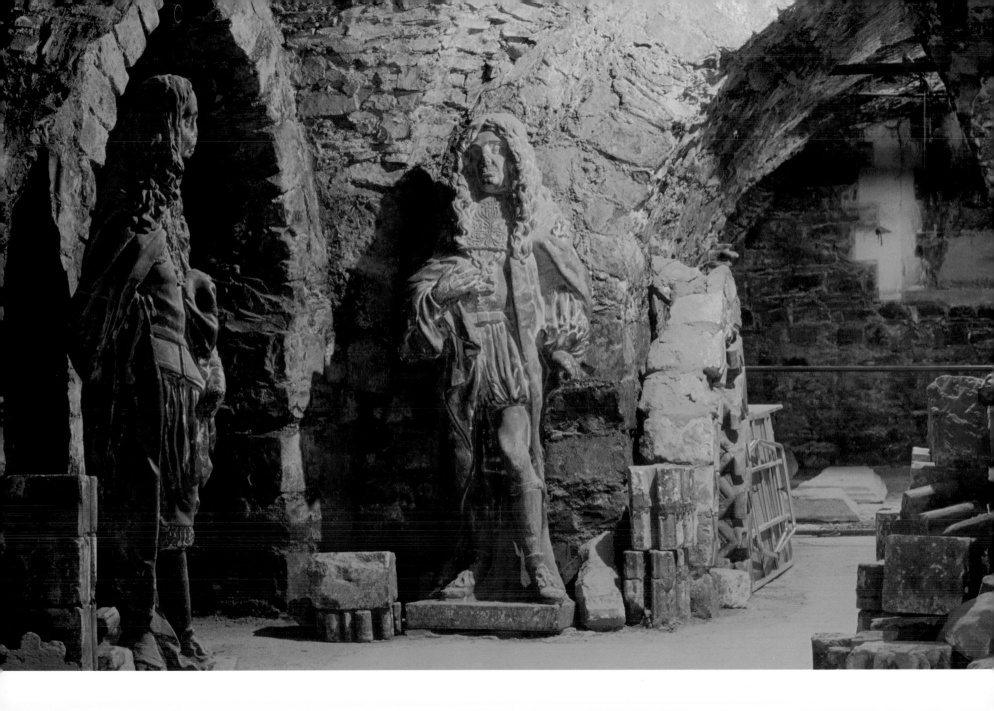

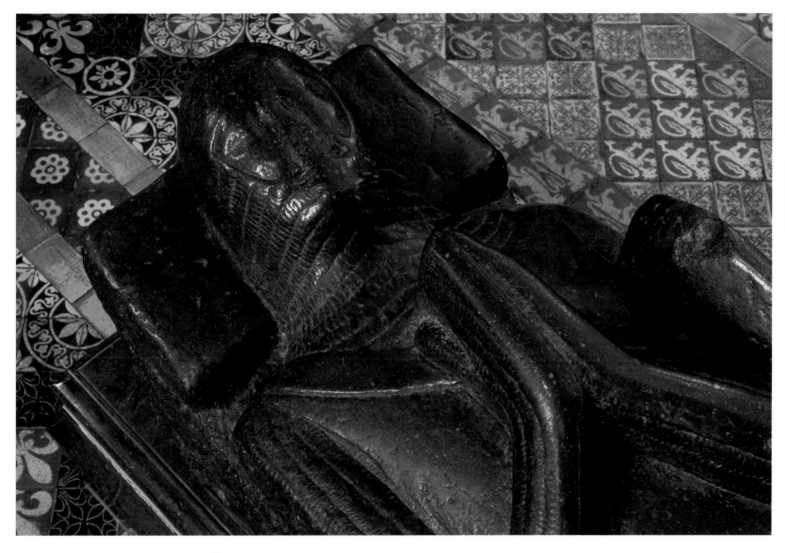

**LEFT:** While it is probable that this effigy is not one of Richard fitz Gilbert de Clare, Earl of Pembroke—"Strongbow"— he was certainly buried in Christ Church Cathedral. He had come to Ireland at the invitation of Dermot MacMurchada, king of Leinster. Dermot offered Strongbow his daughter Eve (Aoife) in marriage as well as the kingdom of Leinster on Dermot's death, if Strongbow helped Dermot regain his kingdom. After Dermot died at Ferns in May 1171, Strongbow assumed the kingship of Leinster in right of his wife. Strongbow died in June 1176 and was buried with great ceremony.

**FAR LEFT:** In the crypt of Christ Church Cathedral, Dublin. Commissioned by the Norman conqueror of Dublin in 1172, the church fell into a poor state of repair by the 19th century and had to be remodeled in the 1870s by architect George Street. Monuments removed during the restoration are on show in the crypt today.

**OVERLEAF**
**LEFT:** Sea stack off the east tip of Ireland's Eye, County Dublin.

**RIGHT:** Ireland's Eye—looking toward the Martello tower.

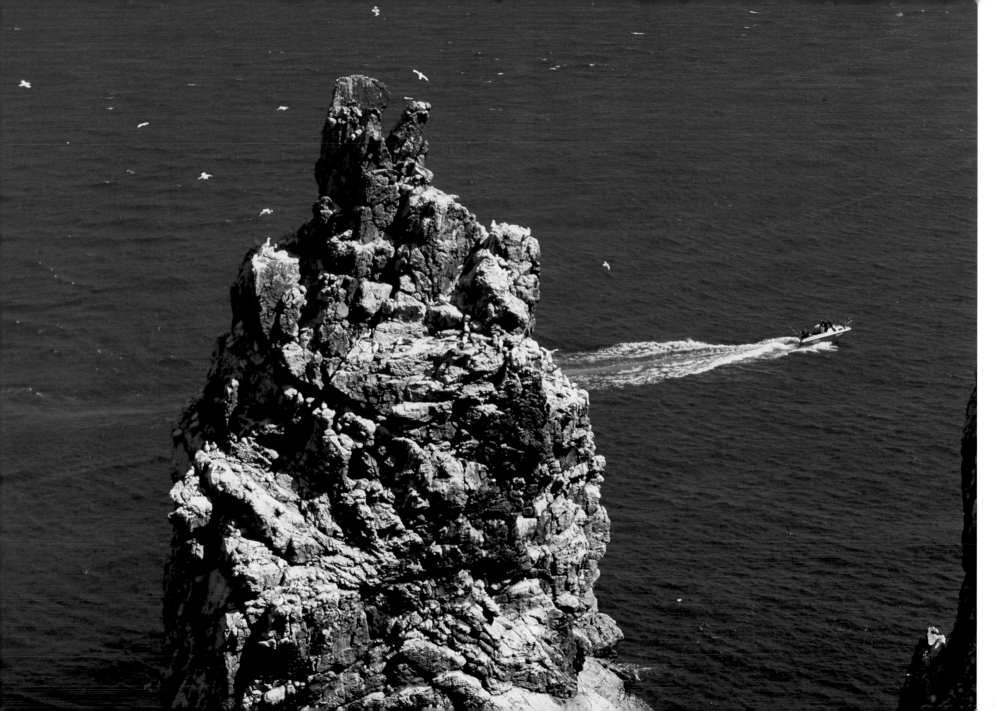

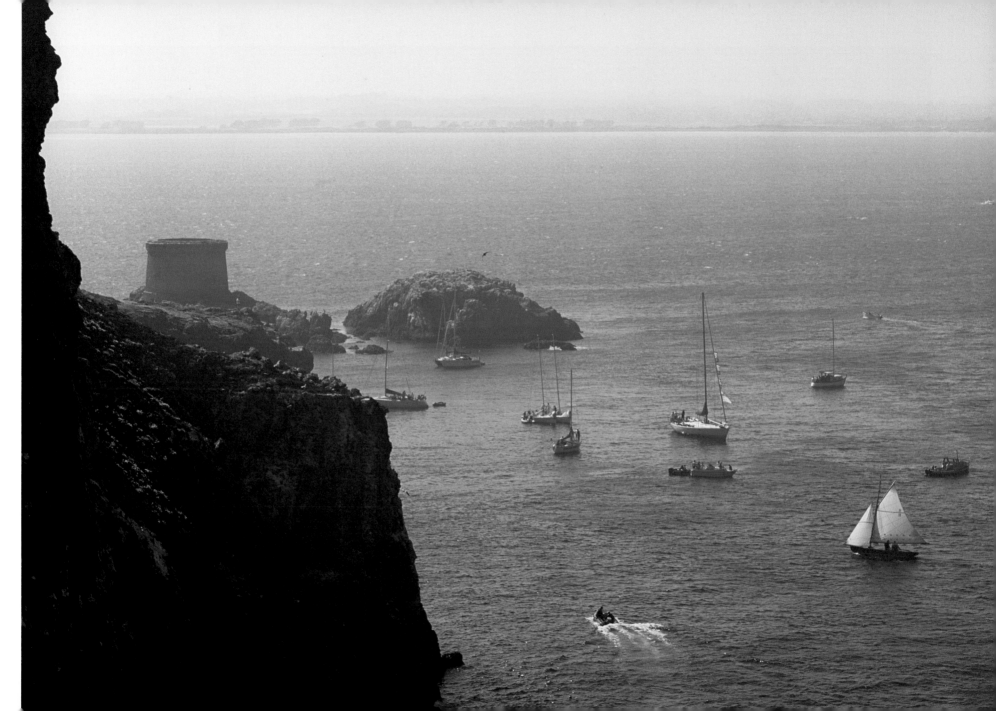

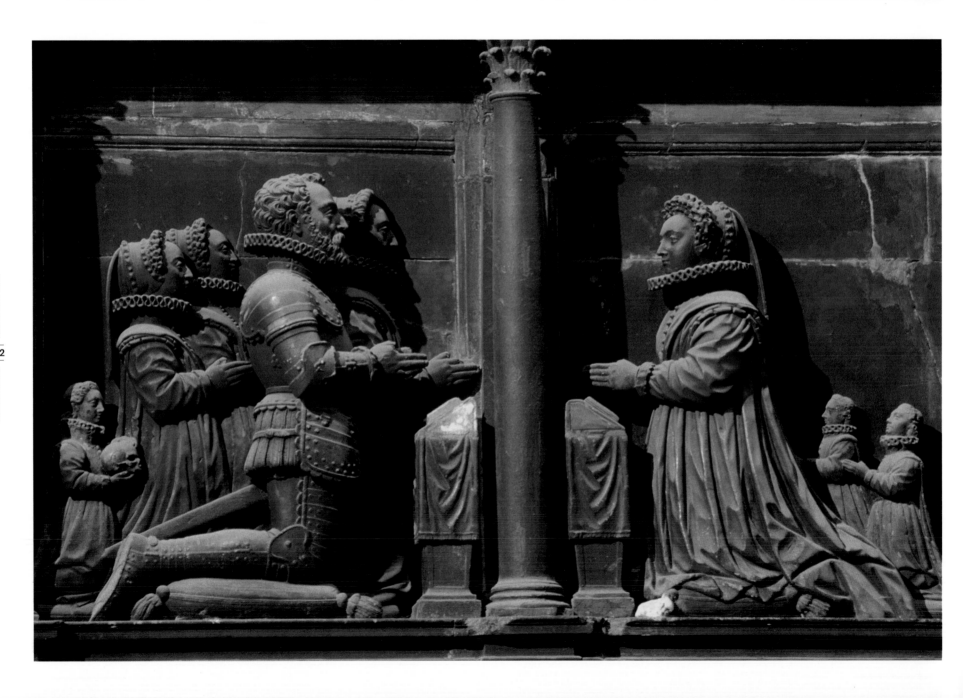

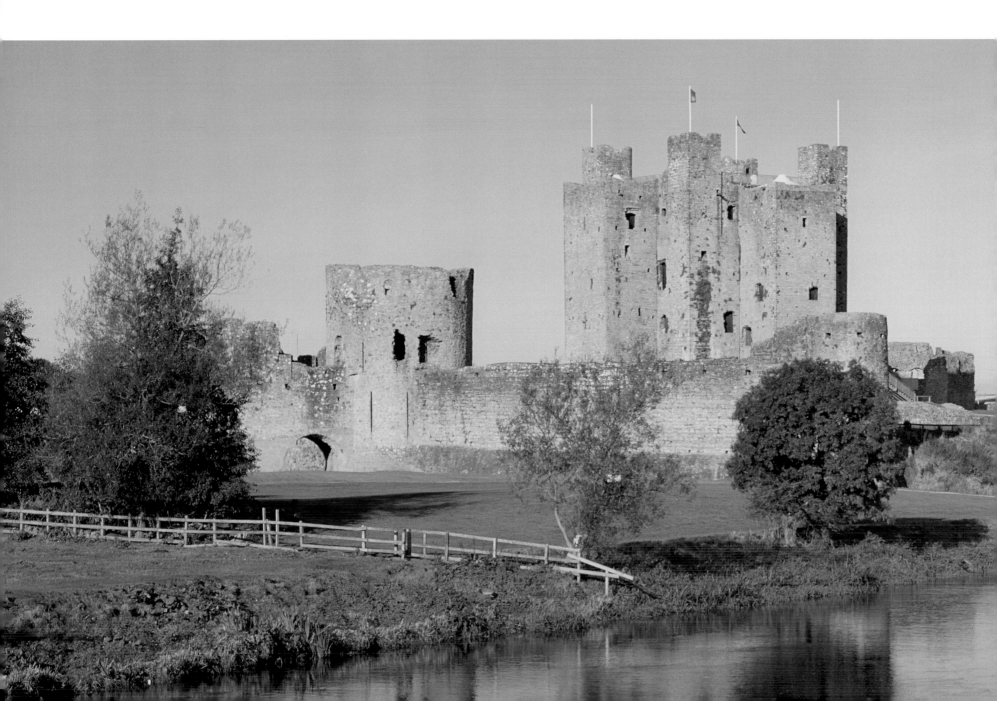

**RIGHT AND FAR RIGHT:** Two views of the statue of St. Patrick in Slaine Friary, Hill of Slane, County Meath. Associated with the lighting of the first Pascal Fire in Ireland by St. Patrick in 433—and hence symbolizing the triumph of Christianity over paganism—it was Sir Christopher Flemmyng who founded a small friary here.

**OVERLEAF**

**LEFT:** One of the carved stones inside the chamber of Fourknocks Passage Tomb, County Meath. Over 60 burials were found in the passage and side niches but none in the central chamber. The tomb was built around 1800 BC.

**RIGHT:** View of the earthworks on the plain of the River Boyne; beyond Cormac's House and the Lia Fáil can be seen in the distance.

**INSET:** Tara, County Meath, boasts one of the most venerated spots in Ireland, that developed from being a religious site to become the seat of the High-Kings of Ireland. This photograph shows the Lia Fáil, the crowning stone of the High Kings.

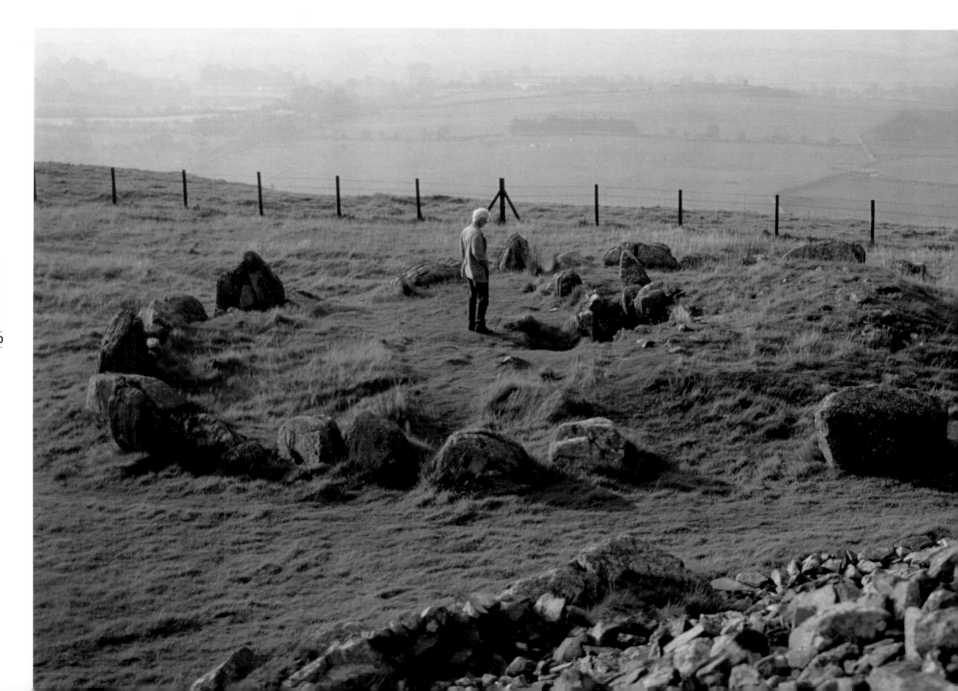

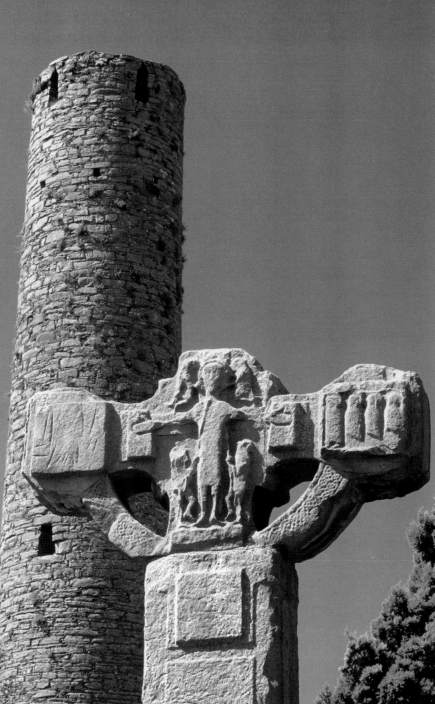

**LEFT:** The unfinished cross and round tower at Kells, County Meath. Granted to St. Colmcille for the foundation of a monastery in the 6th century, the monastery was refounded in 804. It is supposed that that is when the monks of Iona, another of the saint's foundations, fled from the Vikings. They brought with them reliquaries of the saint. The Vikings did not stop at Iona, however. Kells itself was attacked in 919, 950, 969, and 1007 when the Book of Kells was stolen. Miraculously it was refound two and a half months later.

**FAR LEFT:** Loughcrew, County Meath, is a collection of passage graves on two peaks—Cairnbane East and West. Sometimes known as the hill of the witch, this photograph shows the eastern group of which Cairn T is the largest at 120ft.

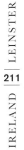

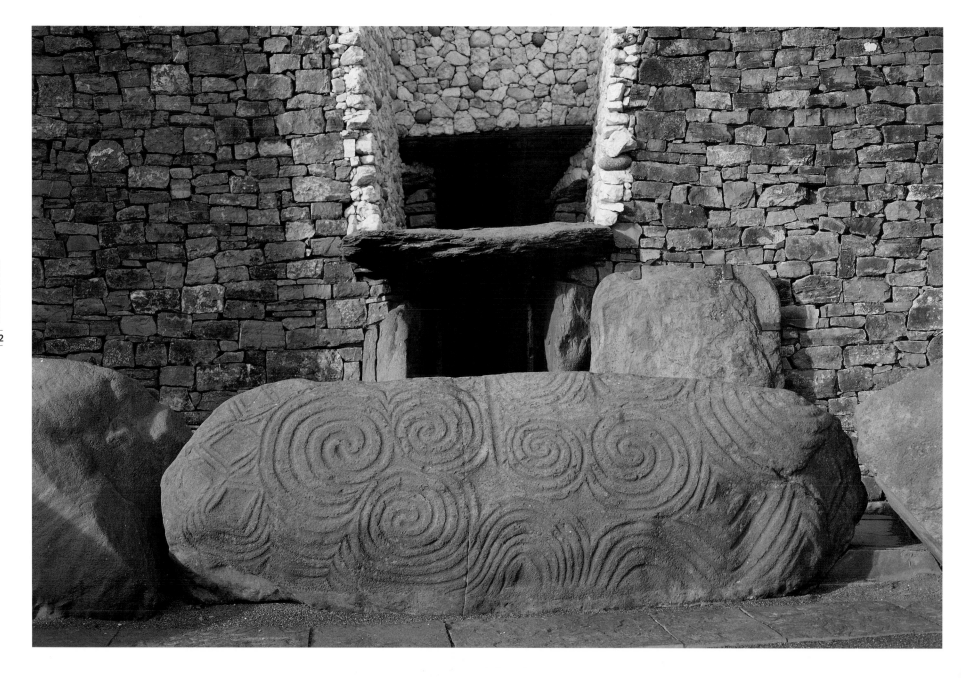

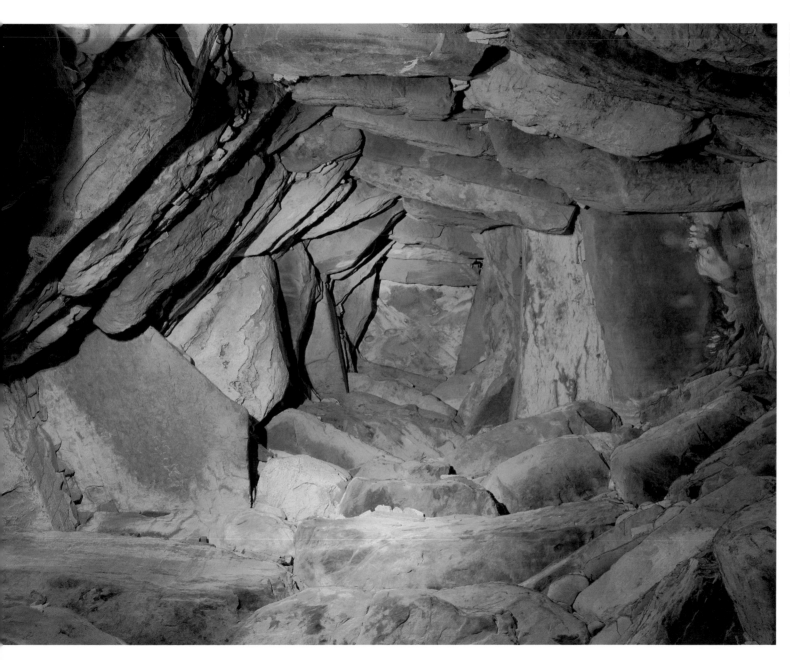

**LEFT AND FAR LEFT:** At Newgrange, County Meath, is one of the best examples of megalithic art in Europe. These photographs show the decorated stone at the entrance of the passage to the burial chamber (**FAR LEFT**) and the corbelled roof which rises 19.5ft above the floor of the central chamber (**LEFT**).

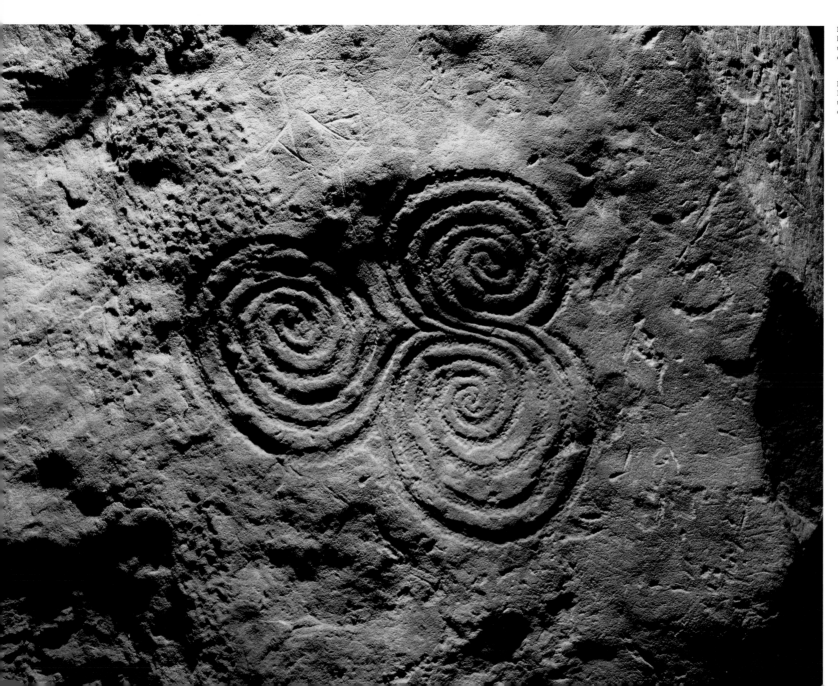

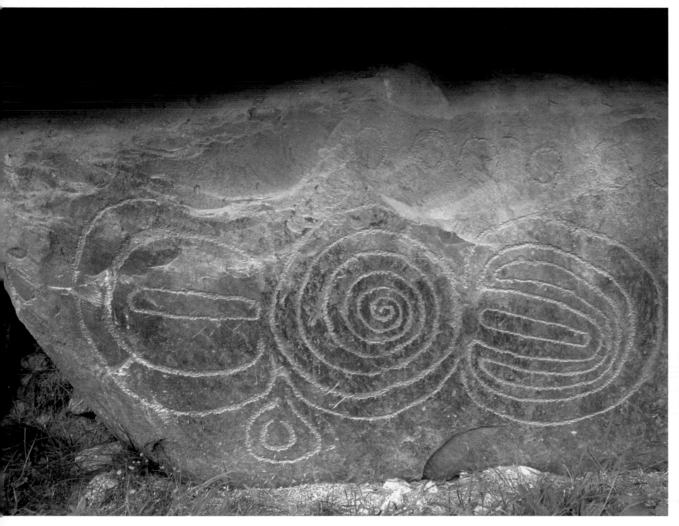

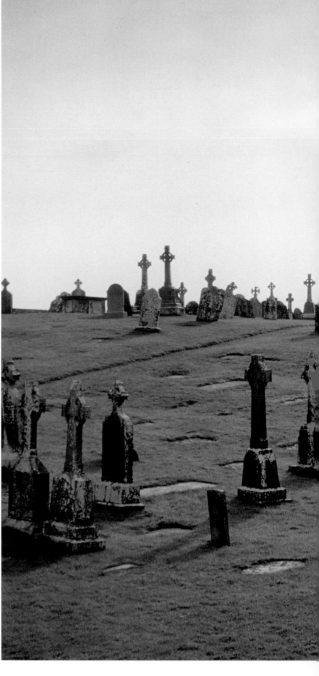

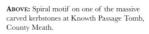

**ABOVE:** Spiral motif on one of the massive carved kerbstones at Knowth Passage Tomb, County Meath.

**RIGHT:** The fine Romanesque Nun's Church at Clonmacnoise, County Offaly, was completed in 1166.

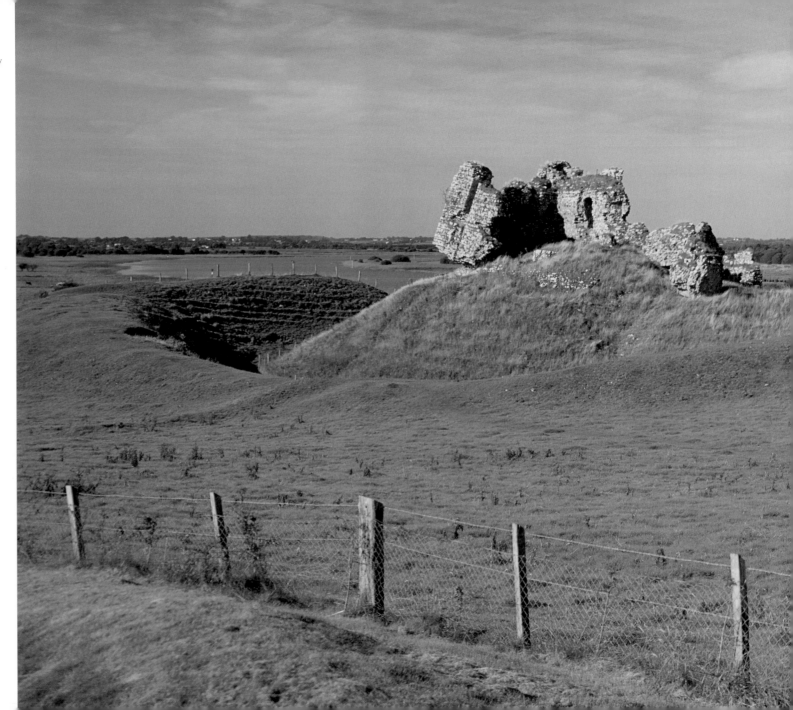

**RIGHT:** Clonmacnoise Castle on the River Shannon was built by Norman John de Grey in 1214. It was blown up in 1650.

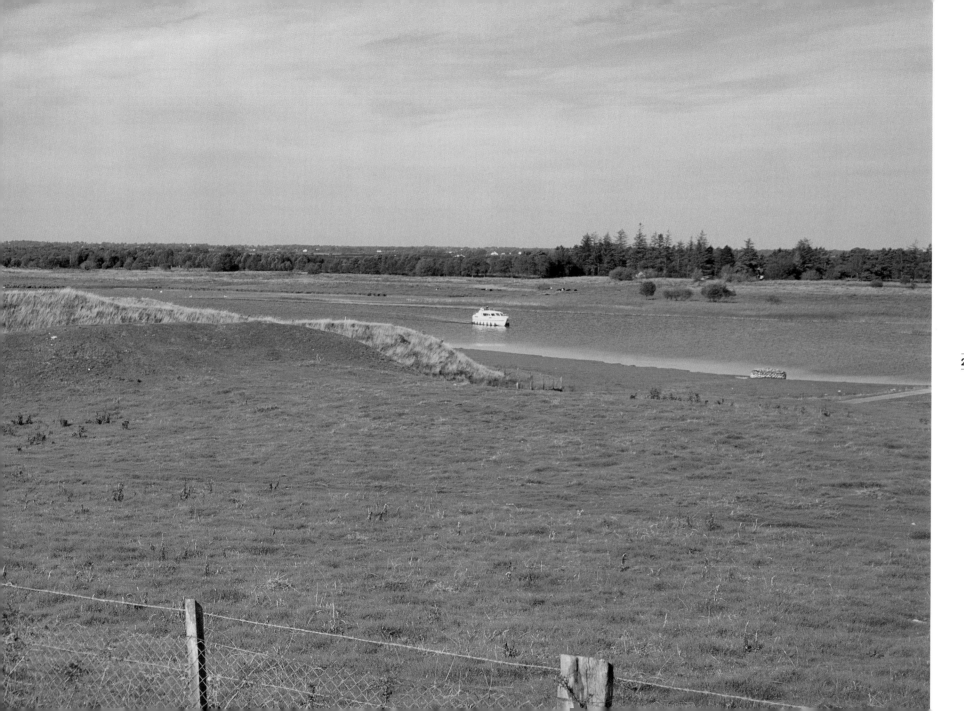

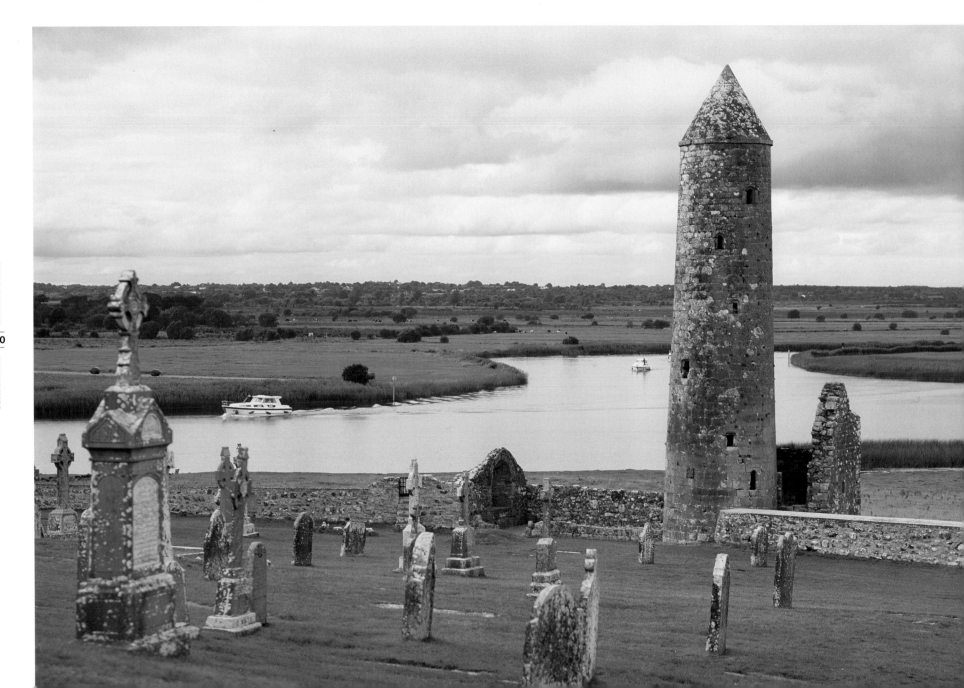

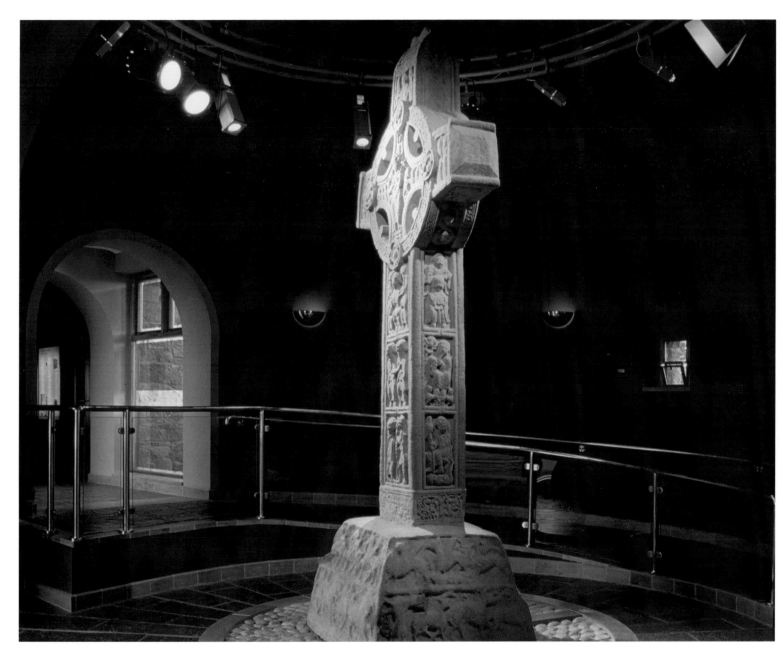

**LEFT:** The original 9th century Cross of the Scriptures is now in the museum.

**FAR LEFT:** The round tower of Temple Finghin on the banks of the River Shannon, Clonmacnoise Monastery, County Offaly. The monastery at Clonmacnoise was founded in 548–549 by St. Ciarán. It had a chequered life: plundered six times between 834 and 1012 and burned 26 times between 841 and 1204, it's remarkable that anything survives!

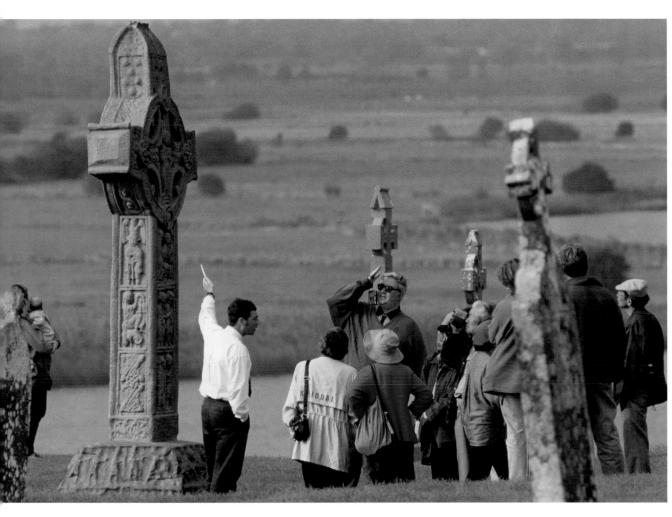

ABOVE: The Cross of the Scriptures outside at Clonmacnoise is a copy (see page 221).

RIGHT: Shannonbridge, County Offaly, from the air showing the 19th century anti-Napoleonic bridgehead defences.

OVERLEAF
LEFT: Tomb of Piers and Margaret Butler, St. Canice's Cathedral, Kilkenny Town. The cathedral was built in the 13th century and sacked by Cromwell in 1650.

RIGHT: Side panel of a 16th century tomb showing saints as "weepers"; Jerpoint Abbey, County Kilkenny. The abbey was founded in about 1160 possibly by the Benedictines; by 1180 it was in the hands of the Cistercian order and survived thus to the Dissolution of the Monasteries.

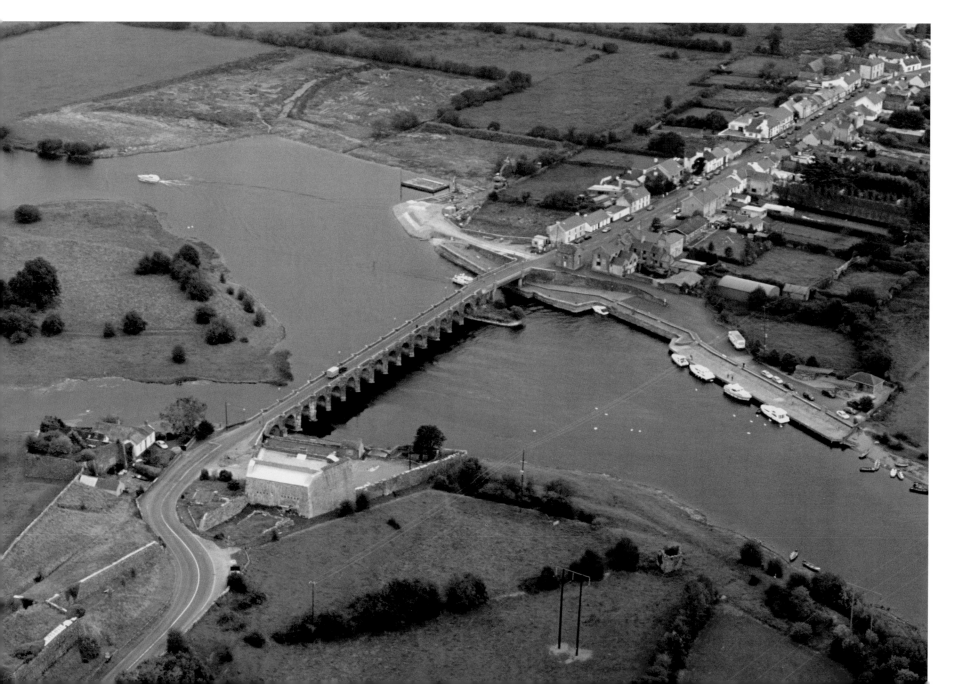

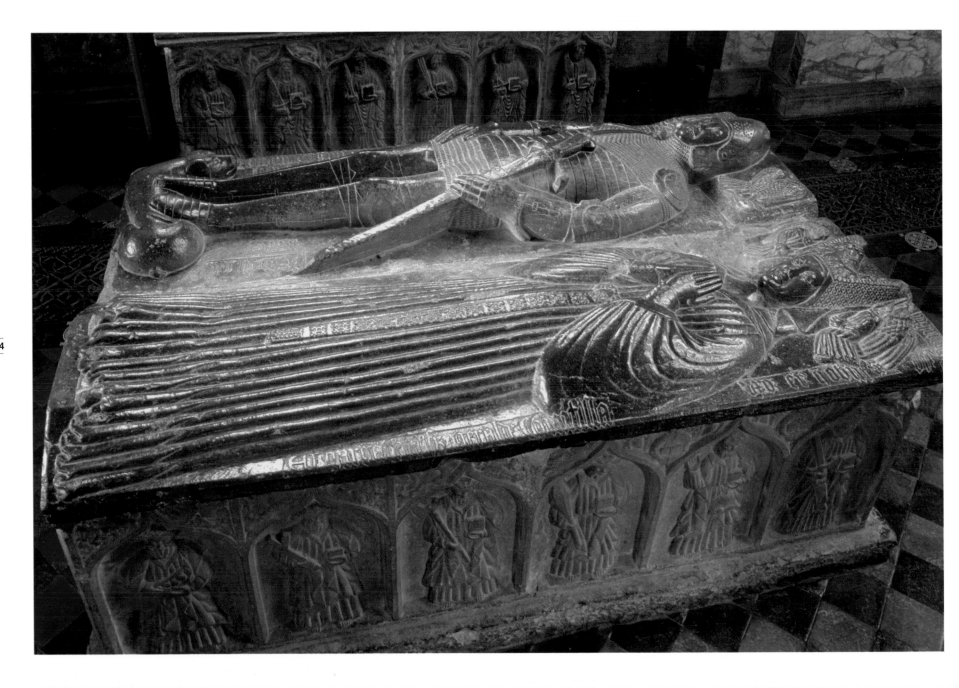

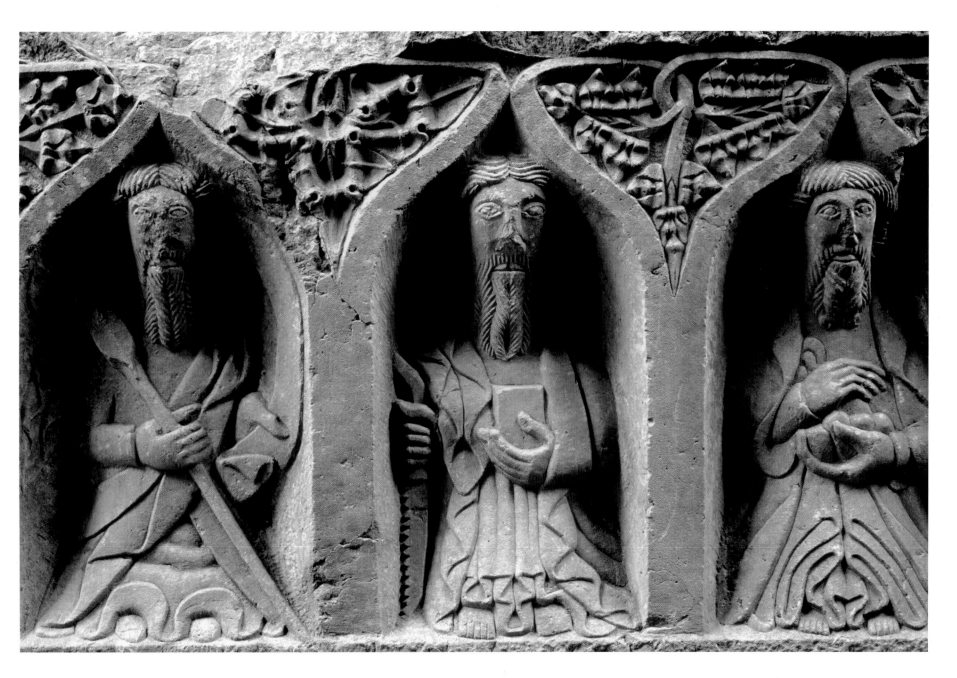

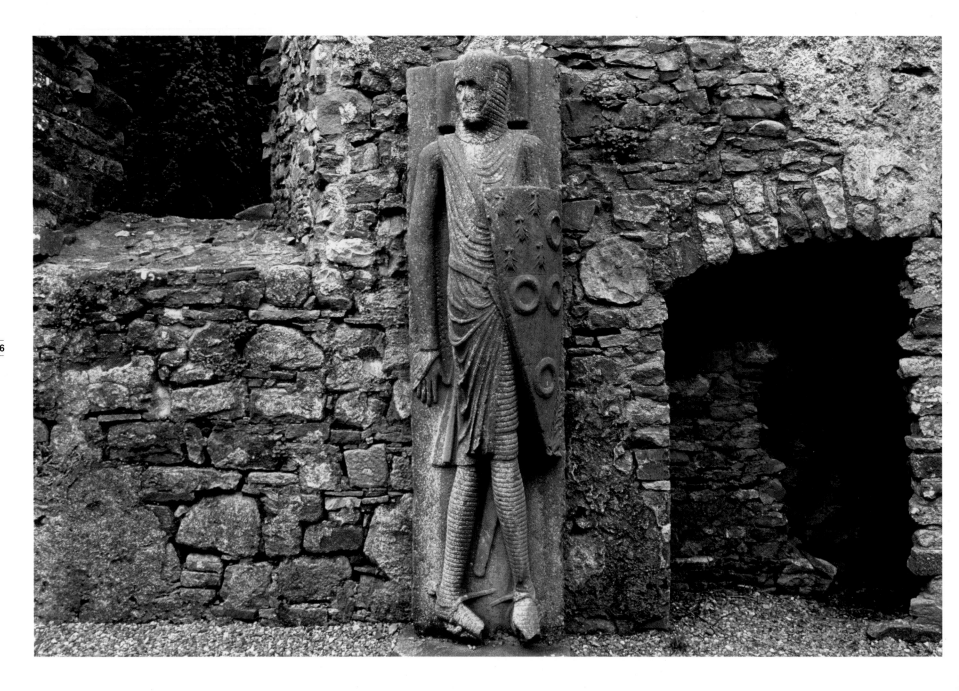

LEFT: A 13th century effigy of Thomas de Cantwell at Kilfane Church, County Kilkenny. Thomas was either the founder or rebuilder of the church, which accounts for the greater than life size effigy—a fascinating example of medieval sculpture. One interesting story about the effigy recounted by Peter Harinson in his brilliant guide to the National Monuments of Ireland is that the church was used as a school for a time and during this period, bad boys had to kiss Long Cantwell's stony lips as punishment.

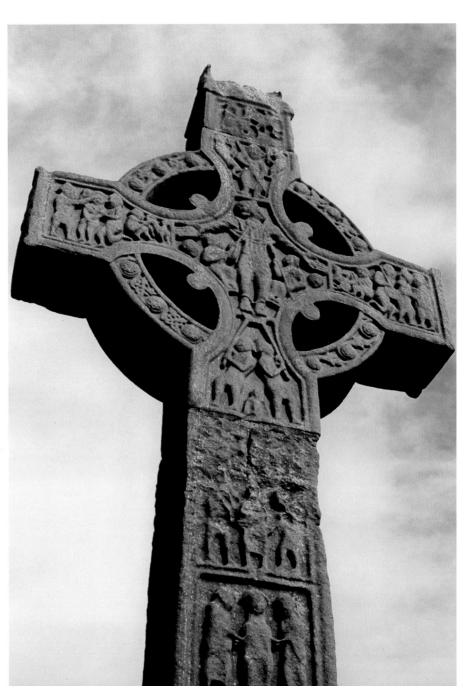

LEFT: The west face of the Tall Cross (or Muiredach's Cross), Monasterboice, County Louth. Quite simply the finest high cross in Ireland, Muiredach's Cross was made around the early 10th century. The images on this side are dominated by the crucifixion.

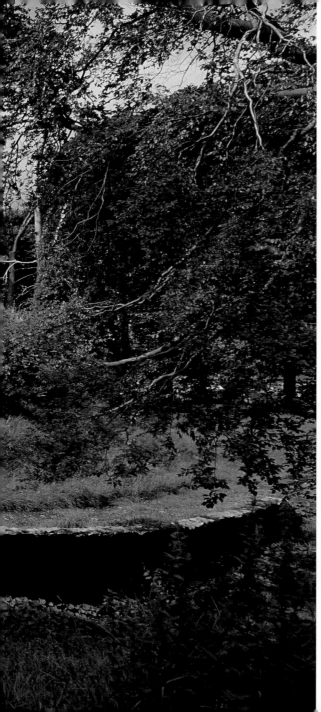

**LEFT:** Dun Dealgan Castle, County Louth, is a Norman motte and bailey castle but the site is also associated with Cúchulainn who is said to have been born locally. Probably built in the last 30 years of the 12th century, the tower on top of the motte is an 18th century folly.

**BELOW:** St. Brigid's Well in the graveyard of Faughart Church, County Lough. St. Brigid was born in 451 or 452 at Faughart, near Dundalk, and the Church was founded in her honor. The old well adjoining the ruined church still attracts pilgrims.

**OVERLEAF:** The view north of New Ross, County Wexford, and the valley of the River Barrow from the summit of Slieve Coilte where the 1798 rebels camped June 7–10.

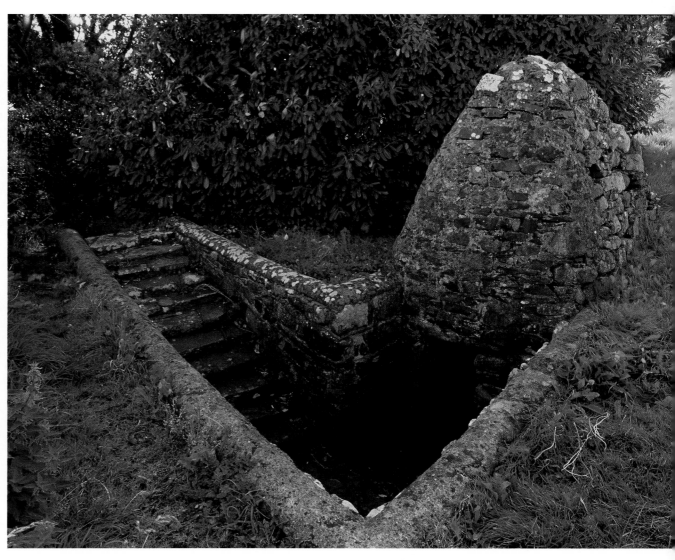

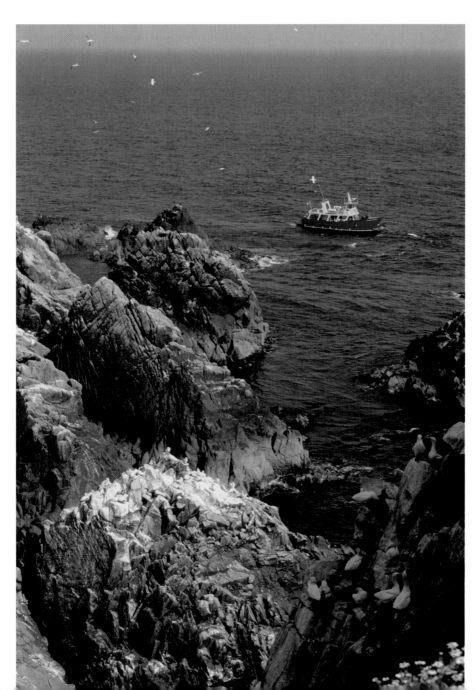

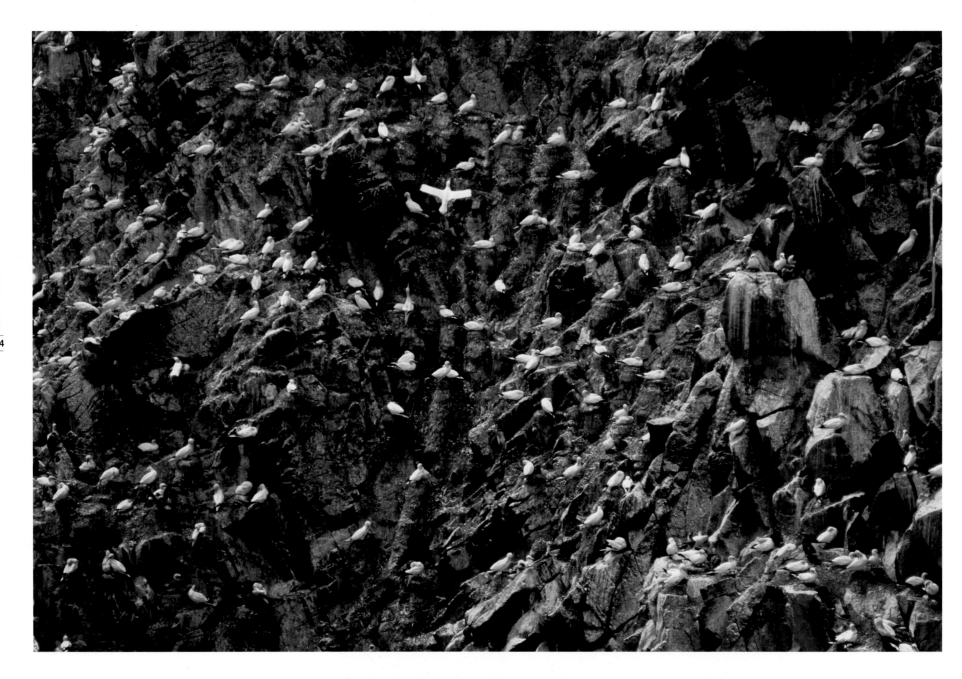

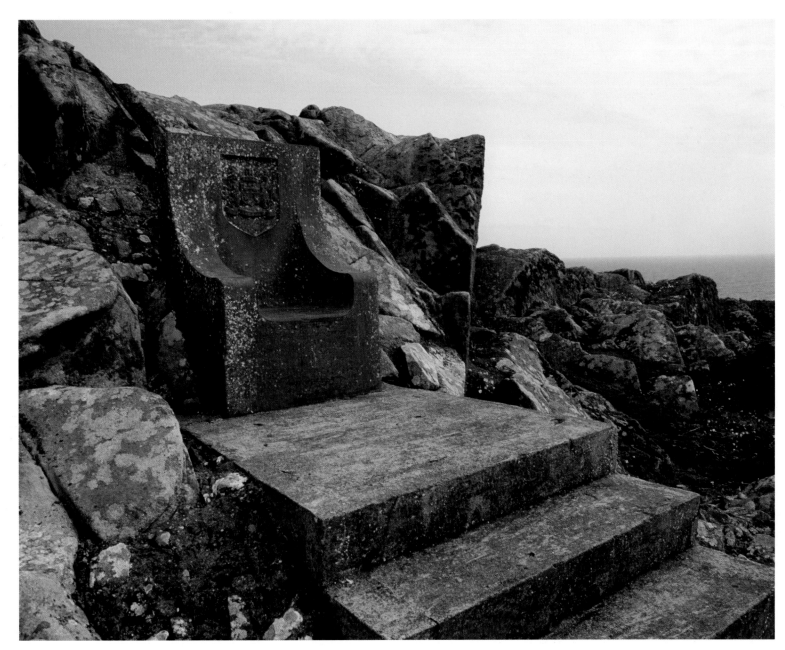

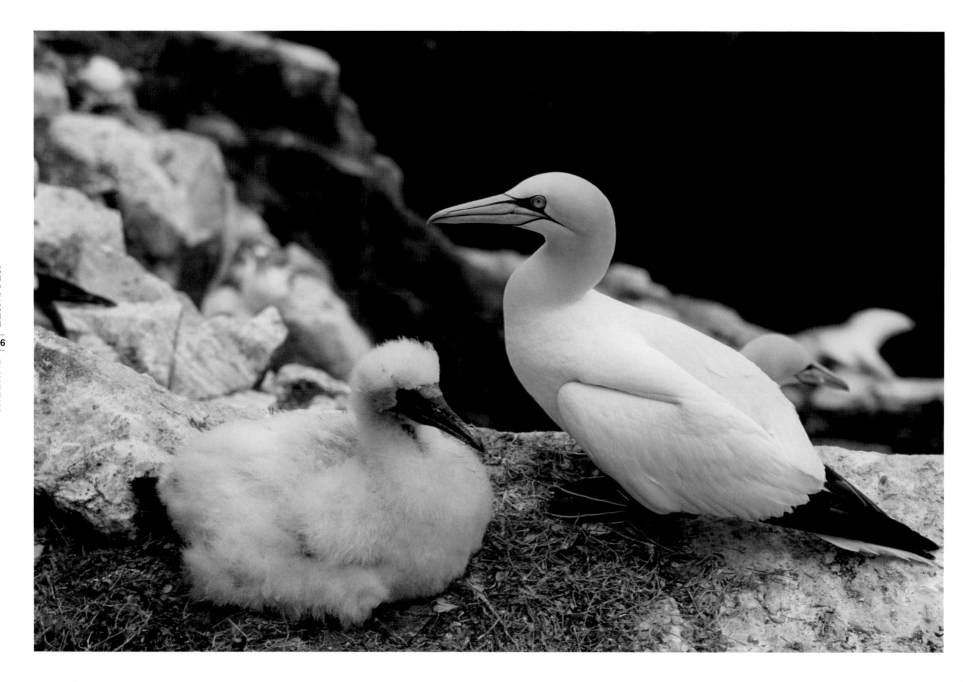

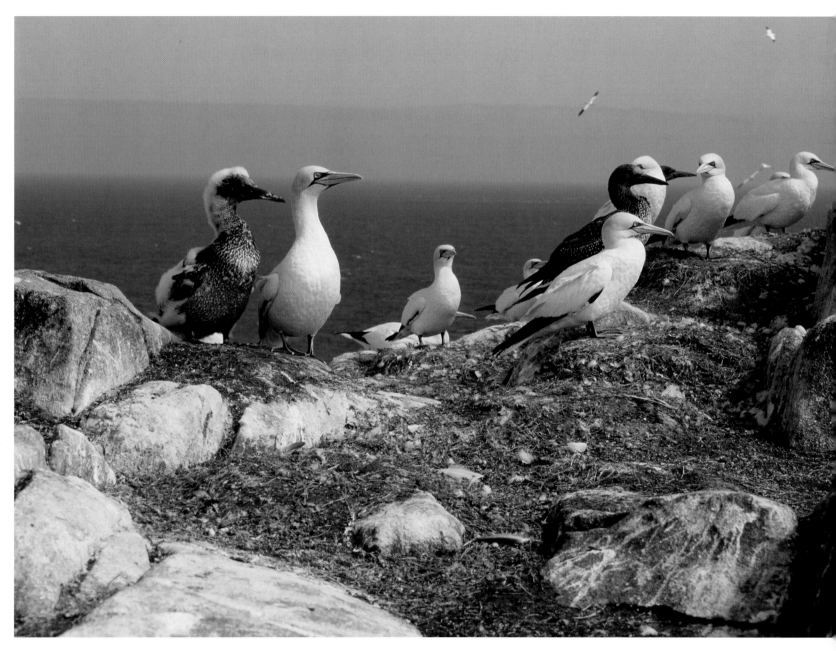

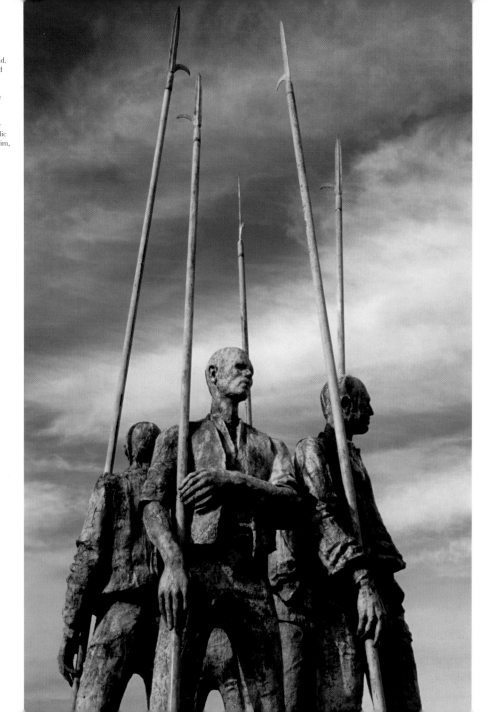

**RIGHT:** "United Irishmen" by Eamonn
O'Doherty on the New Ross-Wexford road.
There was an action here against Wexford
garrison forces on May 30, 1798, during
Wolfe Tone's rising. O'Doherty is one of
Ireland's most famous public artists whose
work may be seen in many of its major
cities—Dublin has his sculpture depicting
Anna Livia Plurabelle (the "Floozie in the
Jacuzzi"). Other pieces of large-scale public
sculpture are to be found in Galway, Antrim,
Dun Laoghaire, Enniskillen, Cobh, and
Navan. Other commissions include the
Great Hunger Memorial in Westchester,
New York.

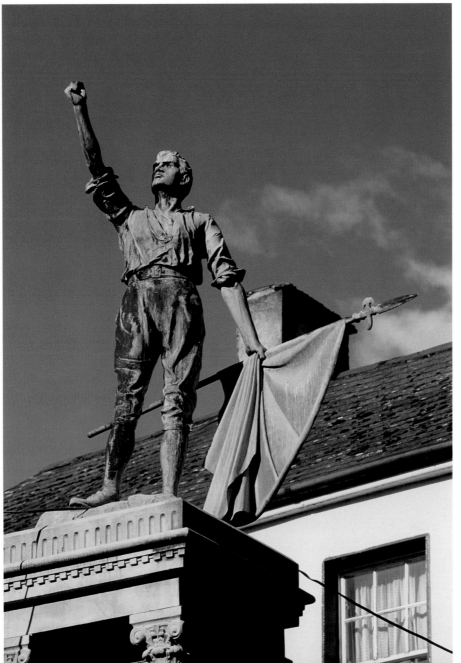

**OVERLEAF:** View east over the River Barrow to the town center, New Ross, County Wexford.

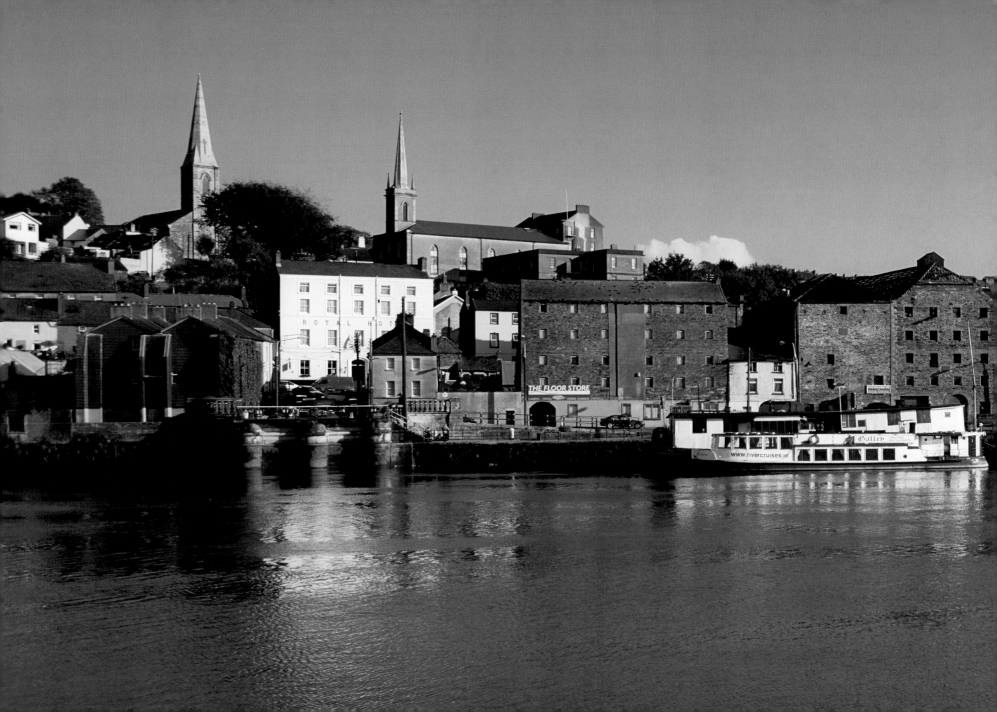

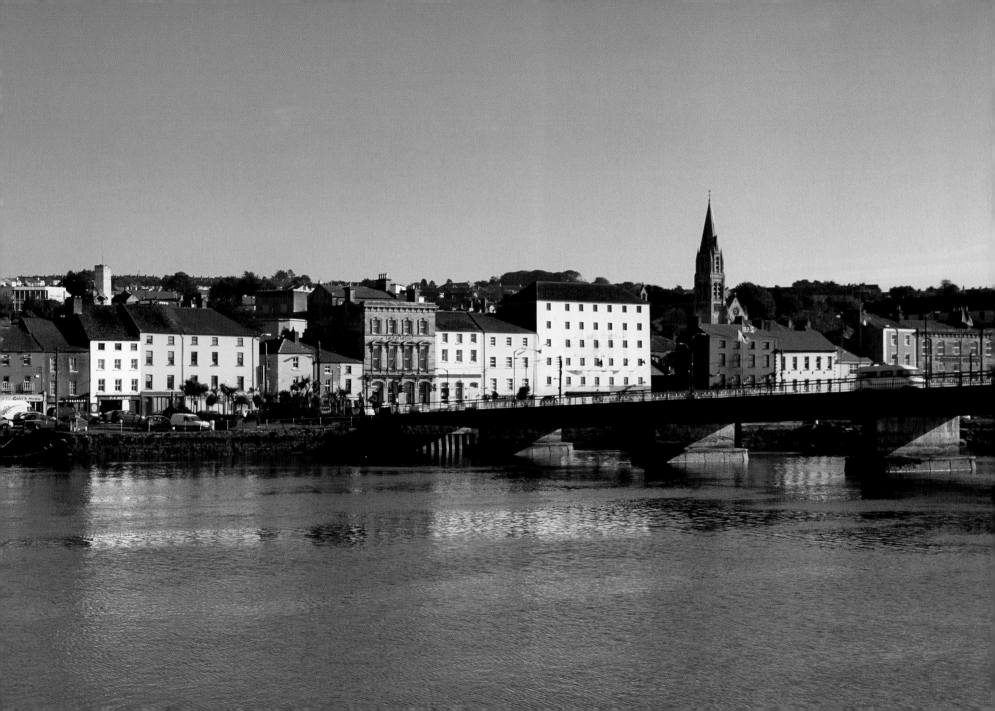

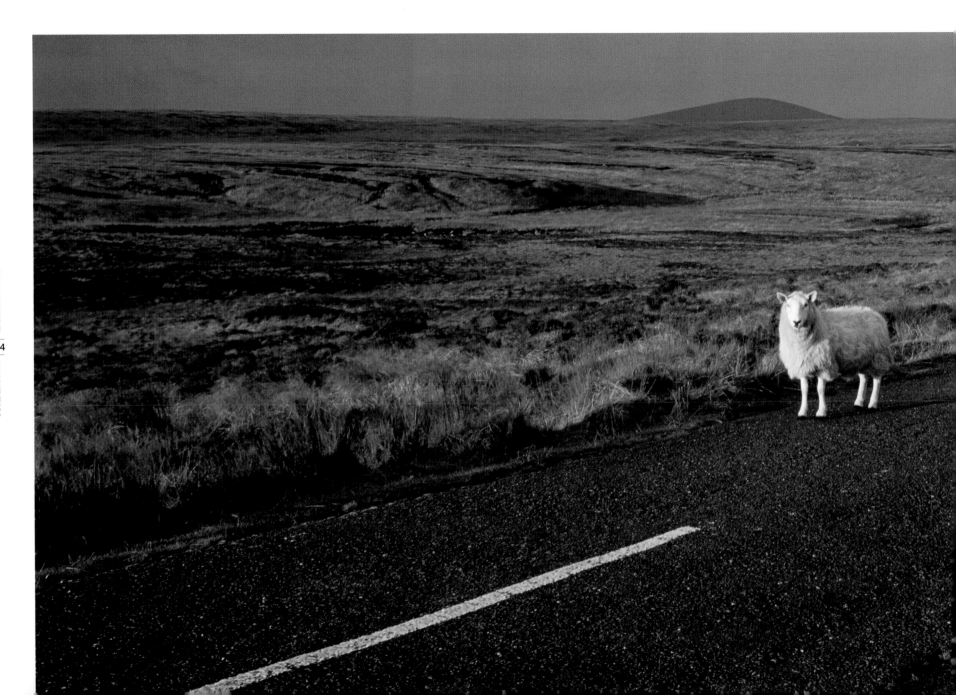

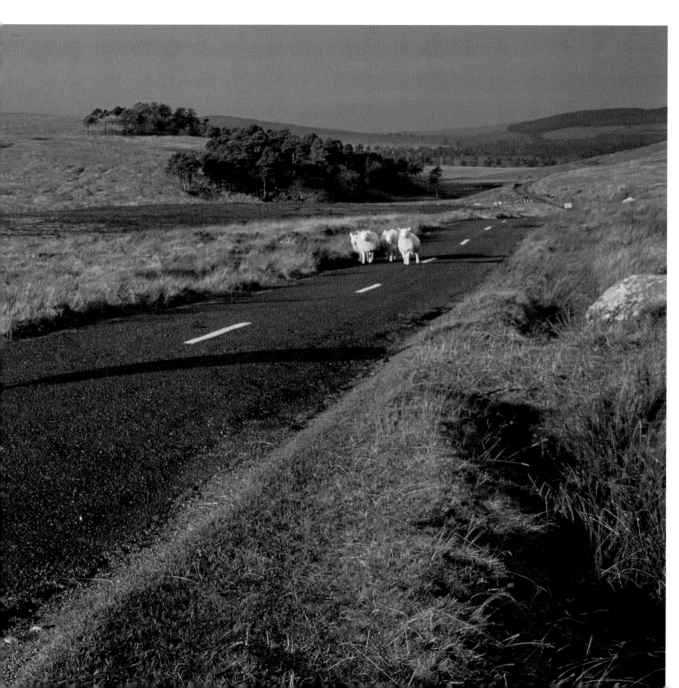

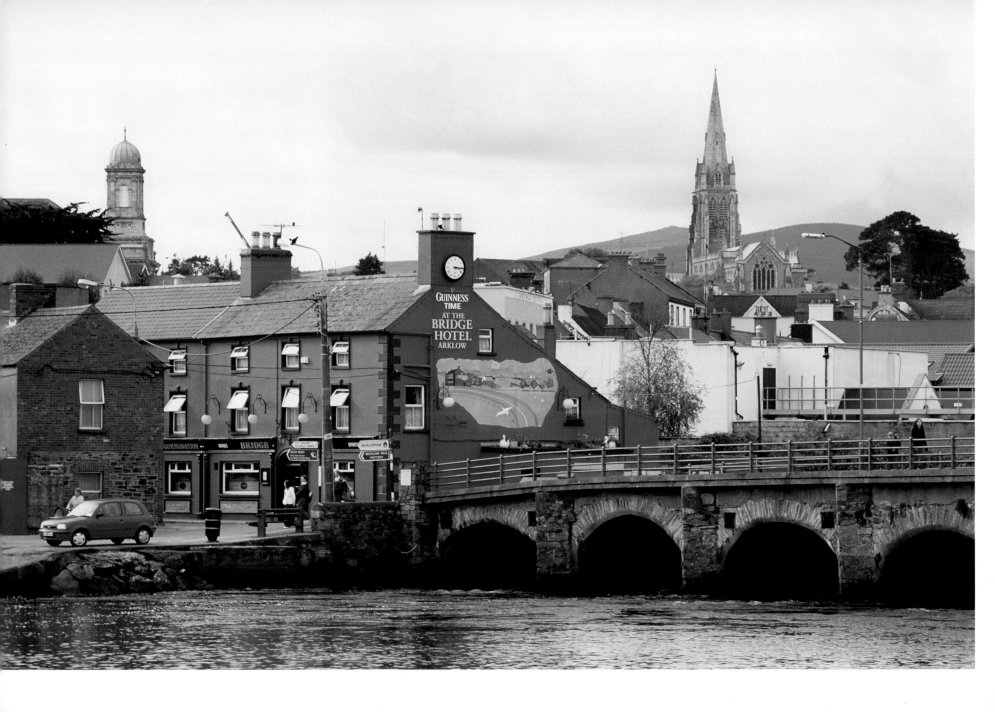

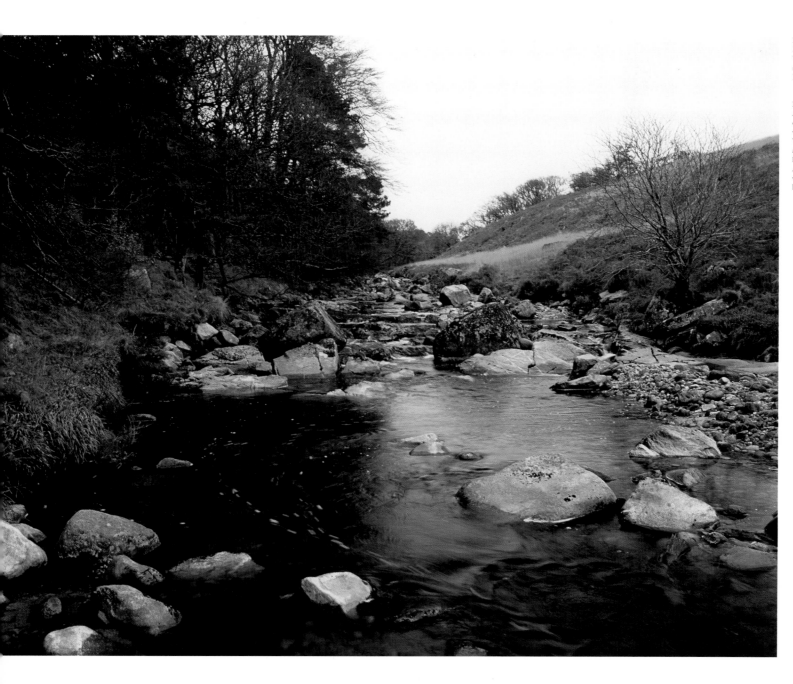

**LEFT:** Near the headwater of the River Liffey. Rising in the Sally Gap in the Wicklow Mountains, the Liffey runs for some 75 miles entering the Irish Sea in Dublin Bay.

**FAR LEFT:** Arklow on the south bank of the Avoca River, County Wicklow, was the scene of the decisive battle of the 1798 rising when Father Michael Murphy led the Wexford Insurgents in a brave but foolhardy attack on Arklow Castle in an attempt to link up with the United Irishmen in Dublin. After two hours of heavy fighting Murphy was killed and his men dispersed with heavy losses.

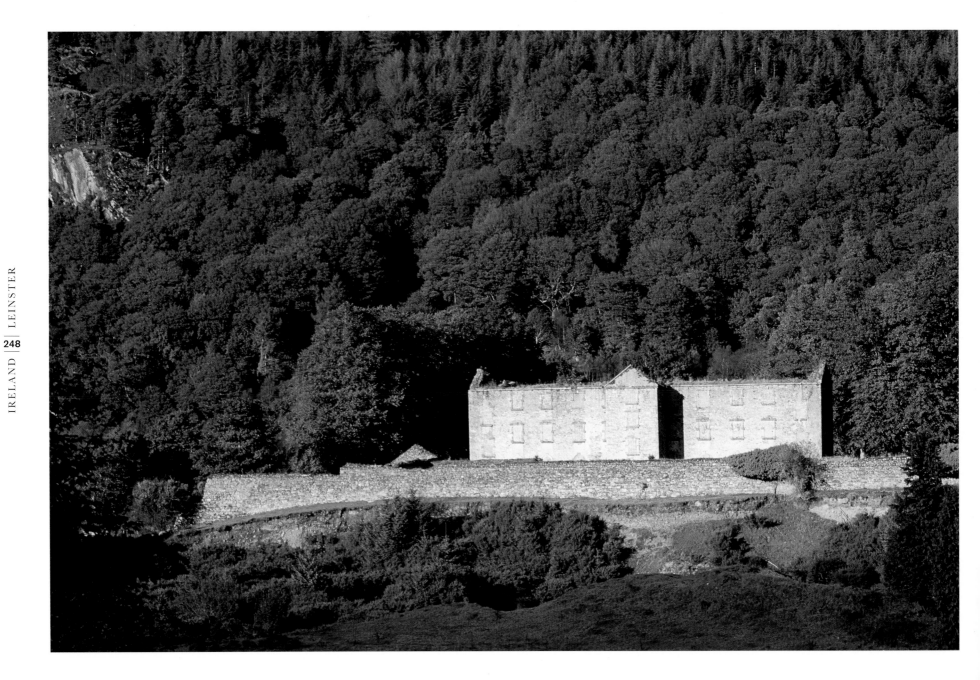

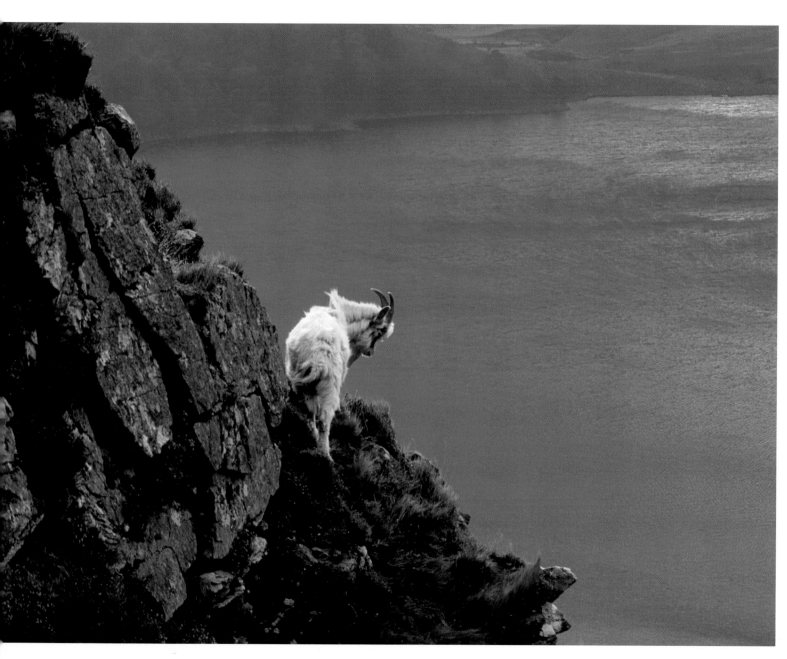

LEFT: Wild goat on the slopes above Lough Tay in the Wicklow Mountains.

FAR LEFT: Drumgoff Barracks on the military road at the head of Glenmalure in the Wicklow Mountains.

**RIGHT:** The Wicklow Mountains from the Military Road south of the Sally Gap. The Wicklow Mountains are the most extensive range of mountains in Ireland. They are not especially high—Lugnaquilla is the highest at 3,038ft—but they are beautiful and make excellent walking. Wicklow Mountains National Park was established in 1991.

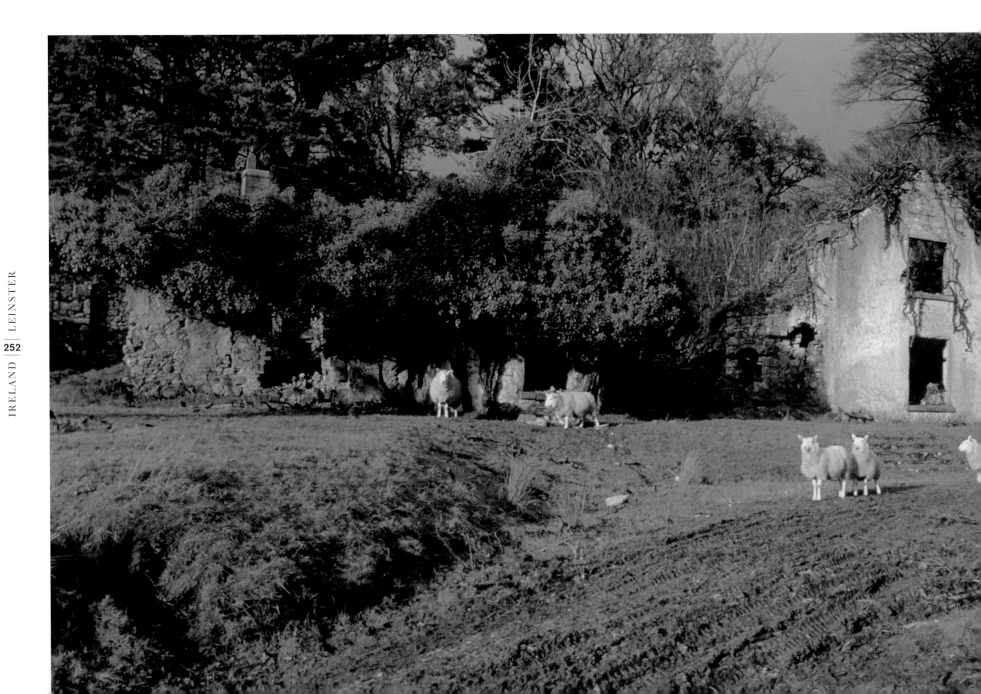

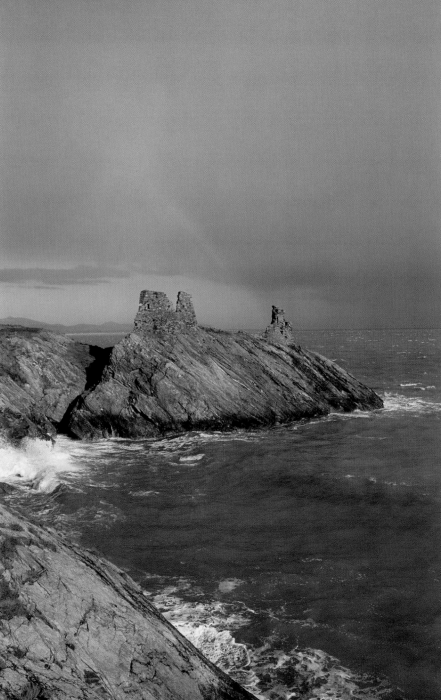

**LEFT:** The Norman Black Castle guards the harbor entrance to Wicklow. The castle was begun by Maurice Fitzgerald when he was granted the district in 1176, but his death a year later delayed its completion. The castle was frequently attacked by the Irish and sometimes occupied by them. Early in the 16th century it was held by the O'Brynes, but they had to surrender to the Crown in 1543. Luke O'Toole invested the fortress in 1641, but was forced to raise the siege when the British Army arrived.

**FAR LEFT:** Country estate at Kippure in the Wicklow Mountains.

**OVERLEAF:** View north across the port of Arklow, County Wicklow.

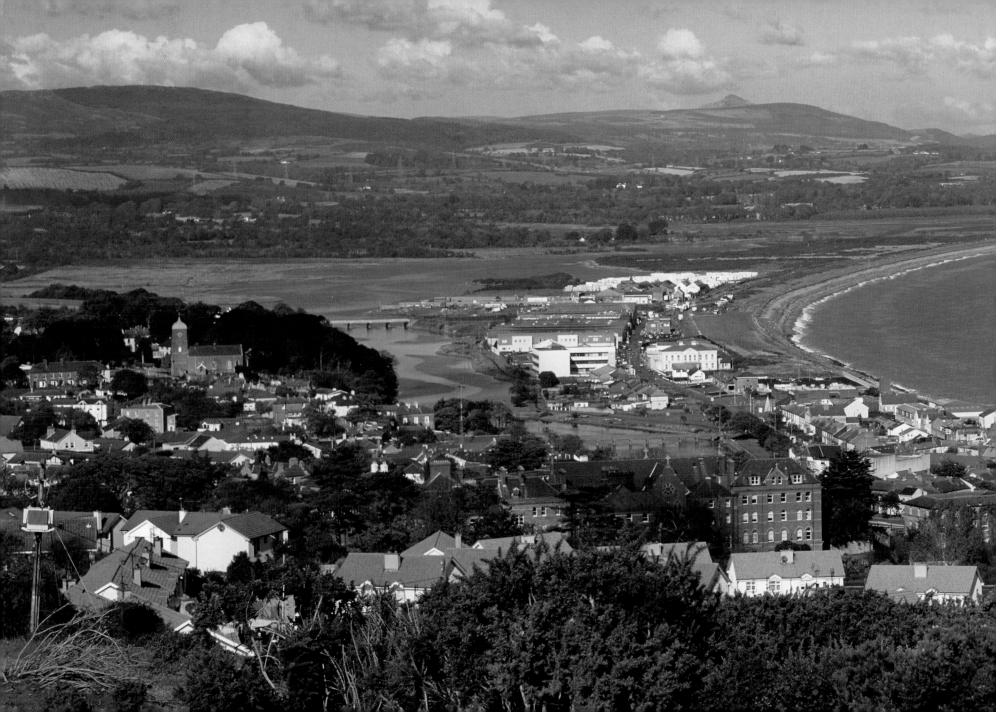

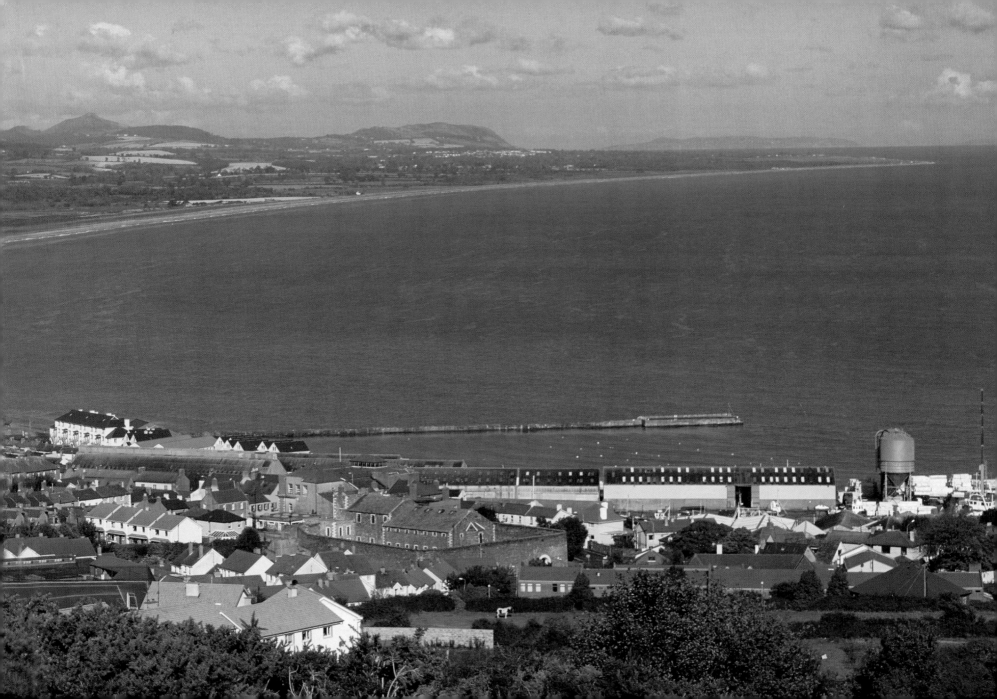

RIGHT: The round tower at Glendalough, County Wicklow, is 100ft high; the roof was repaired using the original stones in the last century. The monastery of Glendalough—the Glen of the Two Locks—was founded by St. Kevin in the 6th century. The site today includes churches, graves, crosses, a cathedral etc., and is scattered over a two-mile stretch of loughs and rivers.

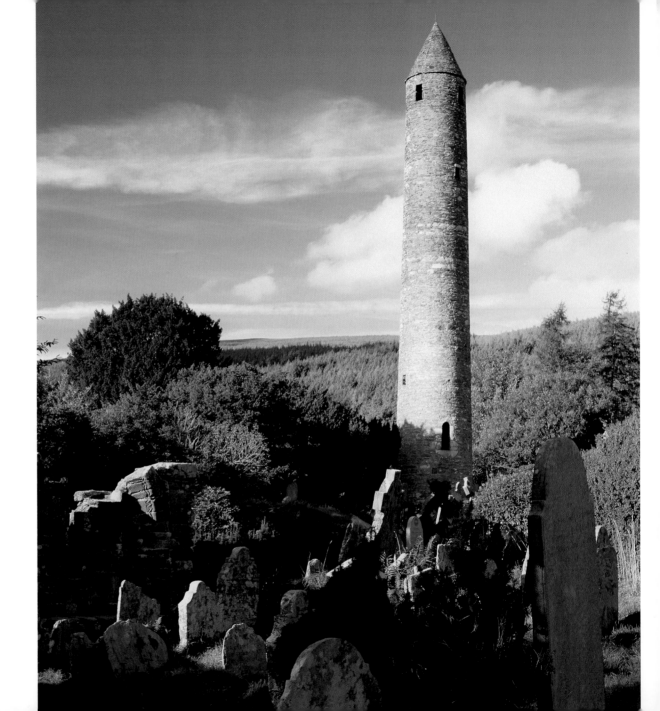